Alternative
Digital
Photography

John G. Blair

THOMSON
COURSE TECHNOLOGY
Professional ■ Technical ■ Reference

Important: Thomson Course Technology PTR cannot provide software support. Please contact the appropriate software manufacturer's technical support line or Web site for assistance.

Thomson Course Technology PTR and the author have attempted throughout this book to distinguish proprietary trademarks from descriptive terms by following the capitalization style used by the manufacturer.

Information contained in this book has been obtained by Thomson Course Technology PTR from sources believed to be reliable. However, because of the possibility of human or mechanical error by our sources, Thomson Course Technology PTR, or others, the Publisher does not guarantee the accuracy, adequacy, or completeness of any information and is not responsible for any errors or omissions or the results obtained from use of such information. Readers should be particularly aware of the fact that the Internet is an ever-changing entity. Some facts may have changed since this book went to press.

Educational facilities, companies, and organizations interested in multiple copies or licensing of this book should contact the Publisher for quantity discount information. Training manuals, CD-ROMs, and portions of this book are also available individually or can be tailored for specific needs.

ISBN-10: 1-59863-382-1

ISBN-13: 978-1-59863-382-5

Library of Congress Catalog Card Number: 2006940096

Printed in the United States of America

08 09 10 11 12 BU 10 9 8 7 6 5 4 3 2 1

Publisher and General Manager, Thomson Course Technology PTR:
Stacy L. Hiquet

Associate Director of Marketing:
Sarah O'Donnell

Manager of Editorial Services:
Heather Talbot

Marketing Manager:
Jordan Casey

Acquisitions Editor:
Megan Belanger

Marketing Assistant:
Adena Flitt

Project Editor:
Jenny Davidson

Technical Reviewer:
Ed Berland

PTR Editorial Services Coordinator:
Erin Johnson

Copy Editor:
Gene Redding

Interior Layout Tech:
Bill Hartman

Cover Designer:
Mike Tanamachi

Indexer:
Sharon Shock

THOMSON

COURSE TECHNOLOGY ™

Professional ■ Technical ■ Reference

Thomson Course Technology PTR, a division of Thomson Learning Inc.
25 Thomson Place ■ Boston, MA 02210 ■ http://www.courseptr.com

*"The most beautiful thing we can
experience is the mysterious.
It is the source of all true art and science."*
—Albert Einstein, 1930

*For Mom and Dad,
who taught me that making mistakes is
always part of the learning process*

ACKNOWLEDGMENTS

IN EVERY BOOK PROJECT there is a group of people working behind the scenes to make this all happen. My agent, Carole McClenden of Waterside Productions, was the one who first suggested that I write a book on alternative digital photography after we had kicked around a few ideas. For those not familiar with an agent's duties, they include coaching, advising, and counseling in addition to the more mundane business side of things. Carole proposed the idea to Megan Belanger, acquisitions editor at Thomson Course Technology PTR, who we had worked with on an earlier project. Megan really liked the concept and carried it through along with having a baby part way through the process just to add in some extra special excitement. Jenny Davidson was the project editor and her hard work shows throughout. Lensbabies, LLC. and Life Pixel Digital Infrared Conversion Services provided products and services to enable me to write the chapters on Selective Focus and Digital Infrared. Randy Smith of HolgaMods.com speeded up my order of a Holga lens so that I could meet deadlines for this book. I appreciate their generosity. Finally, a special thanks goes to my parents, Mary and Bud, to whom I dedicate this book. They taught me it takes plenty of mistakes to learn and grow. I can directly trace my love of experimenting back to them, allowing me to fail without shame and to get up and try again. I love you, mom and dad.

ABOUT THE AUTHOR

JOHN G. BLAIR began writing and photographing in elementary school, publishing and selling his own newspaper at age 10. He has been a professional photographer for nearly 40 years. He has written earlier books including *Digital Boudoir Photography* and *Adobe Photoshop Lightroom* published by Course Technology and *A Glossary of Digital Photography*. He is experienced in boudoir, portrait, wedding, commercial, editorial, stock, and fine art photography. He has worked in various aspects of digital photography since 1991, starting in Photoshop 2.5! His boudoir photography and scenes of him at work were featured on the French television program, *This Crazy World*.

He has taught courses, presented seminars, and lectured on photographic and business topics to groups of all ages from middle school children to professionals. He has presented a number of boudoir and makeup courses to professional photographers as well. John's award-winning work has led to his being named Photographer of the Year twice in five Northern California counties. He has received a number of awards and honors from the Professional Photographers of California. His studio is located in the redwood forests of Northern California, which he shares with his wife and three large dogs. In his spare time, he is a volunteer firefighter.

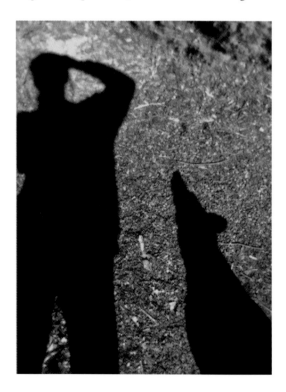

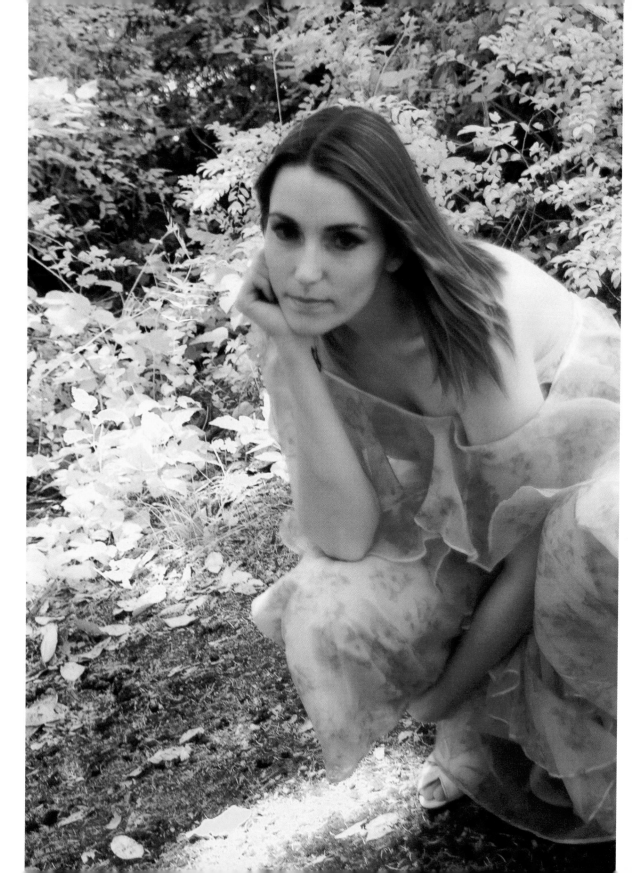

CONTENTS

Chapter 7
Mosaic

Chapter 8
Fresco

Chapter 9
Photoimpressionism

Chapter 10
Sequences

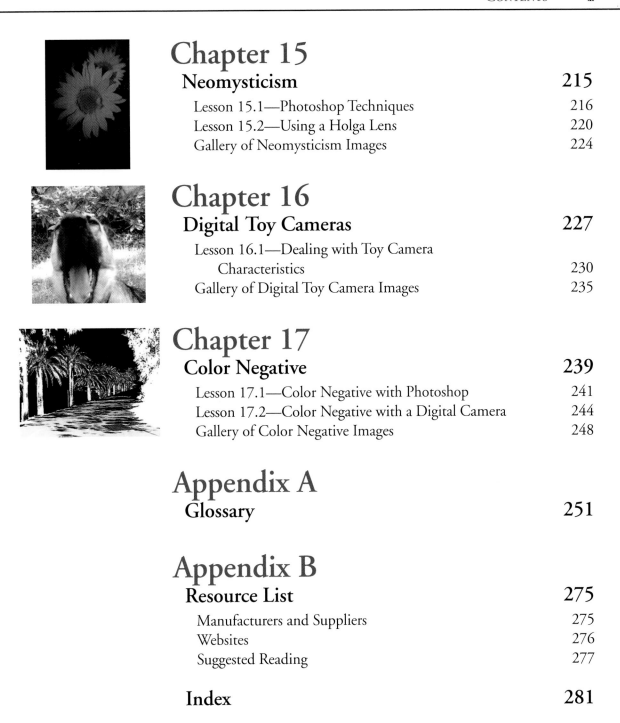

Chapter 15
Neomysticism

Chapter 16
Digital Toy Cameras

Chapter 17
Color Negative

Appendix A
Glossary

Appendix B
Resource List

Index

INTRODUCTION

WHAT IS "alternative digital photography" anyway? That is the number one question people asked when this book idea was first being discussed. Perhaps this is on your mind as well. To some, the term conjures up visions of strange lifestyles involving macabre subjects. Actually, in this book, "alternative" simply means mysterious and out of the ordinary in terms of equipment and results. In day-to-day life many photographers tend to get into a rut with their photography. They need a few ideas to get the creative juices flowing again. That's where *Alternative Digital Photography* comes in. This is a book of lessons and ideas that should help you get excited about your photography and move you in new directions.

This book has its roots in film photography techniques that were around long before digital photography and Photoshop came about. Bored photographers looking for new vistas were cross-processing their film; using strange combinations of color filters; etching on negatives, prints, and Polaroids; interrupting the processing of prints with a flash of light; using unusual films; hand coloring and painting black-and-white prints; painting with light; and trying unusual ways to expose film such as using pinhole cameras. This led to solarization, Polaroid transfers, Polaroid manipulations, slide film processed in the wrong chemicals, Polaroid slide film, black-and-white film push processed in a Dektol print developer, the use of the famous Holga and Diana plastic cameras, and many more experimental techniques. Digital photography entered the scene in a big way over the past few years. At first digital is a lot of fun. After awhile it seems to become a bit mechanical, sterile, and left-brained. Many photographers yearn for some of the fun and unexpected results that film-based techniques could provide. The purpose of this book is to bring back that fun by suggesting digital reproductions of the old techniques such as digital pinhole cameras, digital toy cameras, and digital infrared. It also suggests some new ideas such as Fresco and Neosymbolism.

Not all of the ideas in this book will appeal to everyone. That is by design. Some of the lessons are easy and take a minimum of equipment. Others require purchasing special tools or software. Use the ideas that fit within your interests and budget and ignore the rest, or save them for another day.

And now on to the book… I suggest that you start with "How to Use This Book" and then randomly try out some of the lessons. Good luck with your journey. Feel free to contact me at www.johngblair.com if you have any questions or suggestions along the way.

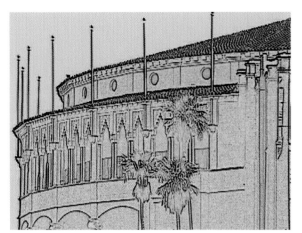
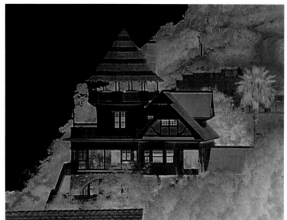

How to Use This Book

This book is broken into chapters that are groups of lessons. Each group of lessons is designed to create a particular style of image. The chapters contain various lessons that will help to create similar types of images in different ways. The easiest way to use this book is to glance through the table of contents and look at the small images with each chapter heading. If a particular style of image looks interesting to you, then flip through that chapter for more example images. Still interested in that image style? Then read the lessons and try a few. Perhaps following those lessons will lead you in another direction and provide even more discoveries. Please feel free to share those new discoveries with the author.

It is not expected that all lessons will appeal to all photographers. The book and the lessons are designed that way on purpose. They are designed to stretch your definitions of what a photograph is and can be. They were created with the idea of removing some limitations in thinking. Some of the techniques are easy and require very little equipment. Others require the purchase of specialized equipment or the modification of existing equipment and may be beyond the budget or interests of some readers. Some of the image styles are quite unusual and don't necessarily appeal to all tastes either. Have fun with them.

Although nearly anyone can use these ideas in expanding their photography and creativity, the book assumes a basic understanding of digital photography. It is assumed also that the reader has mastered his particular digital camera and has his camera manual available to look up the answers to basic questions that may come up. If that is not the case, pick up a basic digital photography book (one is listed in Appendix B, "Resource List") to get up to speed. The ideas in this book took years to gather and develop. Don't expect to master them overnight. Enjoy the experience of trying something new.

CHAPTER 1

Creating Black and White from Color

THE CREATION of black and white, more properly now called "grayscale," images has nearly always been popular with photographers. There is just something special about them. The way black and white can change a scene and focus attention on form, shape, and shadow is part of their appeal. In the past, photographers had their favorite black-and-white film that they had to use if they wanted quality black-and-white images. Using a normal black-and-white enlarging paper with a color negative or even using a special black-and-white enlarging paper designed for use with color negative films did not give the highest quality results.

Today, using different digital techniques, beautiful black-and-white images can be created from color digital files. There are many different ways to do this. The lessons below are just a few of the more popular ways that are possible. Besides Photoshop, there are a large number of software solutions that offer varying degrees of control over the process. For the Mac there is iPhoto, Aperture, Lightroom, Graphic Converter, Photoshop Elements, GIMP, and many more. For PC there is Picasa, Lightroom, Graphic Converter, Photoshop Elements, Photoshop Album, GIMP, and others. All of these should be investigated if you love black and white and don't already have one of the other software programs. There is also a wide variety of plug-ins for Photoshop as well. It would take an entire book just to cover all of the different ways to convert a color image into a black-and-white one. The following lessons should get you started.

We will start with a color digital image of three colors of tulips against a black background as shown in Figure 1.1. This will help to make the differences between different types of black-and-white conversions stand out more clearly. None of the methods are inherently better than the others, although many photographers have their favorites. You may use one type because it is quick and you are in a hurry to get a rough idea of what a black-and-white image would look like. You may use another type of conversion because it gives you better control over the mapping of various colors into various shades of black and white even though it takes longer.

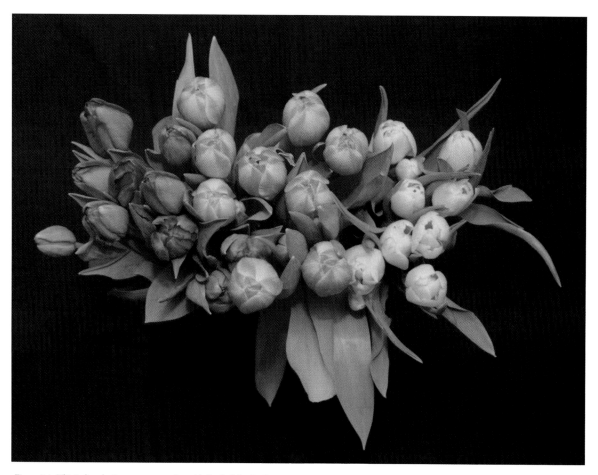

Figure 1.1 *This is the color image we are starting with for the following lessons.*

Lesson 1.1—Creating Black and White with Photoshop Grayscale

This is one of the easiest lessons. Simply open the image in Photoshop and then select Image > Mode > Grayscale as shown in Figure 1.2 for Photoshop CS and Figure 1.3 for Photoshop Elements 3. That's all there is to it. It is fast and easy and produces a decent black-and-white image, as shown in Figure 1.4. Move on to Lesson 1.2 for another "one-step" example technique that produces a different result.

Figure 1.2 Converting a color image into a black-and-white or grayscale image by using the Grayscale command in Photoshop CS.

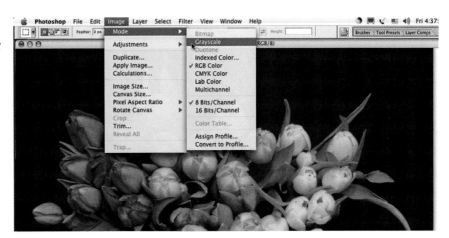

Figure 1.3 Converting a color image into a black-and-white or grayscale image by using the Grayscale command in Photoshop Elements 3.

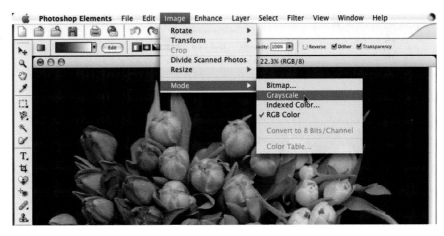

Figure 1.4 This is the resulting black-and-white converted image using the Grayscale command.

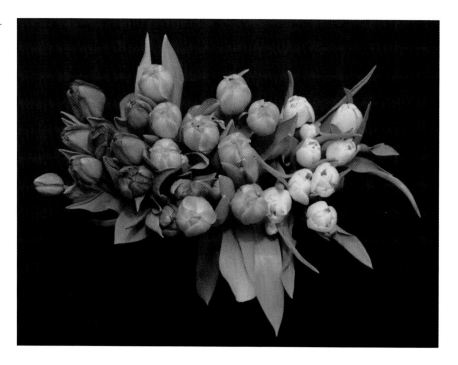

Lesson 1.2—Creating Black and White with Photoshop Desaturate

This is another easy lesson. Simply open the image in Photoshop and then select Image > Adjustments > Desaturate, as shown in Figure 1.5 for Photoshop CS and Figure 1.6 for Photoshop Elements 3 (the command is called Remove Color in Elements). That's all there is to it. It is fast and easy and can produce a decent black-and-white image, as shown in Figure 1.4. Move on to Lesson 1.3 for another technique.

Figure 1.5 Converting a color image into a black-and-white or grayscale image by using the Desaturate command in Photoshop CS.

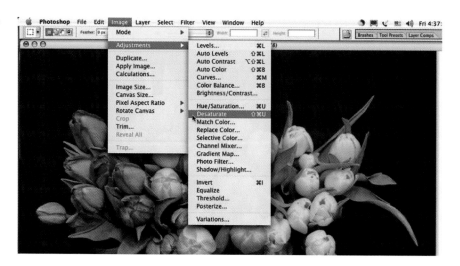

Figure 1.6 Converting a color image into a black-and-white or grayscale image by using the Remove Color (Desaturate) command in Photoshop Elements 3.

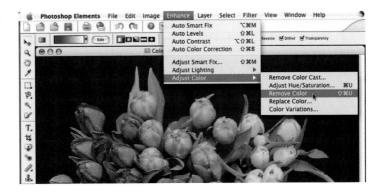

Figure 1.7 This is the resulting black-and-white converted image using the Desaturate command.

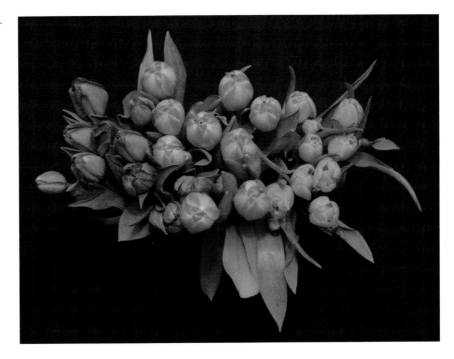

Lesson 1.3—Creating Black and White with Photoshop Lab Color Mode

This lesson shows another simple way to create black and white. Simply open the image in Photoshop and then select Image > Mode > Lab Color, as shown in Figure 1.8 for Photoshop. Photoshop Elements does not support lab color mode, so you have to use the regular Photoshop version. Once you have the image in lab color mode, look at the channels (Figure 1.9). If the Channel window is not open, open it in Window > Channels. Drag channels a and b to the small trash can icon in the Channels palette. Now you have an Alpha 1 channel displayed in grayscale. Go back up to Image > Mode > Grayscale to convert the image back to a grayscale image because the modifications just made change the image to multichannel mode.

You can also convert the image back to an RGB mode if you need to (Image > Mode > RGB) after it has been converted to a grayscale image. The colors do not return, of course, but sometimes all images have to be in RGB mode even if they are black and white. Move on to Lesson 1.4 for more control of the resulting grayscale tones.

Figure 1.8 Converting a color image into a black-and-white or grayscale image by using the lab color mode in Photoshop CS.

Figure 1.9 Converting.

Figure 1.10 This is the resulting *black-and-white converted image* *using the Lab Color Mode command.*

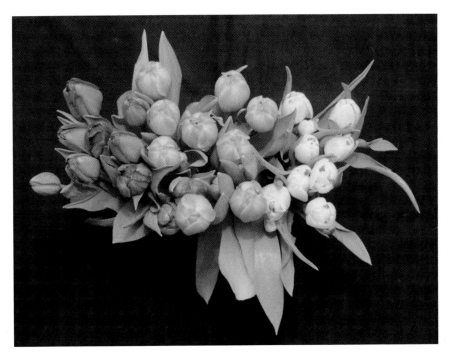

Lesson 1.4—Creating Black and White with Photoshop Channels

There are several ways to use channels or the Channel Mixer to create more control over your black-and-white images. Simply open the image in Photoshop and then open the Channels Palette by selecting Window > Channels as shown in Figure 1.11 for Photoshop CS. Unfortunately, Photoshop Elements does not support channels. In the Channels Palette, click on the individual channels (see Figures 1.12 through 1.14) and look at the black-and-white image made from the grayscale version of each channel. Notice the big change in the ways the image looks. Often the green channel (see Figure 1.13) will be the best conversion. To keep one of the channels, drag the other two channels to the little trash can in the palette. Change the image mode to grayscale by clicking on Image > Mode > Grayscale.

Figure 1.11 *Picking the Channels Palette.*

Figure 1.12 *Choosing the red channel.*

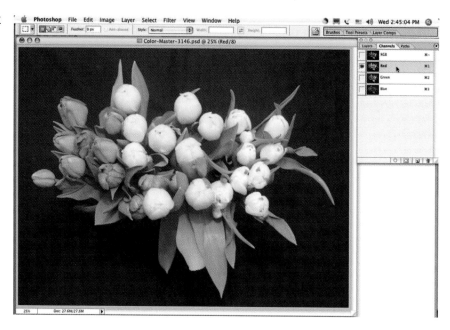

Figure 1.13 Choosing the green channel.

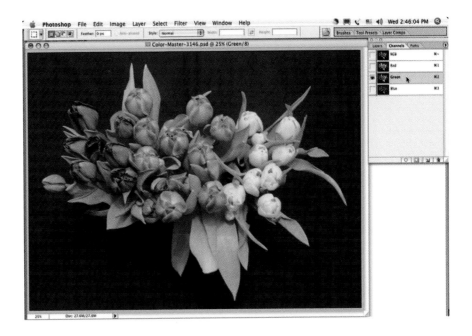

Figure 1.14 Choosing the blue channel.

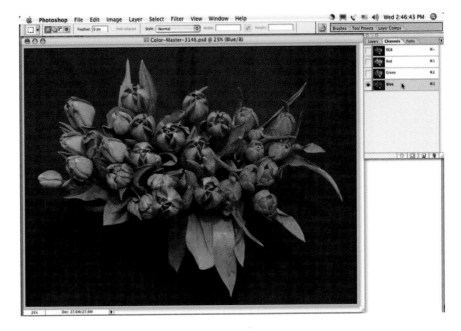

Lesson 1.5—Creating Black and White with the Channel Mixer

Photoshop has had a channel mixer to manipulate the individual channels since about version 5. (Photoshop Elements does not.) To start with, open your image. In the Layers Palette (Window > Layers), create a new layer by clicking on the small black-and-white circle as shown in Figure 1.15. In the pop-up menu, select the Channel Mixer (again in Figure 1.15). The Channel Mixer will appear (see Figure 1.16). Select Monochrome and Preview in the Channel Mixer. This will output your image as a grayscale (black-and-white) image and show you what it looks like in advance.

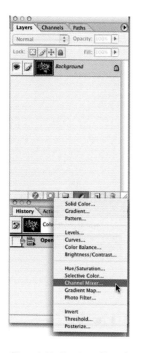

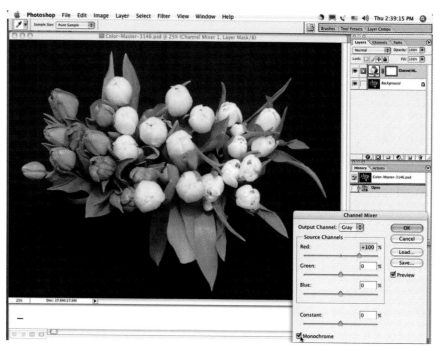

Figure 1.15 *Creating a Channel Mixer layer.*

Figure 1.16 *The Channel Mixer.*

There are four sliders in the Channel Mixer: one for each of the three color channels and one for a constant. Manipulate those sliders to see how your image changes. A rule of thumb says that the three color channels should add up to about 100%. Depending on the image, a higher value than 100% will produce a more washed-out appearance, and a lower value will make the image too dark. You can adjust them by eye until your image looks the way you want it to. Adding more of one color channel will make that color brighter, which also makes it whiter in the grayscale image. To make something that is red in the color version darker in the grayscale version, reduce the red slider by moving it to the left and then move the other sliders to the right to compensate. Figures 1.17 and 1.18 show the effects of adjusting the red slider and then not adjusting the green and blue sliders. Figure 1.19 shows the green and blue sliders adjusted to bring the image brightness back to a more normal setting. The possibilities and degree of control are nearly limitless.

Figure 1.17 The red channel is at 100%.

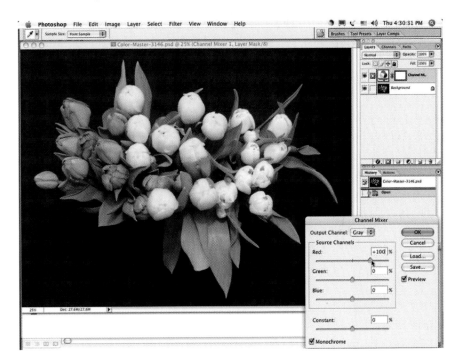

Figure 1.18 The red channel is at 50%, and no adjustments are made to the green and blue channels.

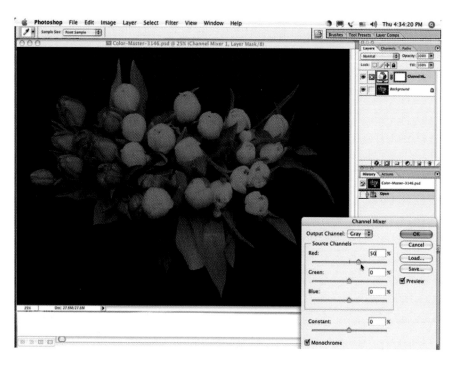

Figure 1.19 The red channel is at 50% with the blue and green channels adjusted to 25% to compensate.

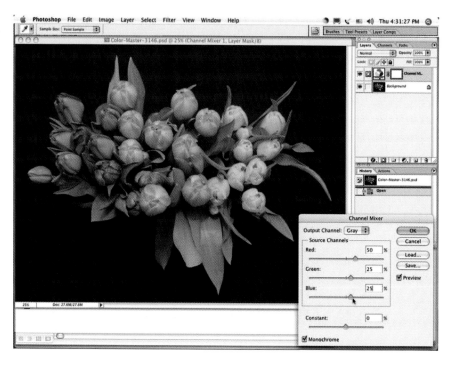

Lesson 1.6—Creating Black and White with Lightroom

Photoshop is not the only game in town. Adobe has also created a new program called Adobe Photoshop Lightroom, or Lightroom for short. This particular program is a fairly complete workflow tool designed just for photographers, while Photoshop has to also satisfy graphic designers and many others that use photographs. The following lesson shows how easy it is to use Lightroom to create black-and-white images and how much control you will have over the tones in your images. Although Lightroom is more expensive than Photoshop Elements, it is quite a bit less expensive than Photoshop. It could be a solution if you currently use Elements and would like to do more but don't need the power of Photoshop. Adobe offers a free 30-day trial of Lightroom at their website, or you can visit the author's website (johngblair.com) for links.

To start off, if you haven't used Lightroom before, you must first import your image(s) into Lightroom as shown in Figure 1.20. This brings the image into the Library module. Next, move over to the Develop module by clicking on Develop at the top, using the top menus, or using the shortcut OpenApple+D (Mac) or Ctrl+D (PC). This is shown in Figure 1.20.

Figure 1.20 Importing an image into the Lightroom Library so it can be worked on.

Once you have the image open in the Develop module, it will look like Figure 1.21. If your screen looks different, you can open and close the side panels and the top and bottom panels by clicking on the little triangle arrow on all four sides. That will either open or close the panels. Once you have the Develop panels open on the right side of the screen, click on Grayscale in the Basic panel or in the HSL/Color/Grayscale panel. They both do the same thing, converting your image to a grayscale (black-and-white) image. You end up with Figure 1.22. Make sure that the right side panels are opened

Figure 1.21 *The image is now open in the Lightroom Develop module.*

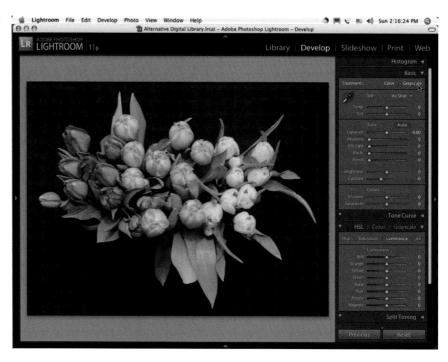

Figure 1.22 *The image is now converted to grayscale by clicking on Grayscale in a panel on the right.*

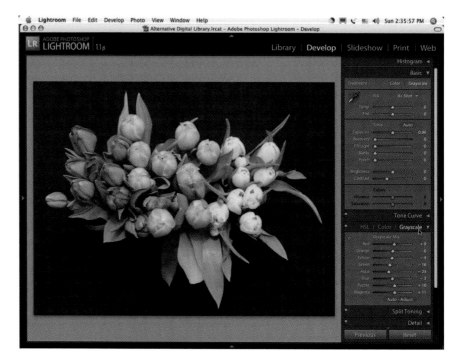

and closed as shown. Adjust Exposure, Recovery, Fill Light, Black, and Punch as necessary to have an overall visually pleasing image.

Now for the fun part. You have a large number of sliders (eight in Lightroom 1.1) in the HSL/Color/Grayscale panel. Moving those back and forth (or typing in numbers on the right) does the same thing as the Channel Mixer in Lesson 1.5 except that you can control things with much great precision in Lightroom. In Figure 1.23 we moved the yellow slider all the way to the right, and the value changes to -100. Notice the effect on the yellow flowers on the right. They have changed from nearly white to almost black with only small changes in tone in the rest of the image. You can use all of the sliders to tweak your image until it looks just as you would like.

Figure 1.23 *The yellow slider is moved to –100, changing the yellow flowers on the right to nearly black.*

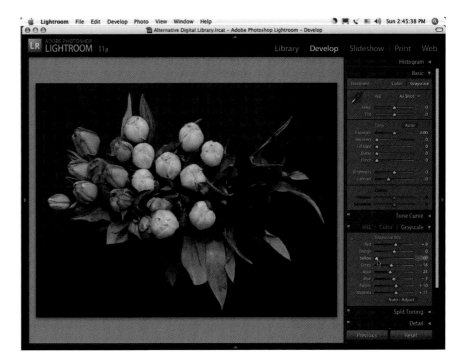

Once you are finished, you can export the image so you can send it to your lab, edit it further in Photoshop, make a slide show, print it, or create a website all from Lightroom. For detailed instructions on any of these features, see Appendix B, "Resource List," for books to help you with that. If you like the mix that you created, you can save it as a preset by going to the top menu and selecting Develop > New Preset and checking the boxes in the pop-up menu to select the controls and functions that you want your preset to save. Then with future images you can just select the preset.

Lesson 1.7—Creating Black and White with Aperture

If you have a Macintosh computer, you have your choice of using Lightroom or Aperture as a workflow tool. If you are on a PC, this will not work for you, and you can skip this lesson.

Like Lightroom, Aperture offers a free trial version at Apple's website. In Aperture, in a way similar to the previous lesson, you begin by importing your image. Figure 1.24 shows the proper steps: File > Import > Images. Next open the Inspector by clicking on Window > Show Inspectors (or just hit the i key) as shown in Figure 1.25. Then open the Monochrome Mixer and click on the checkbox. If the Monochrome Mixer is not shown, go up to the top bar called Adjustments and click on the plus (+) sign. In the pop-up menu, select Monochrome Mixer. You can also press Ctrl+M. The image changes to a grayscale (or monochrome or black-and-white) image. See Figure 1.26 for the example. The Monochrome Mixer's default preset is shown.

Figure 1.24 Importing an image into the Aperture Library so it can be worked on.

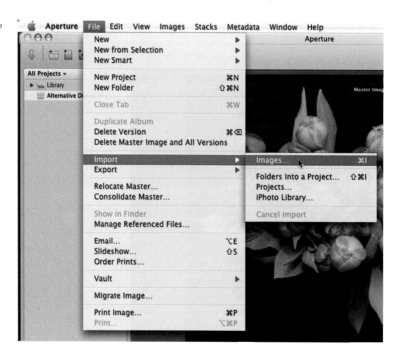

Figure 1.25 Open the Inspector in Aperture.

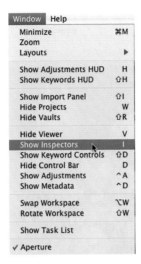

Figure 1.26 The Monochrome Mixer in Aperture. Checking the checkbox turns it on.

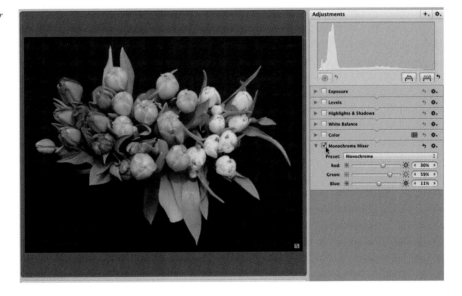

There are a few other built-in presets to simulate the effect of using color filters with black-and-white film. Figure 1.27 shows how to find the built-in presets. Figures 1.28 through 1.32 show the results of each filter preset.

Figure 1.27 Open the available presets by clicking on the double arrows next to the Presets section.

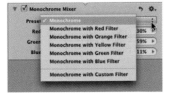

Figure 1.28 *The image with a red filter preset applied.*

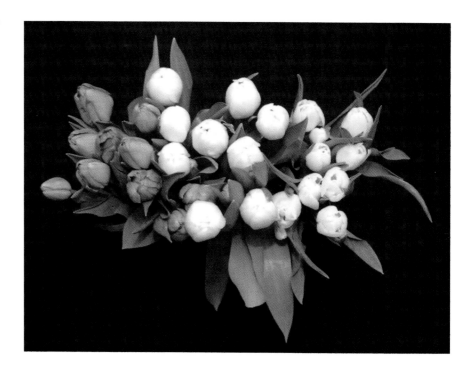

Figure 1.29 *The image with an orange filter preset applied.*

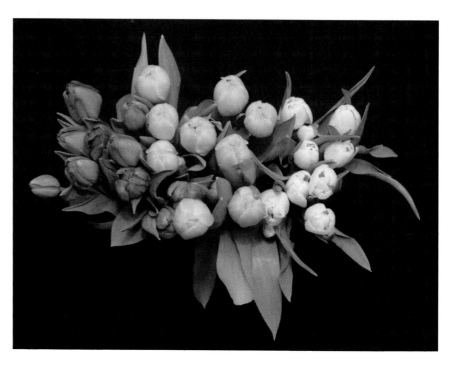

Figure 1.30 The image with a yellow filter preset applied.

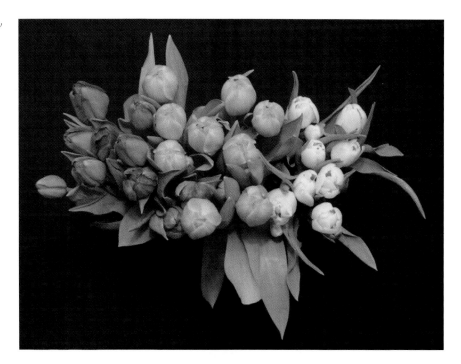

Figure 1.31 The image with a green filter preset applied.

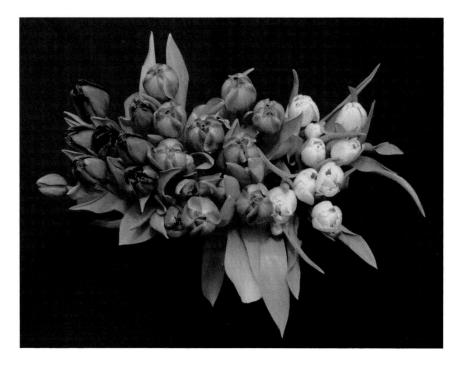

Figure 1.32 The image with a blue filter preset applied.

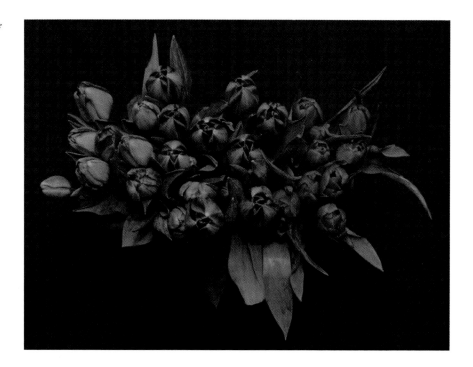

Using the Monochrome Mixer in Aperture is very similar to using the Channel Mixer in Photoshop (see Lesson 1.5). The same rules apply. It will usually produce a better result if the numbers total about 100 in the Monochrome Mixer as well as Photoshop's Channel Mixer. If you create a black-and-white (grayscale/monochrome) style that you like, you can save it in Aperture as a preset. Once you have it set, click on the little gear to the right of the Monochrome Mixer title and choose Save as Preset from the pop-up menu that appears.

Comparison of Different Conversion Techniques

To make it easier to see some of the different conversion techniques all in one place, we have gathered together many of them on these two pages.

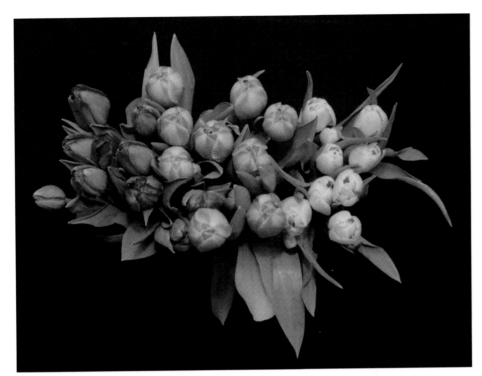

Figure 1.33 The original color image.

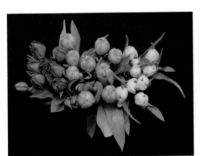

Figure 1.34 Photoshop Grayscale.

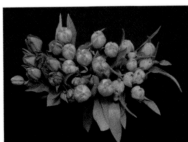

Figure 1.35 Photoshop Desaturate.

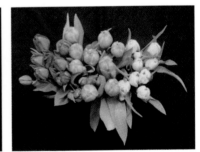

Figure 1.36 Photoshop Lab Color.

Figure 1.37 Photoshop Red Channel.

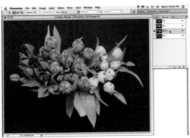

Figure 1.38 Photoshop Green Channel.

Figure 1.39 Photoshop Blue Channel.

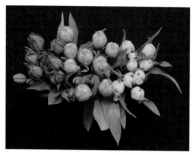

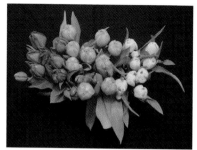

Figure 1.40 Lightroom Grayscale.

Figure 1.41 Aperture Monochrome.

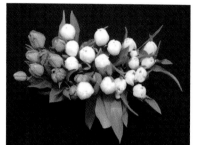

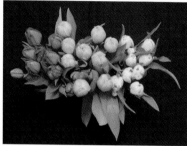

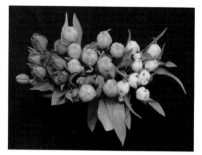

Figure 1.42 Aperture Monochrome with red filter.

Figure 1.43 Aperture Monochrome with orange filter.

Figure 1.44 Aperture Monochrome with yellow filter.

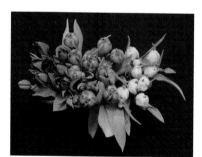

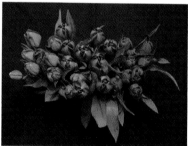

Figure 1.45 Aperture Monochrome with green filter.

Figure 1.46 Aperture Monochrome with blue filter.

Gallery of Black-and-White Images

CHAPTER 2

CREATING SEPIA FROM BLACK-AND-WHITE OR COLOR IMAGES

A SEPIA OR BROWN-TONED image is often used for artistic effect or to simulate an old-time look for an image. These types of images are easy to create. You can start with a color image or a black-and-white (grayscale) one.

We will start with a color digital image of three colors of tulips against a black background as shown in Figure 2.1. This is the same image that was used in Chapter 1, so you will be able to compare the black-and-white (grayscale) versions in Chapter 1 with the sepia ones in this chapter. This will help to make the differences between sepia versions stand out more clearly. None of the methods is inherently better than the others. These are just a few of the many ways to create a sepia-toned image. Besides the other methods, there are plug-ins available for Photoshop that will also easily create sepia images.

Figure 2.1 This is the color image we are starting with for the series of lessons in this chapter.

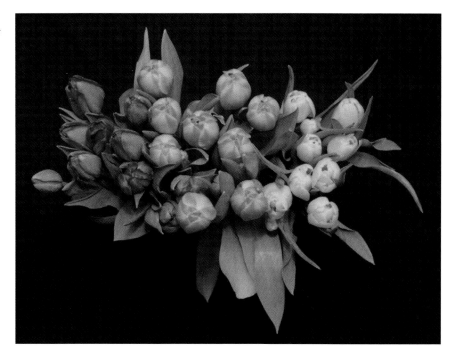

Lesson 2.1—Creating Sepia with Photoshop, Method 1

This is one of the easiest lessons. Simply open the image in Photoshop and then select Image > Mode > Grayscale. See Figure 1.2 in Chapter 1 for more detail on changing the color image to grayscale. Once you have thrown away the color information by answering Yes to the pop-up box in the previous step, go back up to Mode in the top menu and select RGB (see Figure 2.2). If you skip this step, you will not be able to change the color of a grayscale image.

Figure 2.2 After converting a color image into a black-and-white or grayscale image in Photoshop CS, make sure to set the mode back to RGB so you can add the sepia color.

Figure 2.3 Add a Color Balance layer in Photoshop.

Figure 2.4 Add the sepia color by using the Color Balance layer in Photoshop.

Next create a new Color Balance layer for your image in Photoshop. If you have Photoshop Elements and not Photoshop (CS/CS2/CS3), move down to Lesson 2.3 to learn how to create sepia without using a Color Balance layer. To create a new layer in Photoshop, go to the main menu Layer > New Adjustment Layer > Color Balance. If Color Balance is grayed out in your menu, it usually means you forgot to change the image back to RGB from Grayscale in the previous step. To create your new layer, you can also use the Layers Palette. If you don't normally work with the Layers Palette open, go to the top menu and click on Windows > Layers to make it show up. Now click on the black-and-white circle in the bottom of the palette and select Color Balance to create a new Color Balance layer (see Figure 2.3).

Now that you have your new layer, play with the controls to get a pleasing sepia rendition as shown in Figure 2.4. Sepia usually is made up of red and yellow. As a starting point, try setting Shadows to (+20, 0, -5) in the Color Levels boxes in the Color Balance pop-up menu. Then click on Midtones and select (+30, 0, -25). Finally, set Highlights to (+10, 0, -5). Feel free to change the values to your liking. Save your image as a Photoshop (PSD) or TIFF file (with the layers). This will allow you to go back and change them if you like. Figure 2.5 shows the resulting image.

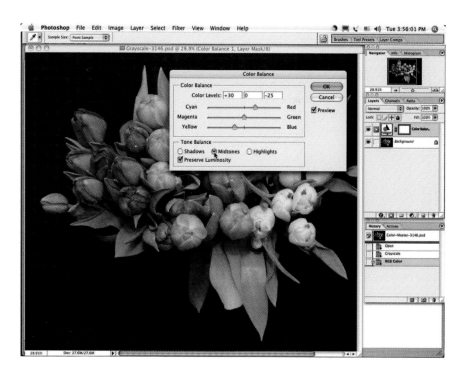

Figure 2.5 *The resulting sepia-toned image.*

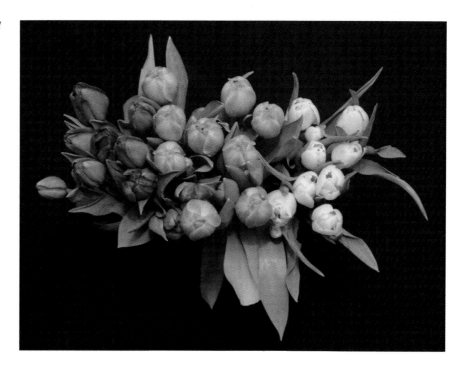

Before you close your file, reduce the size of the image to about 200 by 300 pixels (the exact size doesn't matter). Save another copy to your desktop as a Photoshop file (PSD). Now whenever you want to create a sepia-toned image with this color in the future, follow these steps:

- Open your image.

- Convert to grayscale.

- Change mode back to RGB.

- Open your sepia sample image on your desktop and make sure the Layers Palette is open.

- Drag the Color Balance layer from your sample (just click on it in the Layers Palette and drag it) and drop it onto your new image. Presto! The new image is now sepia toned.

- Adjust the intensity of the sepia tone by changing the layer opacity if needed (see Figures 2.6 and 2.7).

Figure 2.6 *Adjusting the opacity of the sepia image to change its intensity to 50%.*

Figure 2.7 *The final image with the opacity of the sepia image changed to 50%.*

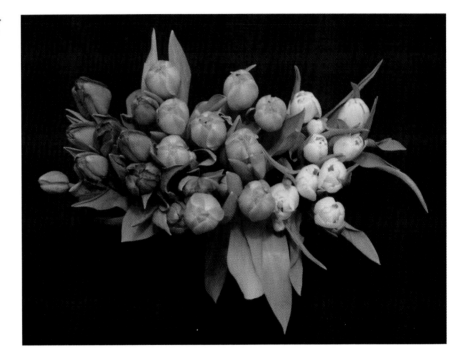

The really cool thing is that you can create several files—a regular sepia tone, a reddish sepia tone, and a more yellow sepia tone—and keep the small sample files on your desktop. You don't have to remember the exact settings or play with them each time. It will provide a fast workflow and a consistent result. Move on to Lesson 2.2 for another technique that produces a similar result.

Lesson 2.2—Creating Sepia with Photoshop, Method 2

As with all things Photoshop, there is more than one way to accomplish the same thing. This lesson is a variation on Lesson 2.1. In this lesson, simply open the image in Photoshop and then select Image > Adjustments > Desaturate as shown in Figure 1.5 (in Chapter 1).

Now repeat the same steps as shown in Lesson 2.1. Since the image was not converted to grayscale, it is still in RGB mode. There is no need to convert the mode back as there was in Lesson 2.1. Add a Color Balance layer just as in Lesson 2.1 and play with the settings to get the flavor of sepia that appeals to you. The reason to use a layer instead of the Color Balance command (Image > Adjustments > Color Balance) is that it is easy to revisit the color and amount of sepia tone later without having to undo other adjustments you may have made. See Figure 2.8 for the sepia image created with Desaturate and compare it to Figure 2.5, created with Grayscale mode.

In fact, this lesson can be done with any black-and-white image that is in RGB mode. Changing the mode to Grayscale or desaturating the image is a quick way to get black and white, but using the Channel Mixer first (see Lesson 1.5) to create the black-and-white image will give you the most control. See Figure 2.9 to see the sepia image created with the Channel Mixer method with red set to 50%, green set to 25%, and blue

Figure 2.8 This is the resulting sepia image when the image is converted to black and white first by using the Desaturate command.

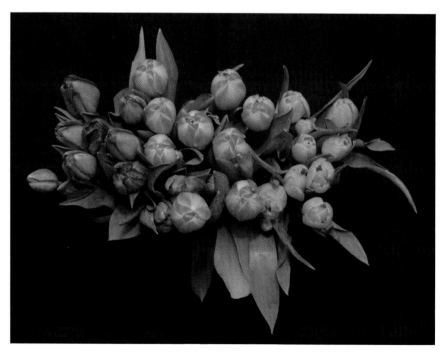

Figure 2.9 This is the resulting sepia image when the image is converted to black and white first by using the Channel Mixer method outlined in Lesson 1.5.

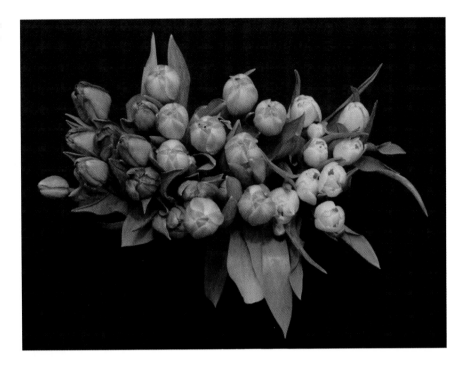

set to 25%. Of course, with the Channel Mixer there are many possible results. Since you used the Channel Mixer in a layer, you can go back and adjust the mix even after you have changed the image to sepia.

Lesson 2.3—Creating Sepia with Photoshop Elements

Since Photoshop Elements does not have the Color Balance layer available, this lesson is the way to accomplish the same thing. This lesson is a variation on Lesson 2.2. In this lesson, simply open the image in Elements and then select Enhance > Adjust Color > Remove Color as shown in Figure 1.5 (in Chapter 1). Now create an Adjustment layer by choosing Layer > New Adjustment Layer > Hue/Saturation. Since the image was not converted to grayscale, it is still in RGB mode. When the Hue/Saturation box appears as shown in Figure 2.10, click on Colorize in the lower right and select a hue. A good starting point is 25. When you click on Colorize, it moves the Saturation slider to 25 as well. Figure 2.11 shows the final image. As in Lesson 2.1, save the image as a Photoshop file (PSD) with the layer intact so you can make adjustments later.

Also, once you have created a good flavor of sepia, save a reduced size of your image on your desktop as a PSD file. Then you can quickly use the same sepia tone again by dragging that sepia layer onto an opened image that has had the color removed but is still in RGB mode.

Figure 2.10 *Using Photoshop Elements to create a new Hue/Saturation layer.*

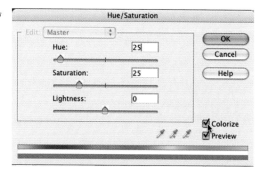

Figure 2.11 *The final sepia image created in Photoshop Elements.*

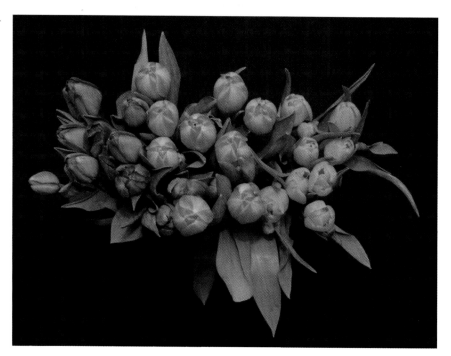

Lesson 2.4—Creating Sepia with Lightroom

We are going to use Adobe Photoshop Lightroom just as we did in Lesson 1.6 in Chapter 1. To start off, if you haven't used Lightroom before, you must first import your image(s) into Lightroom as shown in Figure 1.20 (in Chapter 1). This brings the image into the Library module. Next, move over to the Develop module by clicking on Develop at the top, using the top menus, or using the shortcut OpenApple+D (Mac) or Ctrl+D (PC). This is shown in Figure 1.20.

Once you have the image open in the Develop module, it will look like Figure 1.21 (still in Chapter 1). If your screen looks different, you can open and close the side panels and the top and bottom panels by clicking on the little triangle arrow on all four sides. That will either open or close the panels. Once you have the Develop panels open on the left side of the screen, open the Navigator and the Presets panels. Next, hover your mouse over some of the presets and notice that the image in the Navigator in the top panel changes to show you a preview (see Figure 2.12). To get a sepia tone, choose one of these Presets: Creative-Antique Grayscale, Creative-Antique Light, or Creative-Sepia.

Figure 2.12 Hovering the mouse over a preset on the left side of the screen shows what it will look like in the Navigator (above left) without changing the image.

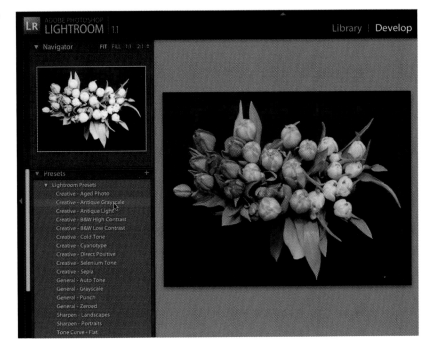

Now that you have the preset selected, click on it, and it applies to your image. Any adjustments that you made earlier have been reset. Now you can adjust the grayscale tones in the Grayscale Mix Panel on the right just as was done in Lesson 1.6. It should have opened automatically when you clicked on the preset. You can also use the other adjustments such as the Tone Curve preset to bring back some of the blown highlights seen in Figure 2.13.

Figure 2.13 *The image converted to sepia. Notice the blown highlights that will be corrected in the next step.*

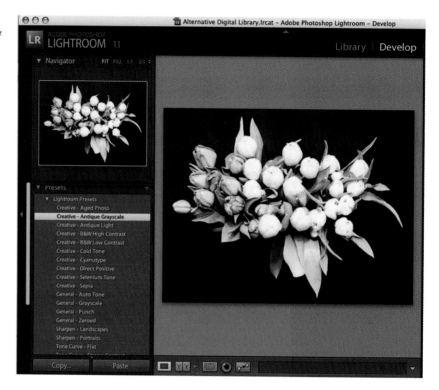

Figure 2.14 shows the Tone Curve being dragged down a bit to bring back the blown highlights in Figure 2.13. If you want to change the color of your sepia image, perhaps to make it a bit less yellow for example, open the Split Toning Panel on the right and move the Hue slider. In Figure 2.15, it is moved to add more red to the image.

Once you are finished, you can export the image so you can send it to your lab, edit it further in Photoshop, make a slide show, print it, or create a website page, all from Lightroom. For detailed instructions on any of these features, see Appendix B, "Resource List," for books to help you with that. If you like the mix that you created, you can save it as a preset by going to the top menu and selecting Develop > New Preset and checking the boxes in the pop-up menu to select the controls and functions that you want your preset to save. Then with future images you can just select the preset.

Figure 2.14 Correct the previous image by dragging the Tone Curve down a bit.

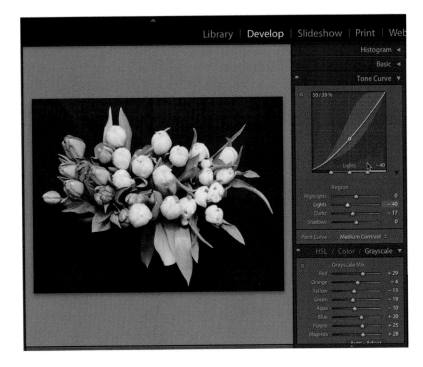

Figure 2.15 The Split Toning Panel is used to change the color of the sepia-toned image.

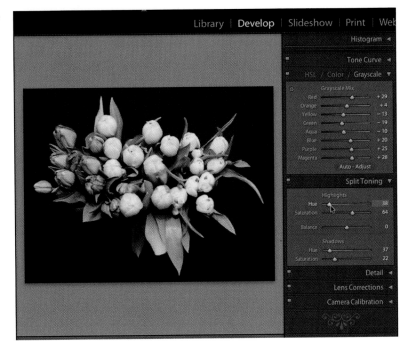

Lesson 2.5—Creating Sepia with Aperture

If you have a Macintosh computer, you have your choice of using Lightroom or Aperture as a workflow tool. If you are on a PC, this will not work for you, and you can skip this lesson. Like Lightroom, Aperture offers a free trial version at Apple's web-site. In Aperture, in a similar way to the previous lesson, you begin by importing your image. Figure 1.24 in Chapter 1 shows the proper steps of File > Import > Images. Next open the Adjustments HUD by clicking on Window > Show Adjustments HUD (or just hit the h key). Figure 2.16 shows the Adjustments HUD open. Then click the little box next to the Sepia Tone Panel as shown in Figure 2.16. This changes the image to a sepia tone. You can adjust the slider underneath to vary the intensity from no sepia tone (the image is the original color image) to a complete sepia tone with no other color in it. If the Sepia Tone Panel is not shown, go up to the top bar called Adjustments and click on the plus (+) sign. In the pop-up menu, select Sepia Tone.

Figure 2.16 Turn on the Adjustments HUD and then select Sepia Tone.

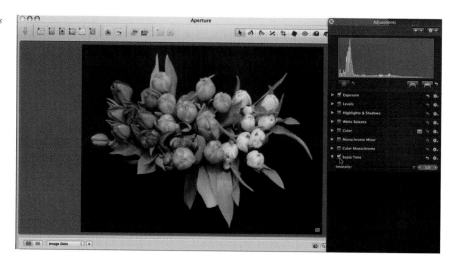

Clicking on the Color or Grayscale Mixer will change some of the tones in your sepia image. You can use some of the other tools such as Highlight/Shadow to change the tones in your sepia image as well. If you don't like the standard color of the Sepia Tone Panel, then you will have to use the Color Monochrome Panel instead. In the Adjustments HUD, deselect the Sepia Tone Panel by clicking on the small box with the check mark. Now click on the small box next to the Color Monochrome Panel instead. If the Color Monochrome Panel is not shown, go up to the top Adjustments bar as before and click on the + sign to get the pop-up menu to select Color Monochrome. Make sure the triangle to the left of the Color Monochrome title is pointing downward and click on the color-filled box next to the word Color. The color selector will pop up as shown in Figure 2.17. You can choose from numerous methods of color selection. The color wheel is the default. Click on the small icons along the top of the color selector to give you Color Sliders, Color Palettes, Image Palettes, or Crayons. See Figures 2.18 through 2.21 for examples.

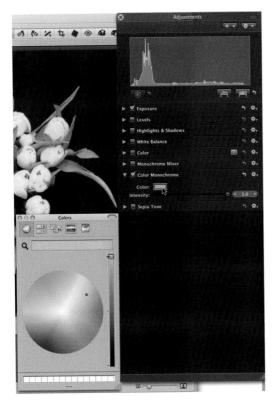

Figure 2.18 Color Sliders.

Figure 2.19 Color Palettes.

Figure 2.17 *The color selector for the Color Monochrome Panel will pop up if the Color box under the Panel name is clicked.*

Figure 2.20 Image Palettes.

Figure 2.21 Crayons.

Within each of these selectors there are more choices for you to play around with. Since there are so many choices, where do you start? The default color wheel is a good place to start. Simply use your cursor to move the little dot around and look at how the image changes. It doesn't take long to get the hang of it.

Another choice is to select Image Palettes (see Figure 2.20). Moving the dot left and right adjusts the intensity of the color. Moving it up and down will adjust the hue. That is an easy and understandable way to work. Using Color Sliders (see Figure 2.18) and selecting Hue, Saturation, and Brightness as the slider choice (the default is Grayscale Sliders) is another way. Select one of those three methods, and you can quickly select your favorite sepia tone. Once you have created one or more that you like, save your selection as a preset by clicking on the little gear to the right in the Color Monochrome Panel. In the pop-up menu, select Save as Preset and type in a name when requested. Now whenever you want that sepia tone on one of your images, click on Color Monochrome and then the gear. Your saved preset will be listed and can be chosen.

Gallery of Sepia Images

CHAPTER 3

HAND-COLORED BLACK AND WHITE

THIS CHAPTER WILL continue presenting methods to manipulate color digital images to give them an older or "old-fashioned" look. Before color film was invented, color images had to be created by adding color to black-and-white images. This chapter will show you ways of adding color to digital images to make them look hand colored. There are lots of ways to do this today, from quick and easy to more painstaking and slower techniques. The hand-colored "look" is more of a soft pastel color, perhaps a bit faded over time, rather than just a splash of bright color thrown onto a black-and-white image.

The same image of tulips used in earlier chapters and shown in Figure 3.1 will be used in this chapter to make it easier to compare the results with those black-and-white images in Chapter 1 and the sepia images in Chapter 2.

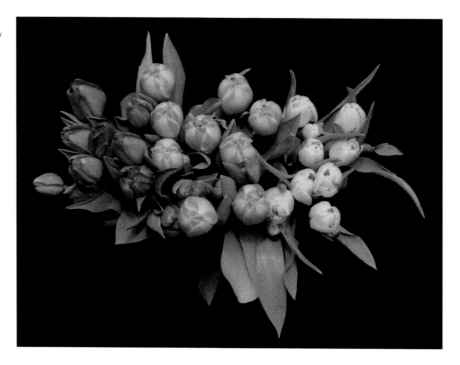

Lesson 3.1—Starting with a Color Image in Photoshop, Method 1

This is one of the easiest lessons. Simply open the image in Photoshop and then create a new Channel Mixer layer. To create the Channel Mixer layer, in the Layers Palette (Window > Layers) create a new layer by clicking on the small black-and-white circle as shown in Figure 1.15 in Chapter 1. In the pop-up menu, select the Channel Mixer (again in Figure 1.15). The Channel Mixer will appear (see Figure 1.16). Select Monochrome and Preview in the Channel Mixer. Adjust the settings to your taste as in Lesson 1.5. This will change your image into a grayscale (black-and-white) image and show you what it looks like. Now make sure that the Channel Mixer layer is highlighted and go to the opacity control in the top right. Move the opacity to the left to add a bit of color. All grayscale is 100%, while full color is 0%. In Figure 3.2, the opacity is set at 74% to give a bit of soft color to the image as if it were colored with watercolor paints.

Figure 3.2 Moving the opacity of the Channel Mixer layer from 100% to 74% to add a bit of soft color.

Lesson 3.2—Starting with a Color Image in Photoshop, Method 2

Start this lesson by opening your color image with Photoshop. Create a duplicate layer by using the flyout menu that you get when clicking on the right pointing triangle in the top of the Layers Palette (see Figure 3.3). Alternatively, you can go to the top menu and choose Layer > Duplicate Layer. Change this layer to black and white by selecting the Desaturate command (Image > Adjustments > Desaturate or Cmd/Ctrl+U). Make sure that the duplicate layer and not the background is selected before you do this. Now your image should be in black and white with a color background layer. You can see the layers when you have the Layers Palette open (Window > Layers).

Figure 3.3 Create a duplicate layer.

Select the History brush as shown in Figure 3.4. Choose a low opacity in the brush controls. A good starting point is 20%. Paint with the brush to bring back the underlying color to a soft degree. Adjust the opacity and size of your brush as needed. You may also need to enlarge the image on your screen (Cmd/Ctrl +) to do the fine details. In Figure 3.5, opacity of 20% is used on the flowers because the colors are bright, but opacity of 50% is being used on the green leaves to bring them out more. The black background in this image will allow you to work faster because any sloppiness along the edges will not show. If you have other than a black layer, it will take more time, and you will have to work with smaller brushes. The advantage to this method over the one in Lesson 3.1 is the painterly quality that one can achieve, simulating the uneven, hand-colored look of a traditional print. It takes more "hand" work, so the unevenness looks more hand colored.

Figure 3.4 *Selecting the History brush from the tools.*

Figure 3.5 *Painting in the colors with the History brush allows more detailed and varying work.*

Figure 3.6 *The final result of using the History brush to paint back the color.*

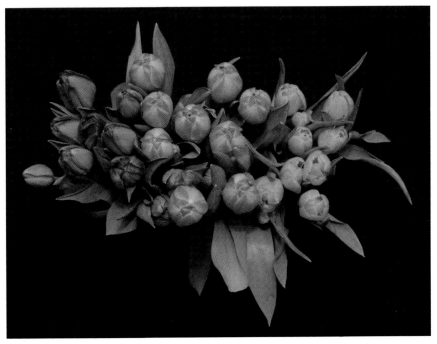

Lesson 3.3—Starting with a Color Image in Lightroom

We are going to use Adobe Photoshop Lightroom just as we did in Lesson 1.6 in Chapter 1. To start off, if you haven't used Lightroom before, you must first import your image(s) into Lightroom as shown in Figure 1.20 (in Chapter 1). This brings the image into the Library module. Next, move over to the Develop module by clicking on Develop at the top, using the top menus, or using the shortcut OpenApple Cmd+D (Mac) or Ctrl+D (PC). This is shown in Figure 1.20.

Once you have the image open in the Develop module, close the left side panel and the top and bottom panels by clicking on the little triangle arrow on those three sides. Only the panel on the right should be visible. Open the HSL/Color/Grayscale Panel and close the others. Click on the word All next to the colored boxes in the HSL/Color/ Grayscale Panel and all of the colored sliders should show at the same time. Now it should look like Figure 3.7. Adjust the Saturation sliders to your taste by moving them to the left so they have negative values. This will give the colors the soft pastel look that was described earlier.

You can see in Figure 3.8 that all of the Saturation slider values are different from each other and are done by eye. Now compare Figure 3.8 to Figure 3.9. In Figure 3.9, moving the Green slider more to the right brightens the greens a little. In Figure 3.10, the greens are brought down to nearly zero. You can quickly and easily create nearly unlimited variations.

Figure 3.7 The color image opened in the Develop module with all sides closed except the right side panels.

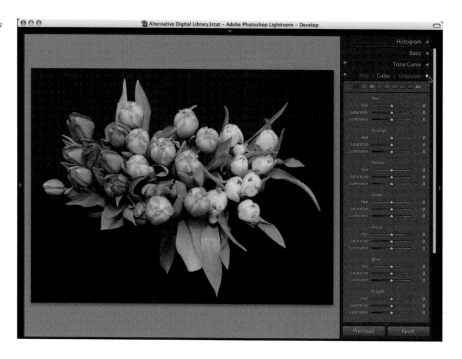

Figure 3.8 Adjusting the Saturation sliders to a negative value gives the image its soft pastel colors.

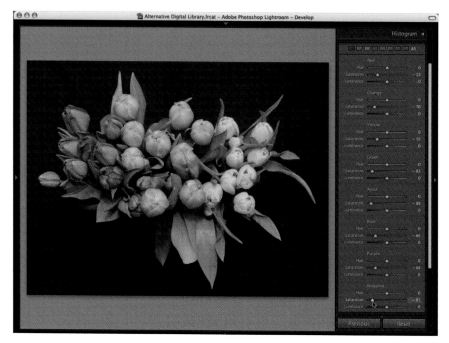

Figure 3.9 Brightening the greens with the Green slider a little gives a different appearance than the version in Figure 3.8.

Figure 3.10 Lightening the greens with the Green slider almost to zero gives a different appearance than the previous two figures.

Lesson 3.4—Starting with a Black-and-White Image in Photoshop

This lesson will start with a black-and-white image. This could be an image from a camera that offers black and white as a function. It could also be a scan from a black-and-white print or negative. In this case, the black-and-white image is created from a color digital original.

Open your image in Photoshop. Using the Channel Mixer technique from Lesson 1.5, Figure 3.11 is produced. Values of red = +50%, green = +30%, and blue = +45% were used. Be sure to check the Monochrome box or the image will not be in black and white. However you obtain your black-and-white image, make sure that the mode is set to RGB. To do this, go to the main menu and click on Image > Mode > RGB Color. If your image is in Grayscale mode, then the following lesson will not work.

You will now paint using the paint tools in Photoshop. Select the Brush tool as shown in Figure 3.12. Next, click on the top of the two colored boxes (in this case they are black-and-white boxes) in the toolbox shown in Figure 3.12. The Color Picker will pop up (see Figure 3.13). Drag the slider down to the colors you want to work with and pick one. Figure 3.13 shows a green color. It shows up in the two boxes in the Color Picker as the new color. It will also show up in the toolbox where you clicked the boxes as the new color of the foreground color. This will be the color that you will paint with. Once you are happy with the color, click OK.

Figure 3.11 The color image from the beginning of this chapter is converted to black and white using the technique outlined in Lesson 1.5.

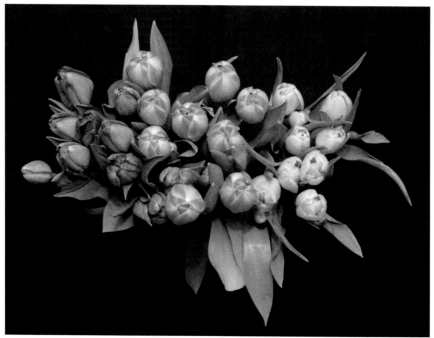

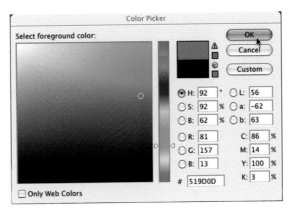

Figure 3.12 *Select the Brush tool to paint with.*

Figure 3.13 *Use the Color Picker to choose the color to paint with.*

The next step is to select the Airbrush tool in the top box. It is the icon that looks like an airbrush and can be seen in Figure 3.14. Also, select settings for Mode, Opacity, and Flow. Good starting points are Normal mode, 40% Opacity, and 4% Flow. Begin painting by using the mouse to move the Airbrush tool around and stroke as you would with real paint. Just like a real airbrush, if you hold the cursor in one place, the paint will continue to flow. You will build up a bright dot of color. Instead, put several layers on to create the hand-colored look. Vary the colors, size of the brush, the opacity, and the flow rate as you work. Use the square brackets ([and]) to decrease and increase the size of the brush. If you keep the mouse in your right hand, use your left hand to operate the two bracket keys as you spray. Reverse the technique if you are left handed. Use brush strokes that mimic how you would work with paint. For example, stroke down the leaves rather than across them. This generally will provide the best results.

Figure 3.14 *Select the Airbrush tool in the top bar along with adjusting the Mode, Opacity, and Flow values.*

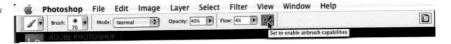

As you work, you will probably have to enlarge the image on your screen to be detailed enough. Sometimes it helps to open the color image (if it started as one) to use as a reference. If you work with two monitors, this is easy to do. If you only have one monitor, but you also have a laptop, then you can open the color image in your laptop.

When you are working on an enlarged version of the image, sometimes you can get lost in the details. In the case of the sample image, it can be difficult to tell if you are painting leaves or part of the flower. You can choose any colors you like. You do not have to follow the colors of the original image. Also, you can add only spots of color if you choose, as seen in Figure 3.16. For example, in Figure 3.15, the flowers on the left have been changed from magenta in the original to red. As you work, come back and add bits of color that are a little brighter or more intense. You want to avoid making the image look too uniform.

Don't be afraid to make mistakes. Unlike with real paint, this is easy to remove. Simply use Cmd/Ctrl+Z to back up one or more steps by undoing what you just did. This is a good reason to work with small steps, releasing the mouse after every few strokes. Then if you slip, you can just undo and redo a little bit of work. Another way to make corrections is to back up one History step if you have the History Palette open. Or you can use Edit > Undo in the top menu.

Figure 3.15 You can change the colors to whatever you would like. Here the magenta flowers on the left have been painted red instead.

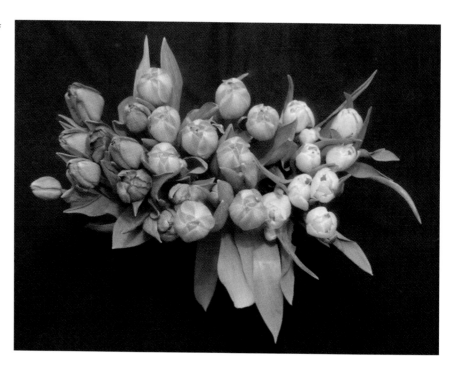

A final way to work to make it easy to make corrections is to create a new layer (top menu Layer > New) at the very beginning, right after you have your black-and-white image ready for coloring. Then do your painting on this new layer, following all of the instructions above. If you make a mistake, for example by painting over the green leaves with red paint, you can use the Eraser tool on the layer you are working on to remove the paint without damaging the image below. This will work only if you are painting on the new layer and not on the background. If you use the Eraser and instead of revealing the image underneath you see your background color (usually white), then it means you are on the background layer. Depending on the color you are painting and on the color of the background, you may have to do more cleaning up on the background. Painting over the lines may show in a print even if it does not show up well on your monitor.

Figure 3.16 *Only parts of the image were colored. The leaves were left without color, and the flower petals were painted different colors than the original color image.*

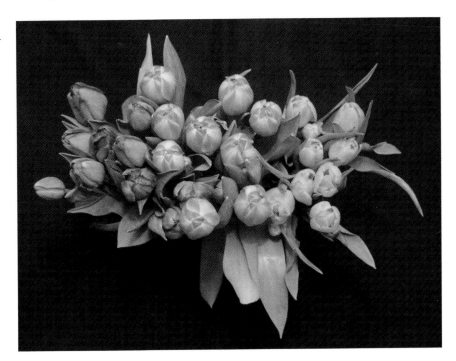

Gallery of Hand-Colored Black-and-White Images

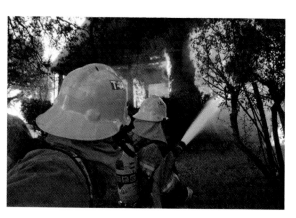

CHAPTER **4**

HAND-COLORED SEPIA

CHAPTER 4 IS SIMILAR to Chapter 3 in that the lessons will show how to hand color images to make them look older. This time the images will be sepia colored instead of black and white. Sepia already makes the images look a bit old fashioned. A soft pastel coloring will enhance the effect and is often even more appropriate with sepia images than with black-and-white images.

The same image of tulips used in earlier chapters and shown in Figure 4.1 will be used in this chapter to make it easier to compare the results with those black-and-white images in Chapter 1, the sepia images in Chapter 2, and the hand-colored black-and-white images in Chapter 3.

Figure 4.1 This is the color image we are starting with for the series of lessons in this chapter.

Lesson 4.1—Starting with an Image in Photoshop

This lesson will start with what you have learned in the previous three chapters.

Step 1—Make Image Black and White

Choose your favorite technique from one of the previous lessons in Chapter 1. They are summarized here for easy reference. If you need more detailed help, refer to the lesson in one of the previous chapters. If your image is already in black and white (or grayscale), move on to Step 2.

Lesson 1.1—Photoshop—Method 1

- Open your image.
- Convert to grayscale (Image > Mode > Grayscale).
- Change mode back to RGB (Mode > RGB).

Lesson 1.2—Photoshop—Method 2

- Open your image.
- Make image black and white (Image > Adjustment > Desaturate).
- Image is still in RGB mode.

Lesson 1.3—Photoshop—Lab Color Mode

- Open your image.
- Convert to Lab mode (Image > Mode > Lab Color).
- Make image black and white (drag channels A and B to the trash).
- Convert to Grayscale mode (Mode > Grayscale).
- Change mode back to RGB (Mode > RGB).

Lesson 1.4—Photoshop—Channels

- Open your image.
- Open Channels Palette (Window > Channels).
- Make image black and white (pick your favorite channel and drag the other channels to the trash).
- Convert to Grayscale mode (Mode > Grayscale).
- Change mode back to RGB (Mode > RGB).

Lesson 1.5—Photoshop—Channel Mixer

- Open your image.
- Open Channels Palette (Window > Channels).
- Create a new Channel Mixer layer (Layer > New Adjustment Layer > Channel Mixer).
- Select Monochrome and preview.
- Move sliders to adjust image to your taste.

Lesson 2.3—Photoshop Elements

- Open your image.
- Make image black and white (Enhance > Adjust Color > Remove Color).
- Image is still in RGB mode.

Step 2—Make Image Sepia

Again, choose your favorite technique from one of the previous lessons. They are summarized here for easy reference. If you need more detailed help, refer to the lesson in one of the previous chapters.

Lesson 2.1—Photoshop—Method 1

- Your image is already open from Step 1.

- Create a new Color Balance layer (Layer > New Adjustment Layer > Color Balance).

- Adjust the sepia color to your taste by adding red and yellow in the Color Levels boxes for Shadows (suggest +20, 0, –5), Midtones (suggest +30, 0, –25), and Highlights (suggest +10, 0, –5).

Lesson 2.3—Photoshop Elements

- Your image is already open from Step 1.

- Create a new adjustment layer (Layer > New Adjustment Layer > Hue/Saturation).

- Since the image is still in RGB mode, click on Colorize in the lower right.

- Select a hue (suggest –25).

Step 3—Add Color Back

Because the image has been converted to black and white, you must manually add the color back in by painting it in. If you need more detailed help, refer to the lesson in Chapter 3.

Lesson 3.3—Photoshop (also Photoshop Elements)

- Your image is already open from Steps 1 and 2.

- Create a new layer (Layer > New). Do your painting on this layer.

- Select the Brush tool from the Tool Palette.

- Click on the foreground color in the Tool Palette and select a color from the Color Picker that pops up.

- Select the Airbrush tool in the top box of the Brush tool.

- Select Mode (Normal), Opacity (40%), and Flow (4%) settings. In Photoshop Elements, there is no Flow setting, so reduce Opacity to about 10% to start with. Suggested values are in parentheses.

- Vary colors, brush sizes, opacity, and flow as you paint to make it look realistic.

- Use the Eraser tool as necessary to clean up your work on the new layer.

Figure 4.2 The final hand-colored sepia image.

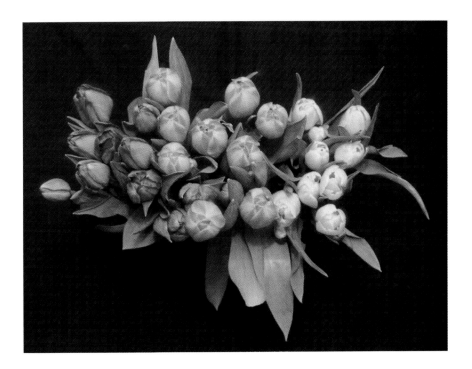

Lesson 4.2—Starting with a Color Image in Lightroom

We are going to use Adobe Photoshop Lightroom just as we did in Lesson 1.6 in Chapter 1. To start off, if you haven't used Lightroom before, you must first import your image(s) into Lightroom as shown in Figure 1.20 (in Chapter 1). This brings the image into the Library module. To make it easy to make multiple variations, create a virtual copy (Photo > Create Virtual Copy). Select your new copy. Next, move over to the Develop module by clicking on Develop at the top, using the top menus, or by using the shortcut OpenApple (Cmd)+D (Mac) or Ctrl+D (PC). This is shown in Figure 1.20 (also in Chapter 1).

Once you have the virtual copy open in the Develop module, select the Antique Grayscale preset in the left side panel. Now you have Figure 4.3. Notice how washed out it is. In the right panels, open Tone Curve. If there are no right panels showing, click on the triangle on the right to make them appear. Put your cursor up on the curve. If you move to the right of the curve, you can adjust Highlights and Lights. As your cursor moves to the right, you can see the word Lights become highlighted, and the section of the curve affected is highlighted along with the possible adjustment range. In this case, drag the curve down as shown in Figure 4.4. Move your cursor farther to the right until the word Highlights becomes brighter. Adjust this part of the curve as well. Look at the result in Figure 4.5.

Figure 4.3 The color image with the
Antique Grayscale preset applied.

Figure 4.4 The lights are being
adjusted. Note that the word Lights is
brighter, and the area around that sec-
tion of the curve is lighter.

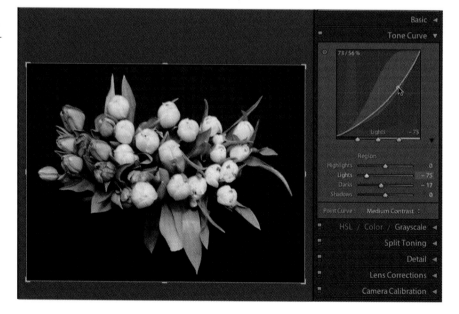

Figure 4.5 The highlights are being adjusted. Note that the word Highlights is brighter, and the area around that section of the curve is lighter.

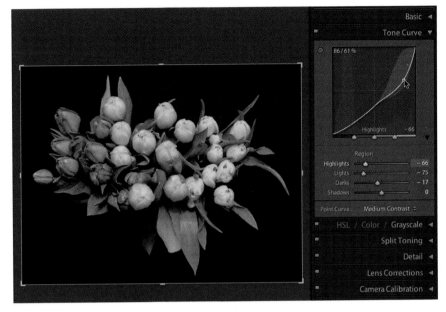

You now have a sepia image showing. Close all of the panels except the ones on the right by clicking on the various little triangles. Only the panels on the right should be visible. Open the HSL/Color/Grayscale Panel and close the other panels. Click on the word All next to the colored boxes in the HSL/Color/Grayscale Panel, and all of the colored sliders should show at the same time. Click on the word Color in the panel title. Now it should look like Figure 4.6. Adjust the Saturation sliders to zero (all the way to the left). Now adjust them one at a time very slightly to the right according to your taste. This will give the colors the soft pastel look that was described earlier but keep most of the sepia tone.

You can see in Figure 4.7 that all of the Saturation slider values are different from each other and are just done by eye. Only the Red, Orange, Yellow, and Green saturation sliders were moved because those are the predominate colors in this image. A different image could perhaps require you to move different sliders for different predominate colors. If you lose all of the sepia tone while you are adjusting the saturation, just go back to the sepia version and export the image to Photoshop (Photo > Edit in Photoshop) for the hand-coloring portion. In that case, follow Step 3 in Lesson 4.1.

Figure 4.6 Opening the HSL Panel and clicking on Color produces this figure.

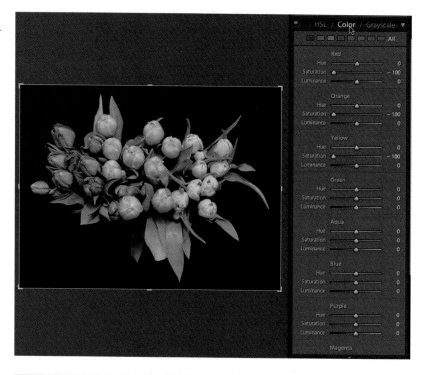

Figure 4.7 Moving just the Red, Orange, Yellow, and Green saturation sliders slightly to the right adds a bit of pastel color back into the image.

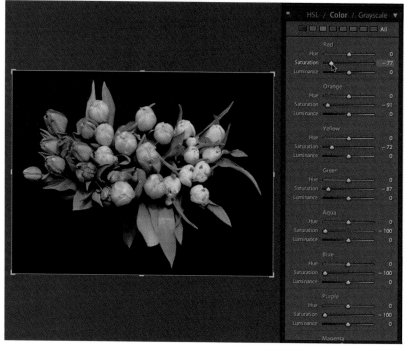

Lesson 4.3—Using Photoshop to Create a Sepia Image

This lesson will show you a way to create a sepia image with a hand-colored look more quickly than having to go through the actual hand painting. There are times when you need something quickly, and here is a way to do it. Open the image in Photoshop and then create a Hue/Saturation layer (Layer > New Adjustment Layer > Hue/Saturation). Slide the saturation slider to the left (see Figure 4.8) to remove the color in the image.

Figure 4.8 Slide the saturation slider to the left to remove the color in the image.

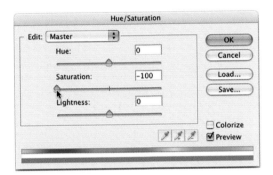

Now create a new Color Balance layer (Layer > New Adjustment Layer > Color Balance). Adjust the Shadows (+20, 0, −5), Midtones (+30, 0, −25), and Highlights (+10, 0, −5) to a pleasing value of sepia. The values shown are good starting points. Now place your cursor on the bottom layer in the Layers Palette. If it is not shown, then open the Layers Palette by using the menu selection Window > Layers. Duplicate the Background layer (Layer > Duplicate). Drag the duplicate layer so that it is at the top of the stack of layers as shown in Figure 4.9.

Figure 4.9 The duplicated Background layer is moved to the top of the stack of layers.

Making sure that the Background copy layer is selected, adjust the opacity as shown in Figure 4.10. Here a value of 30% was chosen. This still shows the sepia tone but allows a bit of the color to show through. This provides a pastel look to the colors and keeps them looking old fashioned.

Figure 4.10 Adjust the opacity of the Background copy layer to allow the sepia to show through.

Figure 4.11 The final hand-colored sepia image from Lesson 4.3.

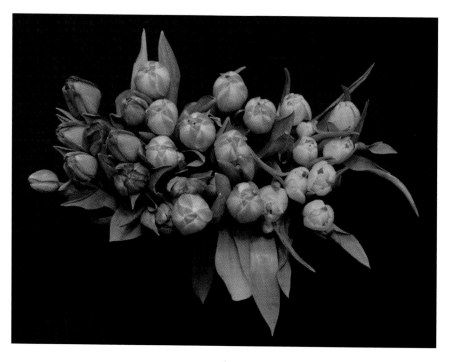

Gallery of Hand-Colored Sepia Images

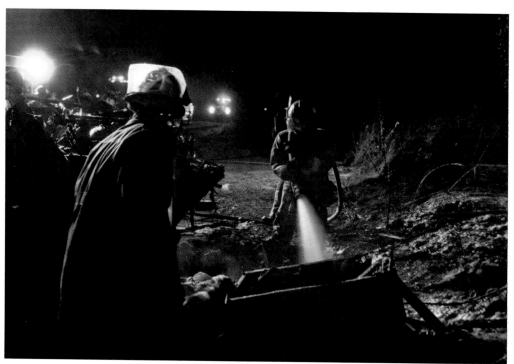

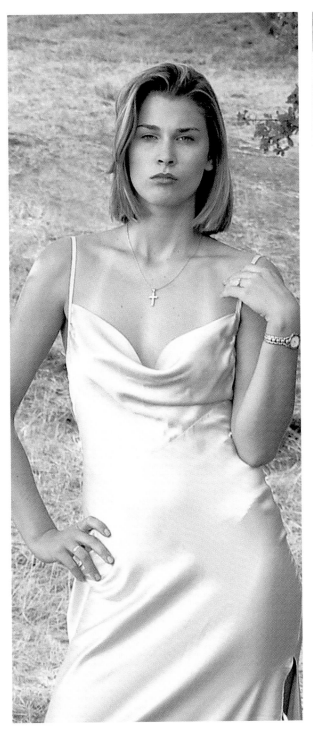

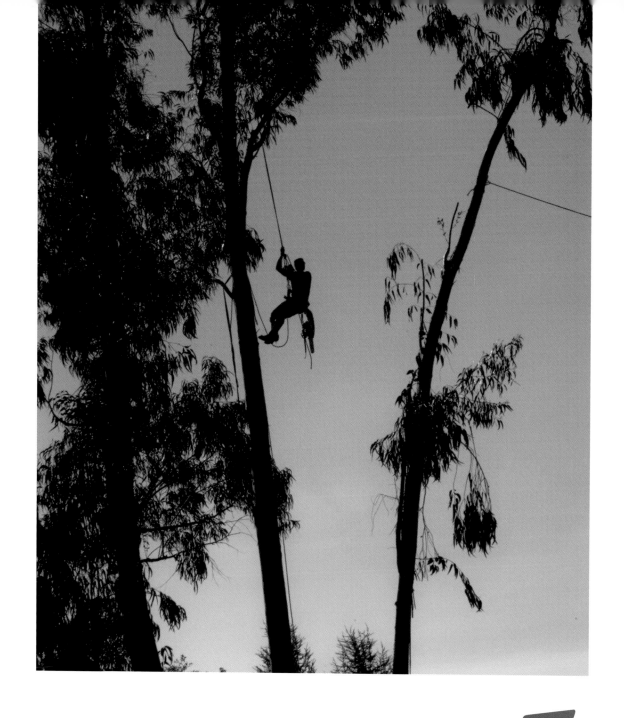

CHAPTER 5

ABSTRACT

AN *ABSTRACT* IMAGE is one in which the subject is so simplified that it is easily recognized yet is not shown with any detail. When would you use something like this? Abstract images work well in graphic situations such as advertisements or to illustrate a story in a book, magazine, or newspaper. Wedding photographers can use abstract images to add interest to a wedding album. Abstract images also make an unusual portrait and can be a nice addition to a portrait client's order. It is also fun to do things differently sometimes.

The lessons in this chapter will show you three simple ways of achieving the abstract quality. The three different techniques are shown in Figures 5.1, 5.2, and 5.3.

 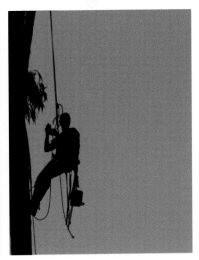

Figure 5.1 *This is a sample showing the defocusing technique that is described in Lesson 5.1.*

Figure 5.2 *This is a sample of the method of photographing shadows to create abstract images.*

Figure 5.3 *A silhouette created by backlighting the subject is the final method explained in this chapter.*

Lesson 5.1—Defocusing

This first abstract lesson involves turning off the automatic focus on your camera. Then back off the focus until the image is recognizable in general, but not specifically. In other words, in our pictures of Jodi, we want to be able to recognize that it is a picture of a woman but not be able to tell that it is Jodi. The first image, Figure 5.4, is a regular, in-focus image. The second (Figure 5.5) is a little out of focus, the third (Figure 5.6) is a little more out of focus, and so on. By the time you get to the last image (Figure 5.8), the subject is barely recognizable as a person. It is probably a little too out of focus for most purposes.

When you first start playing with this, you may find that the depth of field on many of your lenses, especially the zoom lenses, is too great to be able to get this effect easily. Choose your lens with the largest f-stop (smallest number) for best results. Usually, a f2.8 or even a f1.8 will work best. Use either manual mode or aperture priority to be able to use your lens wide open. These images were all taken with an 85mm f1.8 lens on a Fuji S2 digital camera. The S2 uses a smaller sensor size, so the 85mm lens is equivalent to a 128mm lens on a 35mm camera. So a medium telephoto lens that is fairly fast did the best job. The author's 24mm to 200mm f4 to f5.6 zoom lens had too much depth of field to be effective for this technique.

Figure 5.4 The original image created with the proper focus.

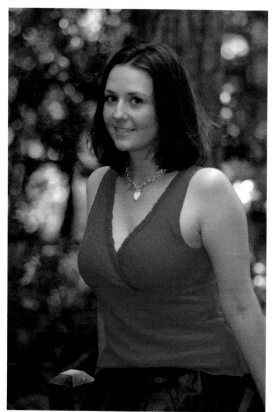

Figure 5.5 *The focus is off a little in this image.*

Figure 5.6 *Even more out of focus.*

Figure 5.7 *This is probably the best image to use out of this series. The subject can be determined, but there is little detail.*

Figure 5.8 *The final image in this series is so out of focus that it is difficult to tell much about the subject.*

Lesson 5.2—Shadows

Another technique is to set up and photograph shadows instead of the person or object. These tend to be even more graphic than the defocusing technique. The shadows can fall on the ground or a wall. If you want a plain background, you can hang a sheet or lay it on the ground. The session can be done in a studio with a plain backdrop and lighting, or it can be done outside. Light angle is important, so if you are working outdoors, the early morning or late afternoon will generally give you longer shadows. If the sun is directly overhead at noon, the shadows tend to be small and distorted (squished). In this lesson, the photography was done outdoors, and shadows were set up to fall on a wooden deck to add some texture to the scene. The shadows were photographed at about 3 p.m. The model was dressed in a western outfit and carried a guitar and cowboy hat for props, as shown in Figure 5.9. Props with distinctive shapes will work best for shadow abstract images.

Figure 5.9 The model is dressed in a western outfit with guitar and a cowboy hat.

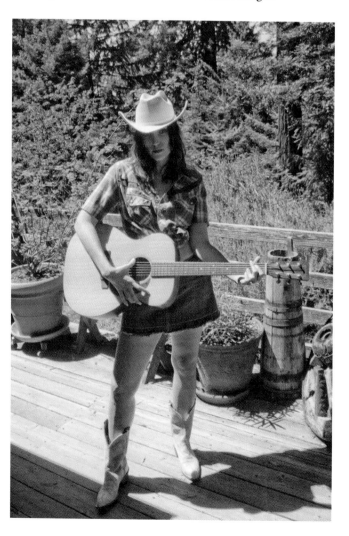

Once you have set up and started to photograph, keep in mind the graphic nature of the images. Look at Figure 5.10. Notice how the shadow image blends into the edge of the photograph. This makes it distracting. Look at Figure 5.11, where the shadow is moved slightly by having the model move so the shadow is more centered in the available space. Now the shadow stands on its own as a graphic element, and the result is a much stronger photograph.

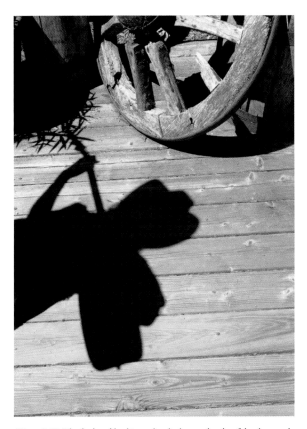

Figure 5.10 The shadows blend into other shadows at the edge of the photograph.

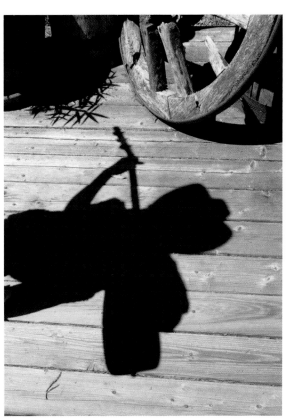

Figure 5.11 The model moves so that her shadow is centered, which makes a stronger image.

Figures 5.12 through 5.15 show a number of variations of the same setup. Once you get started, it can be a pretty fun session. With digital photography, you don't have to hold back because of the cost of film. Feel free to experiment.

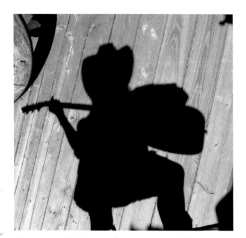

Figure 5.12 *The photographer moves to get a different view without getting his shadow in the photograph.*

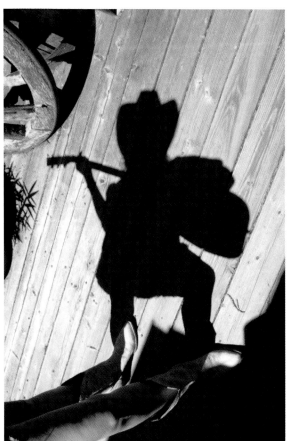

Figure 5.13 *As a variation, the model's legs are included in the image.*

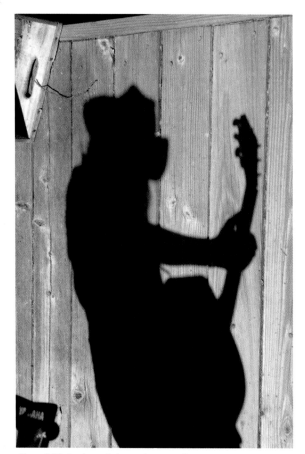

Figure 5.14 *Another variation on the western theme.*

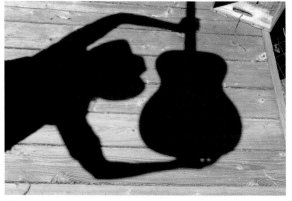

Figure 5.15 *Another variation on the western theme.*

Lesson 5.3—Silhouette

The final technique for producing abstract images is with the use of silhouettes. Silhouettes are dark images that are backlit. The photograph is exposed for the backlight rather than the subject. That keeps the subject dark and without detail. In Figure 5.16, the exposure is correct. The subject is dark and silhouetted, and the background is properly exposed. Somehow the image is not as dramatic as it could be, however. The background has so much detail that it is distracting from the subject. The image is lacking in dramatic graphic effect.

Figure 5.16 The couple is silhouetted against a detailed background that loses much of the graphic appeal of the photograph.

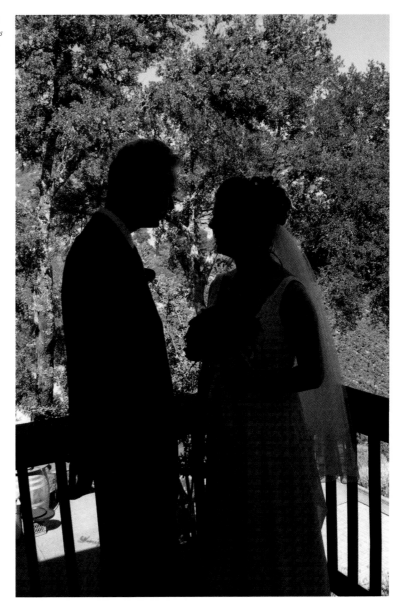

Looking at Figure 5.17, a similar image is posed against an open sky. This puts the focus of the image back on the subject rather than the background. It is a much stronger and more graphic image.

Figure 5.17 Posing a couple against the open sky gives a blank background and a stronger, more graphic image.

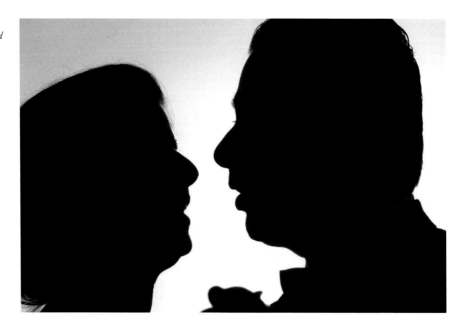

When computing exposure, it is important to expose for the background and underexpose the subject. In Figure 5.18, two firefighters are getting ready to ventilate a roof. The photograph was exposed for the subject, so the details can easily be seen. Although it is a nice photograph, it is not as strong graphically as Figure 5.19. In that figure, the exposure is reduced so that the subject is dark and underexposed, while the rest of the image is properly exposed.

Figure 5.18 This photograph is properly exposed for the subject and is not as strong a graphic image as Figure 5.19.

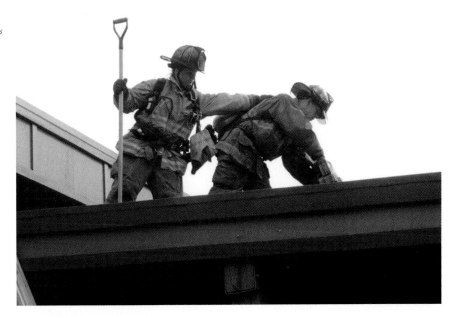

Figure 5.19 The subject is underexposed, which silhouettes the two firefighters. This makes the image stronger graphically.

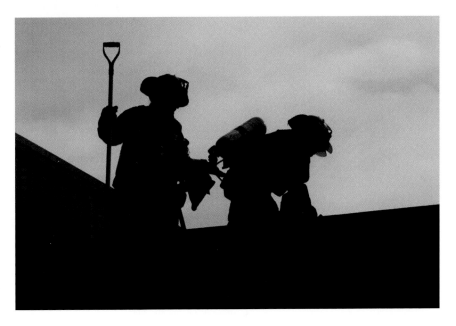

Gallery of Abstract Images

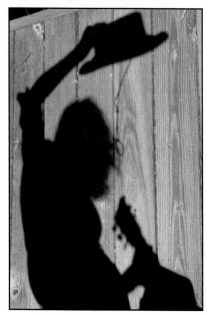

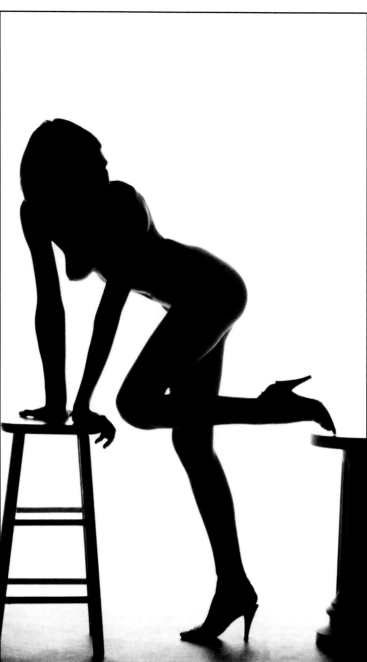

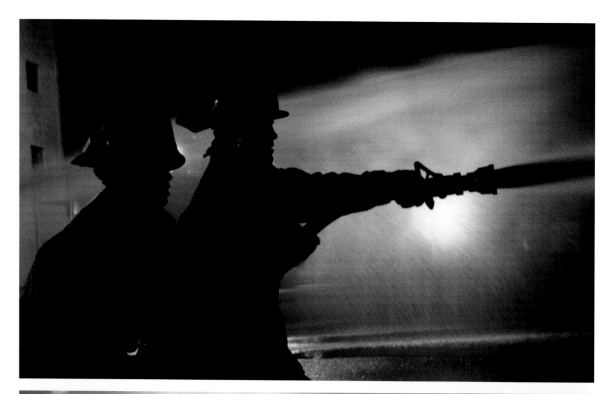

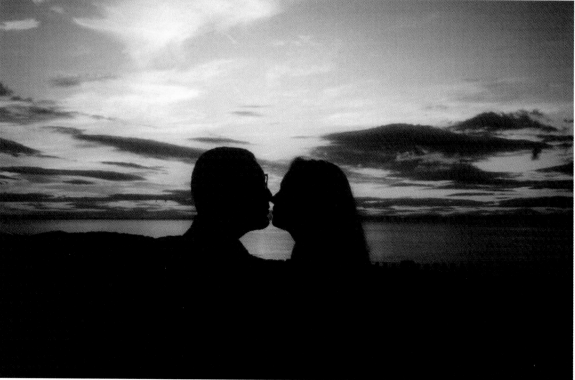

CHAPTER 6

Pleinart

PLEINART IS THE NAME used by the author for a form of impressionistic photography that focuses the attention of the viewer on the main subject and intentionally blurs the rest. The term comes from the French term "en plein air," which was used by impressionistic painters at the end of the 19th century. It means "in the open air," which is where the impressionistic painters were painting. The term "pleinart" is applied to photography to represent, in some ways, this "en plein air" style of painting, but not its location. Pleinart images can be created from photographs done indoors or out. These lessons will show you how to create this effect with tools in Photoshop and a digital image. Pleinart is a light version of photoimpressionism (see Chapter 9). The tools have a lighter touch for a softer effect. The first lesson will start with the same color image of tulips that was used in Chapters 1 through 4 and is shown in Figure 6.1.

The best images for Pleinart tend to be bright and colorful ones as well as those that look a bit old fashioned. For some ideas, pick up a book on impressionism in paintings, and you can see the types of subject matter that lend themselves to this effect. When the image is manipulated, it smoothes out the image and removes pixelation. That means that an image can be increased in size with minimal artifacts if the image is increased to its final size before any manipulation is done.

Figure 6.1 This is the color image that will be used in the first lesson. It is the same image that was used in lessons in Chapters 1 through 4.

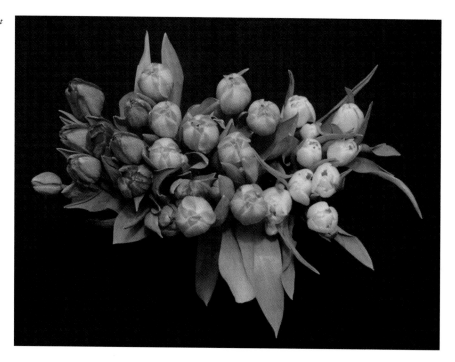

Lesson 6.1—Using a Brush in Photoshop and Elements—Example 1

This lesson utilizes the Art History brush in Photoshop. You can also use the Impressionist brush in Photoshop Elements that operates in a similar manner. The purpose is to change the photograph into an impressionistic version of the image. Although there are filters you can click on to get a one-step impressionistic look, doing it slowly and carefully by hand with this method will provide a much more satisfactory result. Each section or area of the image can be given the appropriate amount of adjustment. Although this procedure can be a little tedious and time consuming, the technique is rather easy.

Open your image and make all adjustments to the image such as Levels and Curves or Brightness and Contrast until you are satisfied with the way your image looks before any manipulation. Next select the Art History brush (see Figure 6.2). Once you have the brush, go up to the Brush menu right under the Photoshop top menu and select a brush size of 15, Normal Mode, Opacity 100%, Style Tight Short, Area 15 to 20 px (pixels), and Tolerance of 0% (see Figure 6.3). In Photoshop Elements (see Figure 6.4), choose Impressionist Brush, Size 15 px (pixels), Normal Mode, and Opacity 100%. Then click on More Options (see Figure 6.5) and choose Style Tight Short, Area 15 to 20 px, and 0% Tolerance. Next, increase the size of your image so you can see enough detail. You can do this by using Cmd/Ctrl+ or by using the top menu View > Zoom In. Go to about 50% (noted in the header bar) to start with. Now you are ready to begin.

Figure 6.2 Select the Art History brush in Photoshop.

Figure 6.3 *Use the bar menu in Photoshop to select the brush parameters.*

Figure 6.4 *Use the bar menu in Photoshop Elements to select the brush parameters.*

Figure 6.5 *Clicking on More Options in Elements brings up this pop-up menu to select three more settings for the brush.*

Place your brush (cursor) over parts of the image and begin moving it with brushing strokes. Make sure especially to work on any edges or lines. Notice how the image diffuses where you touch it. In Figure 6.6, you can see that part of the leaf in the upper right is done, and part is not done. In addition, three of the orange flowers and three of the yellow flowers have been worked on. As you work, try to work on one object at a time. For example, do the flower and then work on the leaves around it. That is usually more effective than working on both at the same time. Assume that you are really painting and work on one object and one color and then move on to the next one.

Figure 6.6 *Parts of this image have been worked on. The leaf in the upper right is only partially done.*

Vary the parameters by making your brush smaller or larger, depending on the detail in your subject matter. If the brush is too small, the effect will not be noticeable except when the image is blown up on your screen. Periodically reduce the size of the image so that you can see the entire image at once. This will give you a better perspective on your efforts.

Figure 6.7 The right half of this figure is finished, and the left hand side was left original for comparison.

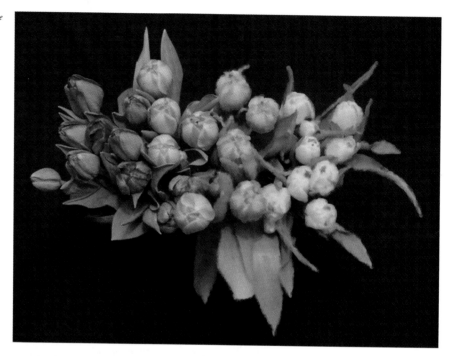

Lesson 6.2—Using a Brush in Photoshop and Elements—Example 2

In this example the subject matter has changed, but the same procedures will be followed as in Lesson 6.1. First, open your image in Photoshop or Elements (see Figure 6.8) and make any adjustments and corrections to make it look the way you want before you begin manipulating it. As before, select the Art History brush in Photoshop (or the Impressionist brush in Elements). Set the brush size and area to about 15 or 20 to begin with and vary according to the effect you are after. Pleinart uses a smaller brush size and area to provide a lighter effect than the similar Photoimpressionism technique in Chapter 9.

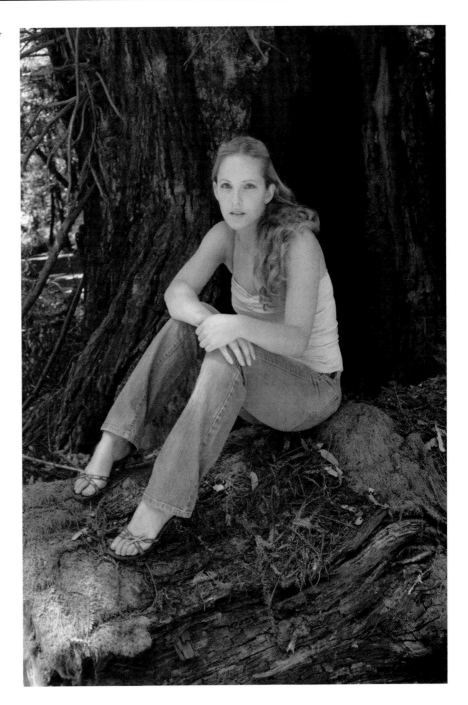

Figure 6.8 *This is the original image that will be worked on.*

Enlarge the image to 50% or higher, depending on the size of your monitor. You want to be able to see the detail that you are changing. If your image has people in it, leave them until last because generally you must be much more delicate, especially around the faces. Once you have the image done except for the people, enlarge it to 100% or 200% and look to see if there are any spots you missed. It will look like the area in Figure 6.9 indicated by the red arrow. If you missed a spot, just go over it with the Art History brush in Enlarged mode.

Figure 6.9 *The red arrow points to a section that was missed by the Art History brush, enlarged to 100%. Go over any spots like this to clean them up.*

As you work closer to the figure in the image, reduce the brush size and the area size to make it easier to complete the details. The finer brush (5 pixels in this case) is run along the edges of the figure, lips, teeth, and eyebrows. The larger brush was then used across the skin to speed up the process. The eyes were left alone. The amount of manipulation is somewhat dependent on the size at which the image will be printed. If the image will be shown small, then the manipulation must be more visible or it won't show up. If an image that was manipulated for small print is enlarged, however, it will appear overdone.

Figure 6.10 shows the final image as it was prepared for a large print, so it doesn't show up as well in small form in this book. Figures 6.11 and 6.12 show details from the image so the Pleinart effect can be seen more easily. Note the difference of the manipulation of the jeans, which are more heavily done than the face.

Figure 6.10 *This is the final image manipulated for a larger print, so it doesn't show as much of the Pleinart effect in the small size printed in this book.*

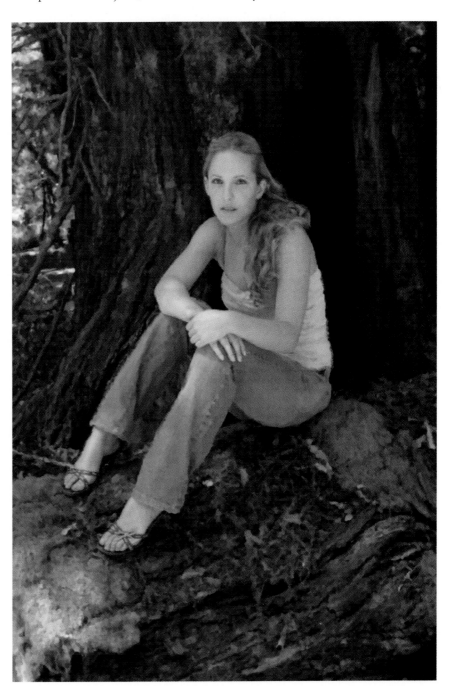

Figure 6.11 Detail from Figure
6.10. Compare it to the detail shown
in Figure 6.12.

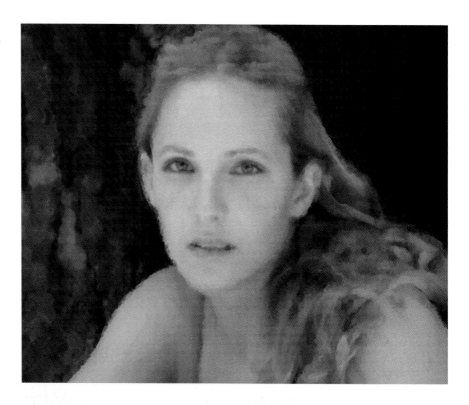

Figure 6.12 Detail from Figure
6.10. Compare it to Figure 6.11 to
see the difference in the amount of
manipulation done to the jeans and
to the face.

Gallery of Pleinart Images

These images are displayed larger than the other galleries so you can see the details of the technique.

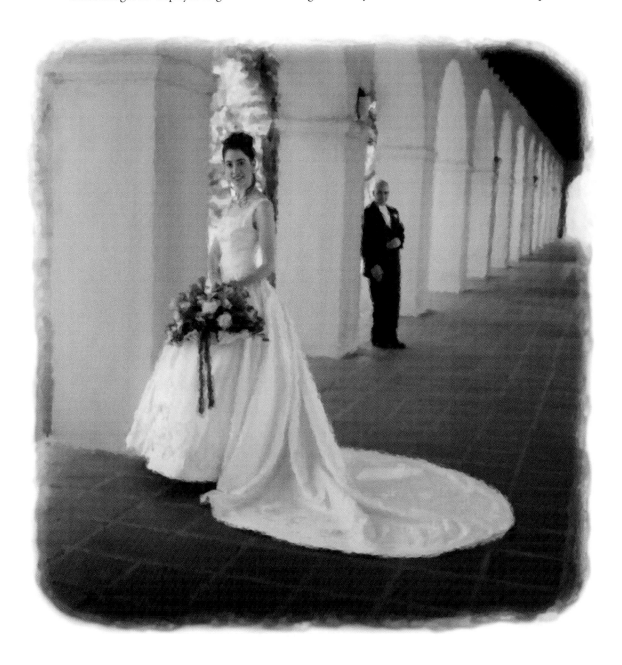

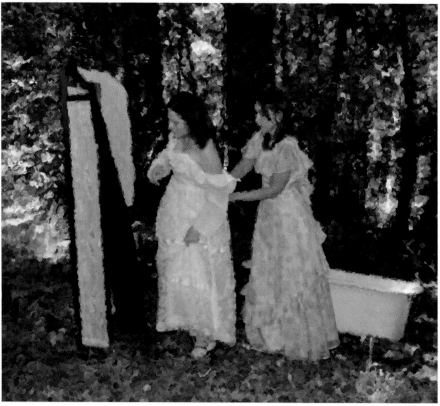

CHAPTER 7

Mosaic

THE MOSAIC STYLE of photography is an assembly of a number of smaller images. It is sometimes known as a *photomontage*. David Hockney is one of the most famous practitioners of the photomontage technique. He has typically used a series of Polaroid or even the standard 3-1/2" × 5" or 4" × 6" drugstore prints obtained from 35mm film. If you enjoy this style of work, do an online search for David Hockney. There are numerous examples of his photomontage work available online that can serve as inspiration for your own work.

Here we will describe three different techniques. The first is to create a panorama in the David Hockney style. This involves leaving the edges of the images showing so that the viewer can tell that the image was created from a number of smaller photographs. This is a somewhat more "artsy" style, useful in wedding albums, for example. Figure 7.1 shows an example of this, and Lesson 7.1 shows how to do it.

Figure 7.1 This is the "David Hockney" style of assembling a panoramic image.

The next style is the creation of an image that is not a panorama but is made up of multiple photographs. It is characterized by pieces missing from the normally square or rectangular overall image. Figure 7.2 shows this, and Lesson 7.2 explains how to do it.

Figure 7.2 Another image created in the David Hockney style that is not a panorama.

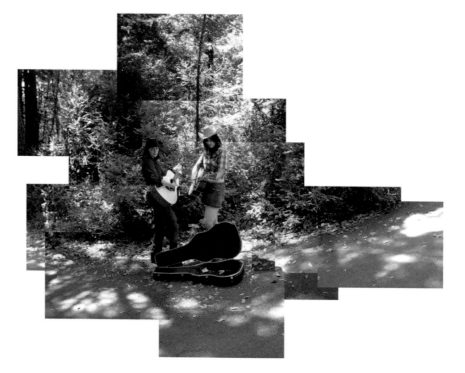

The third and final Mosaic-style image is the creation of an ultrawide panorama in which the borders are trimmed and the edges within the photograph are blended so that the overall impression is of a very wide panorama. Figure 7.3 shows an example, and Lesson 7.3 teaches you how to do it.

Figure 7.3 An ultrawide panorama image created from a number of photographs.

Lesson 7.1—Creating a Panoramic Image in David Hockney Style

This is the easiest style to create. You must first create the individual photographs. Although this can be done on a tripod, it is more fun to do it handheld. Usually it is easiest to photograph with a normal or slightly wide-angle lens, perhaps a 28mm to 50mm in a 35mm equivalent. If you use an ultrawide angle lens wider than 28mm, you will get distortion at the edges that will make it more difficult to line up the edges. If you have to use an ultrawide angle lens, overlap the individual photographs more so you will have less distortion.

To do the photography, hold your camera firmly and keep your eye looking through the viewfinder. Start at one side and take the first image. Rotate your body slightly and, making sure that you overlap the images, take the second image. Repeat as many times as necessary to get in the full panorama. For the full David Hockney style, raise and lower the images so that they don't line up perfectly.

Bring the images back and load them into a folder on your computer. Next, figure out how large you want the completed image. Figure out how many images you will use and reduce the sizes of your original photographs to make the process more workable. If you are not sure, make the images a standard width such as five or six inches. The photographs in Figure 7.4 were reduced to six inches in width. The author uses Lightroom to organize and group his images. Photoshop or Photoshop Elements

Figure 7.4 *All of the images for the first mosaic are opened in Photoshop.*

can also be used to reduce the size of the images. You can prepare an action to do a number of images quickly. See the Help menu in Photoshop or Elements to get instructions on how to do that if you are not familiar with actions. Figure 7.4 shows all of the images opened on the desktop in Photoshop, ready for the layout process.

Step two is to create a new blank document in Photoshop (Cmd/Ctrl+N). Make sure that your document is set up to be in RGB mode (Image > Mode > RGB and 8-bit). Decide if you want the background to be white, black, or another color. White will be the default if you have not changed the background color in Photoshop. If you want black or another color, change the background and foreground colors in the toolbar in Photoshop by clicking on them and choosing your color. Set the size in inches for the number of images that you will be working with. In this case, there are four images that are six inches wide. The maximum size is therefore 6 × 4 or 24 inches. Since the images will overlap, the actual width needed will be less.

To allow working space we will have a height of 20 inches. Use the Move tool to place each image within the new document. Simply click in the middle of each image and drag it to the new document. If you have a number of images, it is easiest to do them in order and keep them in order. This will help with assembling the jigsaw puzzle. In this case, there are only four photographs, so it is easy to do. After dragging each image onto the new document, close the photograph you just finished dragging. This will help to keep you from getting confused with large numbers of images. Each image is placed in its own layer in the new document. Go up to the main menu and click on the Window menu. At the bottom of the pop-up menu will be a listing of the photographs that you have open. That way, you won't misplace any of the photographs. Figure 7.5 shows them all in random order on the new document.

Figure 7.5 *The individual photographs have been dragged onto the new document but not yet placed in order.*

Now arrange the photographs into the correct order. It will help if you click on the box in the Tool menu bar that says Auto Select Layer. When you click on a photograph on the new document, Photoshop will automatically choose the correct layer, so you are just moving that photograph. Look for overlapping points in each photograph to help line them up. Keep moving them around until you are happy with the selection. Save a copy in Photoshop format. That way you can come back to your image and readjust things as necessary.

Once you are satisfied, flatten the image (Layer > Flatten). Save another copy, this time as a .TIFF file. You also can add the word *Flat* to the end of the name right before *.tiff.* That will help you identify which version is which. You can use any other Photoshop tools to make adjustments. Here the image is lightened a little. There was no effort to try to match the individual exposures because the effect is supposed to be a little different. Figure 7.6 shows the finished image.

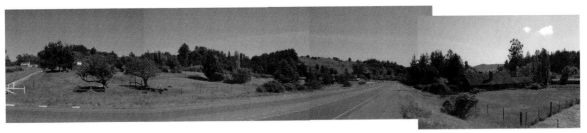

Figure 7.6 *The finished image.*

Lesson 7.2—Creating an Entire Image

In this lesson we will assemble an entire image rather than just a panorama. Photograph the entire scene with lots of smaller crops of the entire view. You will be assembling these into a larger view. Make sure they overlap and that you venture out away from the entire subject. It also helps to take a single image of the entire scene to help with the assembly of the mosaic. When you are trying to figure out where a piece goes, you can look at the single large photograph. It is kind of like looking at the box cover image when assembling a jigsaw puzzle. Figure 7.7 shows the entire scene.

Now gather all of the photographs for your image. It is usually easiest to have them all in one folder and to make the photographs smaller before working on them. The author keeps his photographs in Adobe Photoshop Lightroom, so he exported them all as 4" × 6" (at 300 ppi). You can also do that in Photoshop or Photoshop Elements. Figure out how large you want to have the final image and how many photographs you will be working with. If you are not sure, 4" × 6" is a good starting size. You can work with the full-size photographs, but it will take longer for your computer to work with that much data.

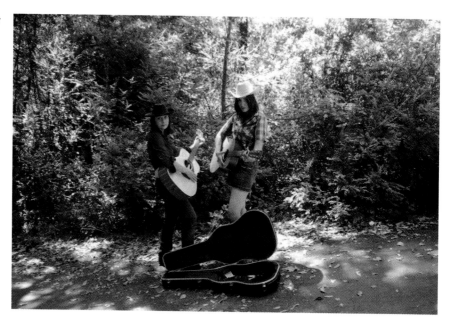

Figure 7.7 An overall look at the scene that we will be working with.

Figure 7.8 shows all of photographs that will be used for this lesson. They are shown in the Photoshop Browser. Now highlight them all and double-click. This will open all of the photographs. Reduce the amount of screen space that each one takes up (Cmd/Ctrl– a few times until it is small enough). The bottom right of Figure 7.9 shows the small images after they have been reduced. There is one last larger image to reduce in the figure. Don't get confused between reducing the size of the images before working on them (Image > Image Size), which actually reduces the number of pixels or data in the image, and simply reducing the size of them being displayed on the screen, which does not reduce the number of pixels. Those are two separate operations. The first makes less data, so you can work on them faster. The second makes it so that you can see the entire layout of your image at the same time.

Now create a new document in Photoshop (File > New), as seen in Figure 7.10. You will get the New menu, as shown in Figure 7.11. You need to know how large your new image will be. This is not the same as how large you want to print it in the end. The size needed here is determined by how large your individual photographs are (did you reduce them?) and how many photographs wide and high your overall image will be. If you are not sure, guess high. You can easily crop it at the final stage. We selected 36 inches wide and 24 inches high because we had reduced the size of the images to six inches and figured that there would be no more than six photographs across and four high. Once you drag a couple of photographs onto the new document, you will have a good idea if it is large enough. You can easily add more space if needed.

Now display each photograph in turn and drag it onto the new document with the Move tool (arrow tool in the Photoshop toolbox that is shown in Figure 7.13). To display each photograph, use the Window menu as shown in Figure 7.12. The individual

Figure 7.8 The Photoshop Browser shows all of the images that we will be working with in this lesson.

Figure 7.9 The photographs are opened and reduced in size. The smaller images are shown in the lower right of the figure.

Figure 7.10 This is how to create a new document in Photoshop.

Figure 7.11 *The New menu.*

Figure 7.12 *The Window menu shows all of the photographs that you have open.*

Figure 7.13 *The Move tool.*

photographs are listed at the bottom of the menu. It is easiest to start at the bottom or top of the list. Click on one, and it will show on the desktop, no longer hidden under your new document. Use the Move tool (Figure 7.13) and drag it into an appropriate spot on your new document. Use the Window menu to bring it up again and close that photograph since you know that you have used it. Otherwise you may get confused if you have a lot of images.

Drag all of your photographs onto the new document and close each one in turn. Each time you drag an image, a new layer is created in the new document. This will allow you to move the images around easily until you get them lined up properly. In the top bar (Tool menu for the Move tool) of Photoshop, it helps to turn on the Auto Select Layer feature. This will be shown only if you have the Move tool selected as shown in Figure 7.14. This feature means when you click on a photograph in your new document, Photoshop will automatically select the correct layer that a particular photograph is on. It is a pretty slick feature. Try moving a few photographs around with it turned off and then with it turned on. You will quickly see the power of this timesaving feature.

Figure 7.14 Turn on the Auto Select Layer feature in the Tool menu for the Move tool.

Drag your images around until you form the image that you like. You may find that you have some images left over that were duplicates as you covered the scene or that could be left out to give the image the uneven edges as shown in Figure 7.15. In some cases you can improve the composition somewhat by deciding which image should be on top and which one underneath. Simply click on a layer in the Layers Palette and drag it up and down in the stack. Figure 7.16 shows Layer 20 about to be moved. By doing this you can choose how the photographs are stacked in your image. Be sure to save your image in the Photoshop format (PSD) as you go along. This will preserve the layers. You can also save it as a layered TIFF file.

Figure 7.15 The layout of the image with the leftover photographs along the edges.

Figure 7.16 Layer 20 is about to be moved in the Layers Palette.

Now delete the extra photographs that you don't need. Click on the photograph, and that layer is highlighted in the Layers Palette. Go to the Layers Palette and drag that layer to the trashcan icon in the bottom of the palette. That photograph will disappear, and the others will not be affected. Figure 7.17 shows some of the photographs already deleted.

Use the Move tool to adjust the placement of each photograph until you are happy with how they are lined up. You can also use the four arrow keys (up, down, right, and left) to make small adjustments. They do not have to line up perfectly; in fact, that is part of the charm of this technique. Use the Crop tool to remove the extra white space. Be sure to save the final image again and then flatten the layers (Layer > Flatten) and save another copy and add *final* to the name. TIFF is a good file format to use for your final image.

Figure 7.17 *Some of the extra photographs have been deleted by dragging their layers to the trash.*

Figure 7.18 *The final image.*

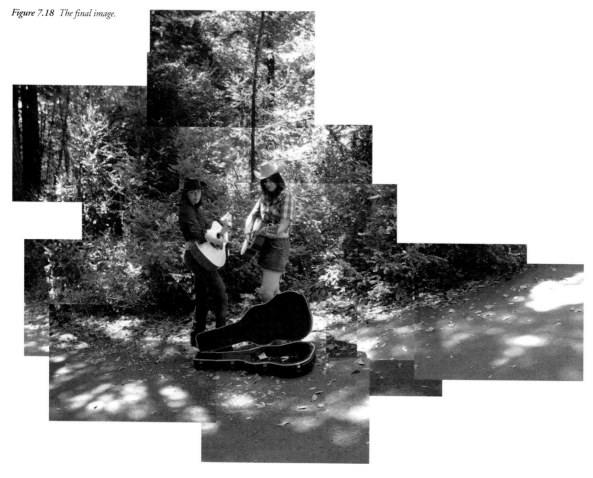

Lesson 7.3—Creating a Wide Format Panorama Image

In this lesson we will create a wide format panorama image. We want this to look as if we used an extremely wide-angle lens to create a photograph that doesn't have the distortion associated with a fisheye lens. It is similar to Lesson 7.1 except that we hope to minimize the overlap points and make them appear as seamless as possible.

The photography is important for this lesson. Make sure to use as close to a normal lens (about 50mm as measured by a 35mm equivalent that takes into consideration the generally smaller size of the image sensor) as possible. Overlap the images. It helps to use manual exposure so that the exposure is not different for each photograph in the series. The following steps are the same as the ones in Lesson 7.1, but they are repeated here for completeness.

Bring the images back and load them into a folder on your computer. Next figure out how large you want the completed image to be. Figure out how many images you will use and reduce the sizes of your original photographs to make the process more workable. If you are not sure, then make the images a standard width such as five or six inches. The photographs in Figure 7.19 were reduced to six inches in width. The author uses Lightroom to organize and group his images. Photoshop or Photoshop Elements can also be used to reduce the size of the images. You can prepare an action to do a number of images quickly. See the Help menu in Photoshop or Elements to get instructions on how to do that if you are not familiar with actions.

Figure 7.19 All of the images for this mosaic are opened in Photoshop.

Figure 7.19 shows all of the images opened on the desktop in Photoshop, ready for the layout process.

Step two is to create a new blank document in Photoshop (Cmd/Ctrl+N). Make sure that your document is set up to be in RGB mode (Image > Mode > RGB and 8-bit). Decide if you want the background to be white, black, or another color. White will be the default if you have not changed the background color in Photoshop. If you want black or another color, change the background and foreground colors in the toolbar in Photoshop by clicking on them and choosing your color. Set the size in inches for the number of images that you will be working with. In this case, there are three images that are six inches wide. The maximum size is therefore 6 × 3 or 18 inches. Since the images will overlap, the actual width needed will be less. To allow working space, we will have a height of 8 inches. Use the Move tool to place each image to the new document. Simply click in the middle of each image and drag it to the new document. If you have a number of images, it is easiest to do them in order and keep them in order. This will help with assembling the jigsaw puzzle. In this case, there are only four photographs, so it is easy to do. After dragging each image onto the new document, close the photograph you just finished dragging. This will help to keep you from getting confused with large numbers of images. Each image is placed in its own layer in the new document. Go up to the main menu and click on the Window menu. At the bottom of the pop-up menu will be a listing of the photographs that you have open. That way you won't misplace any of the photographs.

Now arrange the photographs into the correct order. It will help if you click on the box in the Tool menu bar that says Auto Select Layer. When you click on a photograph on the new document, Photoshop will automatically choose the correct layer so you are moving only that photograph. Look for overlapping points in each photograph to help line them up. Keep moving them around until you are happy with the

Figure 7.20 The individual photographs have been dragged onto the new document and placed in order.

selection. Save a copy in Photoshop format. That way you can come back to your image and readjust things as necessary. Figure 7.20 shows them all placed properly in order on the new document. The far-left figure does not quite line up, so the original image is reopened, and about an inch is cropped off of the right side so that it will overlap better. The new cropped image is dragged onto the new document, and the old photograph and layer are discarded. Figure 7.21 shows how the cropped image overlaps better.

Figure 7.21 The left photograph has been cropped and replaced.

Once you are satisfied, flatten the image (Layer > Flatten). Save another copy, this time as a TIFF file. You can also add the word *Flat* to the end of the name right before *.tiff*. That will help you identify which version is which. You can use any other Photoshop tools to make adjustments. Here the image has been lightened a little, and the overall image has been cropped to get rid of the uneven borders. Figure 7.22 shows the image so far.

Now use the Clone tool and the Healing tool to work on the overlapped edges to blend them as much as possible. It won't be perfect, but it can still look pretty realistic at first glance. With some practice in your photography technique as well as your Photoshop skills, you will be able to blend the overlap points and produce Figure 7.23. The key points are to have the originals as close in exposure as possible. Auto exposure will make this task more difficult. If you have used auto exposure, you will have to adjust each image individually by eye before dragging it onto the new document. Choose your overlap points carefully. If you photograph with lots of overlap, you will be able to choose the overlap so that it does not go through someone's face wherever possible.

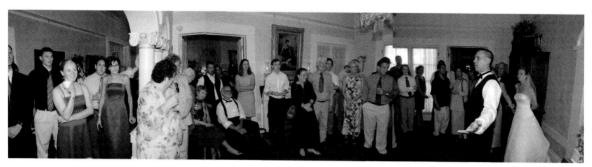

Figure 7.22 *The image lined up and cropped so the edges will be even.*

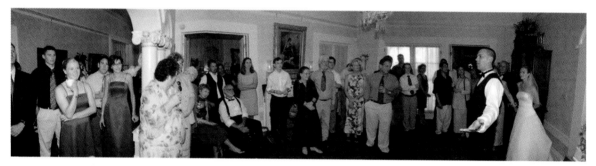

Figure 7.23 *The final image with the overlap points retouched.*

Gallery of Mosaic Images

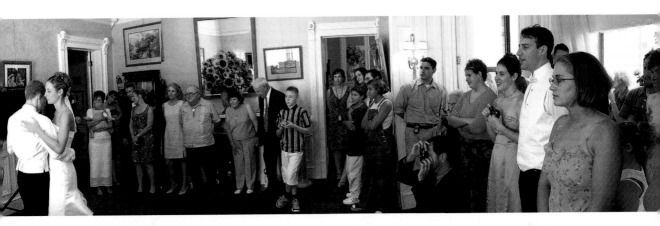

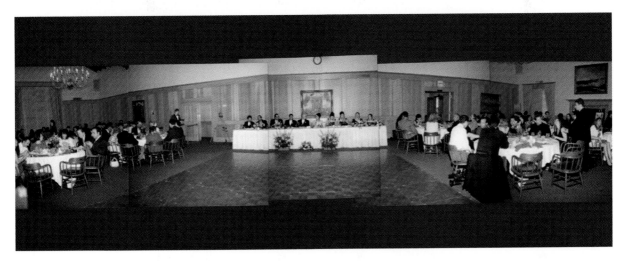

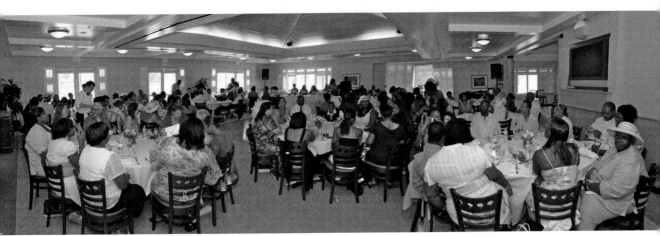

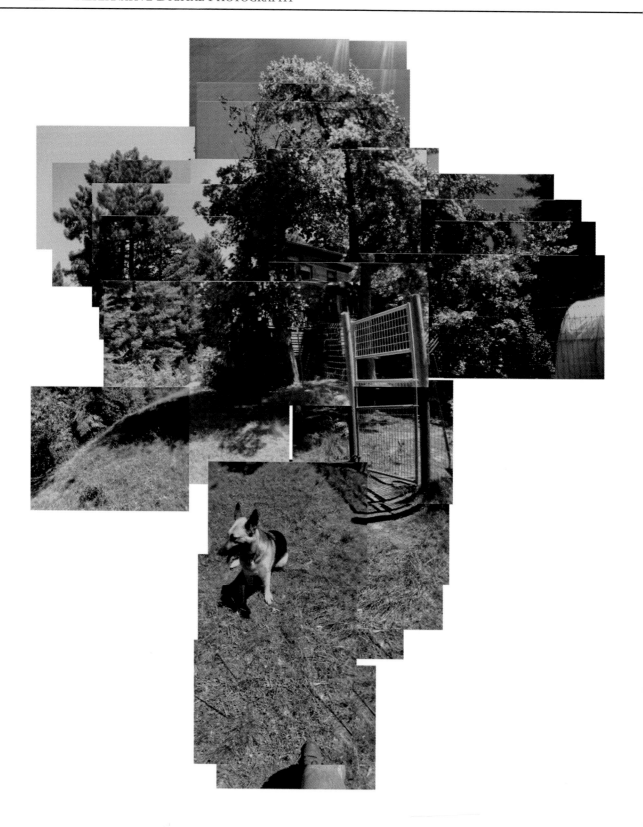

CHAPTER 8

FRESCO

THIS CHAPTER WILL deal with the use of a couple of Photoshop filters. There are many choices of filters, and there are plug-ins for Photoshop as well as other software programs. The number of possible effects is nearly limitless. To help narrow the field a little, these lessons will apply only a couple of the more common filters. They are particularly suited to the old-fashioned style of some of the other lessons you've seen in this book. The Fresco filter is what we will use in these lessons.

Figure 8.1 shows the original photograph that was used to create the opening image on the opposite page. The original is only 640 × 480 pixels, 300K pixels (which is equal to 0.3MP). As reproduced here, you can see that this image is not sharp enough nor does it have enough pixels to make a good-quality image.

Figures 8.3 and 8.2 show an enlarged section of both the original and the final image to show you the detail that is possible even when using a low-quality and small original image. The lessons that follow will show you how to do it.

Figure 8.1 This is the original used to create the opening image.

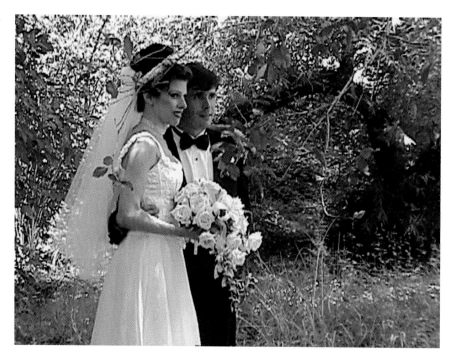

Figure 8.2 An enlarged section of the final image.

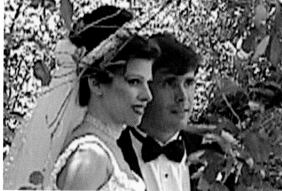

Figure 8.3 An enlarged section of the original image showing the pixelation and general lack of sharpness.

Lesson 8.1—Applying a Single Filter

This is the easiest method. Open your image in Photoshop. Next, enlarge your image to its final size. In this case, the original is 2.1 inches by 1.6 inches at 300 ppi (pixels per inch). It was enlarged to 8 inches by 10.7 inches, also at 300 ppi, by using Bicubic Smoother. Bicubic Sharper is best used for reductions in size. Next the filter is applied: Filter > Artistic > Fresco. Figure 8.4 shows the Filter Selection menu. Figure 8.5 shows the pop-up Filter menu that also shows the image. The pop-up menu can be enlarged to fill the entire computer screen, which is what was done in this figure. You can zoom in or out on the figure in the same menu. Use Cmd/Ctrl+0 to fill the screen. Use Cmd/Ctrl+ or Cmd/Ctrl– to zoom in or out on the image.

Figure 8.4 Select the Fresco filter.

Figure 8.5 The Fresco filter.

There are three different selections you can make to adjust the effect of the filter. They are Brush Size, Brush Detail, and Texture. Figure 8.6 shows a close-up of the menu. Notice that all of the values are set to the minimum values. Figure 8.7 shows a close-up of the faces after applying the Fresco filter with minimum settings.

Figure 8.6 *A detailed view of the adjustments that are possible.*

Figure 8.7 *The faces in detail with the minimum settings.*

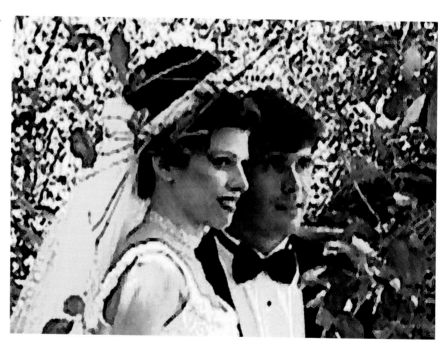

Move the settings in the menu to maximum values as shown in Figure 8.8; the result is shown in Figure 8.9. Again it is a close-up of the faces to compare with Figure 8.7. The results are pretty similar. To make more radical changes, we will have to follow the Fresco filter (or proceed it) with another filter. We will do that in Lesson 8.2. Still, this lesson is a quick and easy way to make an interesting image out of a photograph that, because of its technical limitations, was really not that usable.

Figure 8.8 *The settings can be moved to maximum.*

Figure 8.9 *The settings on maximum and a detailed look at the faces.*

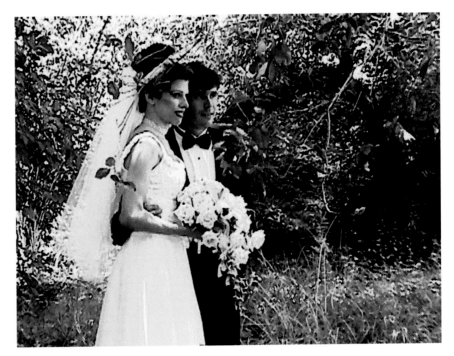

Besides the Fresco filter, there are a number of other artistic filters that can be played with. When you have clicked on the filter, there is a box that allows you to experiment with other filters. Click on the box right above Brush Size. In Figure 8.6, the box has the name of the current filter, Fresco, in it. Figure 8.10 shows the pop-up menu of choices. Figure 8.11 shows the choices in a more visual manner. Clicking on each triangle will reveal more choices and a rough idea of what will happen. You can click on each one to see what it will do to your image. Many will look strange. Four others that are especially good to try are Dry Brush, Palette Knife, Smudge Stick, and Watercolor. Try more, and be sure to try the various setting choices that you have as well.

Figure 8.10 The pop-up menu gives other choices of filters.

Figure 8.11 Visual choices of other filters that are available.

Lesson 8.2—Applying Multiple Filters

The next stage after applying one filter is to apply a series of filters. This increases the possible options to a huge and nearly unlimited number. Here we will use the same image we started with in Lesson 8.1, but we will apply several filters. The following figures are sections of the final image so that you can see the effects more easily. The same procedure is followed for Lesson 8.1. In these cases, the Watercolor filter was applied first with the default settings. Then the Filter menu is activated (Filter > Artistic > *select one*), and then the various possible second filters are tested, with the result showing in the large box next to the choices. Figure 8.12 is the Watercolor filter, followed by the Dry Brush. Figure 8.13 follows the Watercolor filter with the Fresco filter. Figure 8.14 is the Watercolor filter for the first filter and the Palette Knife filter as the second filter. Figure 8.15 has the Smudge Stick as the second filter. The final example is the Watercolor filter applied twice.

Figure 8.12 The Watercolor filter followed by the Dry Brush.

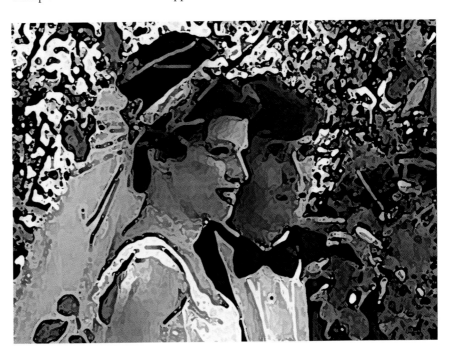

Figure 8.13 *The Watercolor filter fol-lowed by the Fresco filter.*

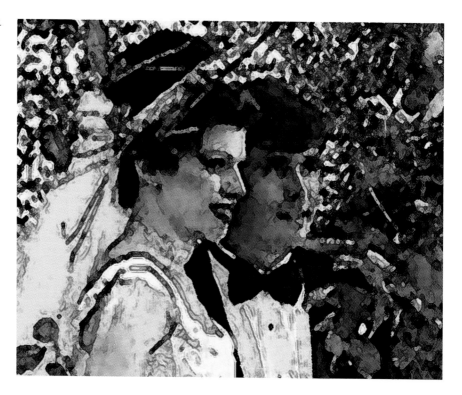

Figure 8.14 *The Watercolor filter fol-lowed by the Palette Knife filter.*

Figure 8.15 *The Watercolor filter followed by the Smudge Stick filter.*

Figure 8.16 *The Watercolor filter applied twice.*

Gallery of Fresco Images

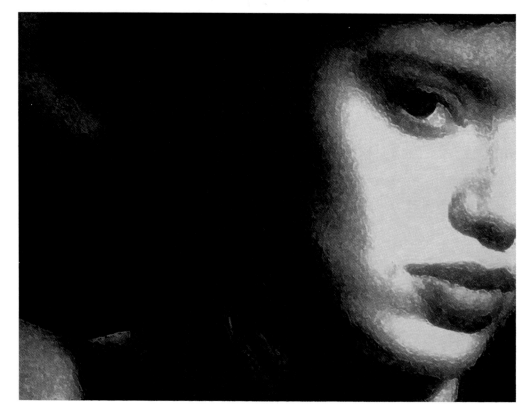

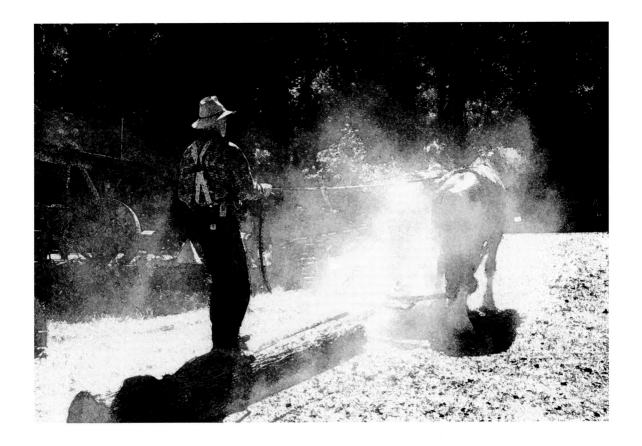

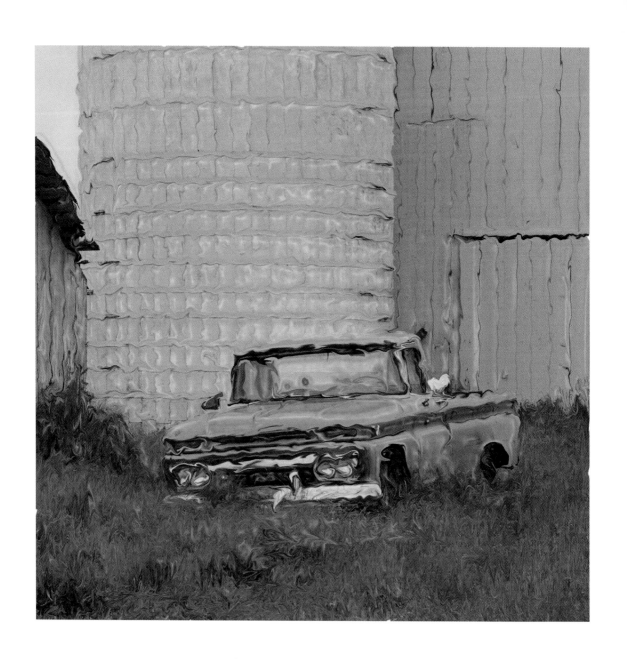

CHAPTER 9

Photoimpressionism

PHOTOIMPRESSIONISM IS A TERM used by the author to describe the manipulation of Polaroid SX-70 prints. SX-70 film is made up of a gel-based substance that does not fully harden for several hours or more. At first it was considered a defect because prints placed in your pocket while they were fresh could end up marked by anything you carried in that pocket. Artists learned to use this to their advantage and manipulate the prints with small tools such as sharpened chopsticks, spoons, and dental tools. The effect is quite interesting and resembles an impressionistic painting. Figure 9.1 shows an example of an SX-70 photoimpressionism piece. Each piece could take anywhere from 15 minutes to over an hour to manipulate. Then it could be scanned and more touch-up work done in Photoshop.

Unfortunately, the Polaroid Corporation was greatly affected by the digital revolution and finally went into bankruptcy. After emerging from bankruptcy, Polaroid discontinued making SX-70 film in 2006. There may be a few boxes around in obscure locations, and it is sometimes found on eBay, but in general SX-70 film is nearly all gone. There is a new version of the film out called SX-70 Blend, but though it is fine for regular photographs with an SX-70 camera, it is not suitable for manipulation. We are left with trying to duplicate the effect digitally. The following lessons will lead you through the process.

What types of photographs lend themselves to the photoimpressionism technique? Look to the impressionistic painters for inspiration. Subjects that are brightly colored or old-fashioned looking tend to look best with this alternative digital process. Using an SX-70 was one of the author's favorite techniques. This digital version is now a close second.

Figure 9.1 This is a photoimpression-ism image created by manipulating a fresh SX-70 print.

Lesson 9.1—Photoshop Filters

This is the easiest way to get an approximation of impressionism. The figure was cropped square to resemble the square SX-70 film. Next, various Photoshop filters were tried. See Figures 9.3 through 9.7 for five different filters applied.

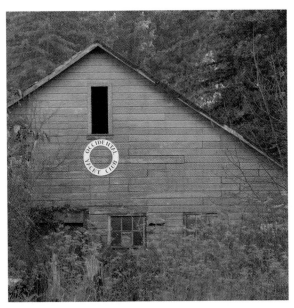

Figure 9.2 This is the original image.

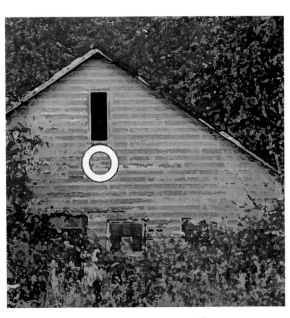

Figure 9.3 The image with the Dry Brush filter applied.

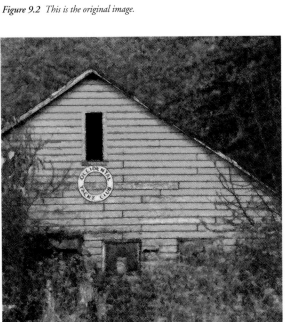

Figure 9.4 The image with the Fresco filter applied.

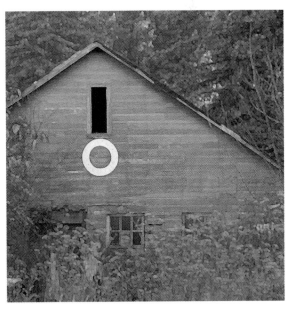

Figure 9.5 The image with the Paint Daubs filter applied.

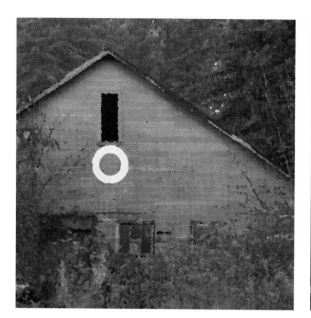

Figure 9.6 *The image with the Palette Knife filter applied.*

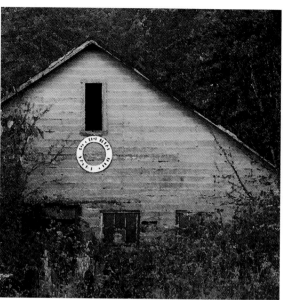

Figure 9.7 *The image with the Watercolor filter applied.*

Lesson 9.2—Photoshop and the Smudge Tool

The next tool to try is the Smudge tool. It shares the same space in the toolbox with the Blur tool and the Sharpen Tool. Figure 9.8 shows how it is selected. The Smudge tool has a size, mode, and strength. In Figure 9.9 there are three different settings used. On the top left side, the Brush is set to 29, and Strength is set to 100%. Notice how there is no detail and just a smear. On the right side, the Brush is the same size, but Strength is reduced to 50%. More detail can be seen. Finally, in the center, the Brush is set to 15, and Strength is set to 50%. Each image will often require different settings. This is a matter of personal style, the size of the photograph, and the subject matter of the photograph. You may decide to use different settings on different portions of the image.

The Smudge tool should be used along any lines in the image. In our sample, the tree branches, the edge of the roof, and the siding boards all have lines that need to be worked on. As the cursor is moved along the line with the mouse, a pen and template, or a touch pad, jiggle or wiggle it back and forth. The jiggle is what gives it the effect. The line is smudged in both directions.

Figure 9.8 *The Smudge tool is selected.*

Figure 9.9 *The left side of the top has Brush = 29 and Strength = 100%. The center has Brush = 15 and Strength = 50%. Finally, the right side has Brush = 29 and Strength = 50%.*

Figure 9.10 *The finished figure using the Smudge tool with settings of 15 pixels and 30% Strength in the top and 20 pixels and 40% Strength in the rest.*

You will probably find that it helps to zoom into the area that you are working on to at least 50%, 66.7%, or even 100% so that you can better see what you are doing. When you are zoomed in, keep in mind that you will have to exaggerate the effect somewhat to compensate for reducing it when you print it out. Keep in mind the final size at which you want to display the image before you begin. Start in one corner and move across the image to the other side and then back. Zoom back out to see if your technique is too strong or not strong enough. It is easy in Photoshop to undo and redo a small section if you check it periodically. It takes a long time to work on the image, over an hour in the case of Figure 9.10. But the results are worth it. The effect is much more unique than those in Lesson 9.1, where only filters are used.

Lesson 9.3—Photoshop Liquify Filter

The same original is used in this lesson as was used in Lessons 9.1 and 9.2. One thing to notice about the SX-70 manipulated images is that often there are white streaks in them. This is caused by the lower layers of the emulsion being exposed in the manipulation process. Some photographs will not need this, but many will benefit by it. To simulate this effect of the SX-70 manipulation technique, first apply the Plastic Wrap filter (Filter > Artistic > Plastic Wrap). Experiment with the different settings until you get a suitable one. A light effect usually will work best. The exact settings will be determined by the size of your image, the particular image, and your own style. Figure 9.11 shows the settings used, and Figure 9.12 shows the image with the Plastic Wrap filter applied.

Figure 9.11 *This is the Settings menu for the Plastic Wrap filter. Relativity low settings were chosen for this image.*

Figure 9.12 *The Plastic Wrap filter applied to the image.*

The next step is to use the Liquify filter. It is more of a tool than a filter, but it is found under the Filter menu. It is used in a manner similar to the Smudge tool in Lesson 9.2. The look and effect are different. As the name implies, the tool changes the image to a liquid or gel (similar to the SX-70 emulsion), and it can then be pushed around. There are five settings for the tool: Brush Size, Brush Density, Brush Pressure, Brush Rate, and Turbulence Jitter. Figure 9.13 shows the tool controls for the Liquify tool. On the left side of the display in Figure 9.14 is a vertical set of tools.

The top tool is the Forward Warp tool, which looks like a finger. This is usually the best tool to use for these types of manipulations. Use the tool to push portions of the image around. The tool settings used in this case were Brush Size = 25, Brush Density = 73, Brush Pressure = 100, Brush Rate = 80, and Turbulence Jitter = 50. These are lighter values (except for pressure). Experiment with the values until you find what works for you. The top of Figure 9.14 has been worked on with the Liquify Filter tool. Figure 9.15 is the final figure. It compares very favorably with the SX-70 film manipulation technique.

Figure 9.13 *The Liquify tool Settings menu.*

Figure 9.14 *The top of this figure has been worked on with the Liquify Filter tool.*

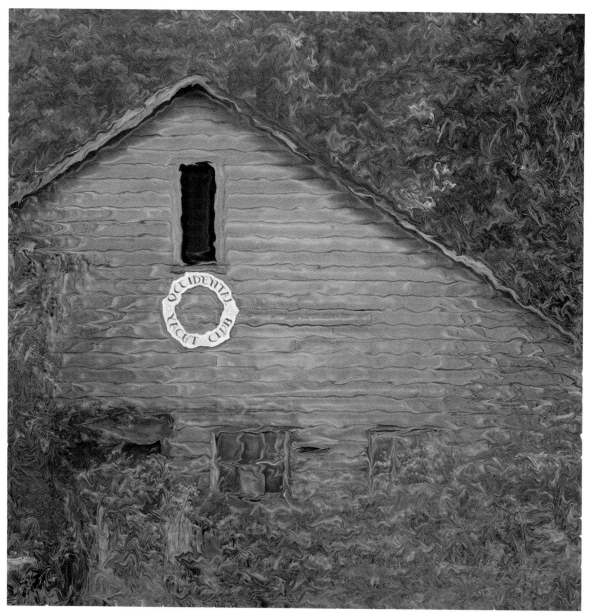

Figure 9.15 *The final figure with the Plastic Wrap filter, followed by manipulating the image with the Liquify Filter tool.*

Gallery of Photoimpressionism Images

CHAPTER 10

SEQUENCES

THE MAIN ALTERNATIVE part of this technique is the presentation. Rather than presenting a single image that has to stand on its own, these lessons are about preparing a group of images to tell a story. A sequence can make a different sort of portrait presentation. It can also be interesting in wedding albums and for high school seniors. Besides selecting a variety of images, part of the challenge is in the use of white space and layout. Rather than just putting a bunch of photographs into a grid formation, think of how the eye will flow through your layout. Since we read left to right in the Western world, our eyes also tend to travel that way when looking at an image. Lead your viewer's eyes through the layout with interesting curves. Most of these examples are very straightforward with few graphic elements, but you can certainly add those if you are so inclined. Sometimes you need more than one page to present your images. In that case, think in terms of a double-page spread, or two facing pages in a book. This gives even more possibilities to exercise your design skills.

Figure 10.1 This is a figure showing the 44 photographs of a portrait session that will be edited for use in the first lesson. The images are displayed in Adobe Photoshop Lightroom. Ten images of the 54 originals were rejected because of blinks or unflattering expressions.

Lesson 10.1—Sequence Example 1

This lesson will work on a group of portrait images, such as what you might do with a high school senior. In this example, the subject is wearing the same outfit in all of the photographs, and the sequence is of different poses. You could also do a page of different "looks," where each photograph is of the same person, but she is wearing a different outfit with different props and a different background.

The first step is to think about what you are going to do before you even photograph your subject. It this case it was decided to have a variety of poses at the same location with the same outfit. That meant that the subject had to be encouraged to vary her expressions and poses and keep doing it on a freeform basis as the session progressed.

Without having to worry about the cost of film because we are using digital, 54 photographs were captured for this example. The author used Lightroom to select and process the photographs and output eight smaller versions to work on. You could use Photoshop, Photoshop Elements, Bridge, or any number of other software programs to select and process your images.

Next decide how large the final montage will be. The author selected 8-1/2 inches by 11 inches, a standard paper size, but you could choose 8 × 10, 11 × 14, 16 × 20, or any other size. Once you have selected the final output size, estimate about how large your smaller photographs will need to be to appear the correct size in your layout. That is the size that you want to reduce them to. The choice does not have to be exact because you can vary it somewhat after the layout is done. Create them a little larger if

you are not sure. The author selected 2 inches by 3 inches, a somewhat standard "wallet" size that should work well with the final output size selected. Figure 10.2 shows the eight best images in the Photoshop Browser.

Now create a new document of the size you determined earlier. Go to the top menu and select File > New as shown in Figure 10.3. The menu pops up (Figure 10.4).

Figure 10.2 The eight best images chosen for their variety of expressions and poses from a portrait session.

Figure 10.3 A new document in your final output size is created.

Figure 10.4 The New menu pops up.

Type in a name for your layout. The example shows Jodi. Either fill in the Width, Height, and Resolution or click on the Presets menu as we have done in Figure 10.5. We chose Letter size, but you can choose whatever size you like or create a new preset for future use. If you create a new preset, just click on the Save Preset button right under OK and Cancel. Next, select Color Mode (RGB will be the usual choice) and the color of the background you would like. Here we chose RGB Color and white. You can click on the Advanced menu if you want to change the Color Profile or Pixel Ratio. Otherwise, leave them alone and click OK.

Figure 10.5 *The Presets menu to select the layout size and resolution.*

The new document appears as a white sheet unless you chose another color. Now go back to the Browser and open all of the images (eight in this case). Drag each of them onto the new document using the Move tool (arrow in the Photoshop toolbox) and then close the original. Each photograph that you drag onto the new document will automatically be placed onto its own layer, which makes it easy to move them around in a few moments. You should see something like Figure 10.6. Make sure that the Auto Select Layer box in the upper-left corner (Figure 10.7) is checked. This will tell Photoshop to choose the layer of the photograph you click on. You won't have to worry about which layer is which. Photoshop will do it.

Now start moving the photographs around. You may prefer to turn on the grid lines (View > Show > Grid) and the rulers (View > Rulers) to make it easier. Also, consider turning on the Snap feature (View > Snap), which will make sure that the edge of your photographs will move to the nearest grid line, guide line, or the edges of the document. Select the ones that you would like under View > Snap To > (choose any or all). Figure 10.8 shows the grid lines and rulers turned on.

Figure 10.6 *The new document with all of the photographs. Notice that Photoshop has automatically created the white background layer and separate layers for each of the individual photographs for a total of eight layers plus the background.*

Figure 10.7 *The Auto Select Layer box should be checked.*

Figure 10.8 *The grid lines and rulers turned on.*

Now move your images to where you think they look best. You can overlap, put them in a pattern, or arrange them however you like. Keep in mind some suggestions:

- People should generally look into a photograph. If someone is facing to his right (left in the photograph), he should be on the right side of the photograph so he is looking towards the center. This tends to make the viewer's eyes go back into the photograph rather than out of the photograph.

- Strive for balance in color, shape, and form.

- You can overlap the images if you want to, even though it wasn't done in this example.

- To delete an image, click on it, and then drag the highlighted layer in the Layers Palette to the little trash can in the palette.

- To make one photograph move to the top if they overlap, click on it, and then drag the highlighted layer in the Layers Palette up or down to a new position.

- It often looks better to have a bit more white space at the bottom of an image than you have at the top.

- Save your image as a Photoshop file (PSD format) as you go along so you don't have to start over if you have a problem.

Once you are finished, do a last save as a PSD file to keep your layers intact. That way you can work on it again if you need to. Then flatten the file (Layer > Flatten Image) and save as a TIFF or JPEG. Figure 10.9 shows our final figure with the grid lines and rulers turned off.

Lesson 10.2—Sequence Example 2

In this lesson, we will work on an event where things were happening, and the photographs are not just different poses of an individual. These are images taken with a digital toy camera as part of wedding photography coverage. The entire wedding has been condensed to 42 images taken throughout the day. Figure 10.10 shows all of the images displayed in Lightroom.

Now we are going to lay them out just as we did in Lesson 10.1. If you need more detailed instructions, flip back to that lesson to see the figures and detailed instructions. Here is a summary of what we are doing:

- Edit and select your images in Photoshop or a similar program.

- Do any adjustments, color corrections, and retouching.

- Reduce them in size. In this example all of the images were reduced to 1.5 inches by 2 inches.

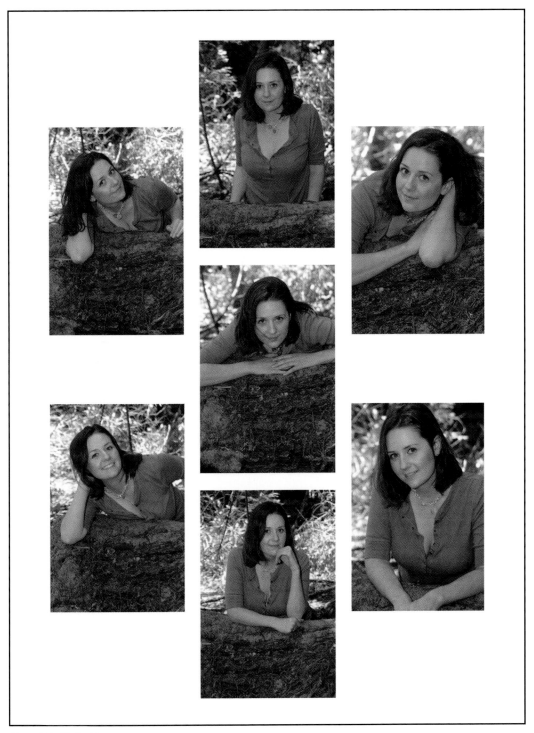

Figure 10.9 The final image.

- Create a new document of the appropriate size. In the example, a 16 × 20 was created.

- Open all of the photographs that will go onto the new document.

- Drag them one at a time onto the new document and then close the original.

- Save the new document as a Photoshop (PSD) file.

- Make sure that the Auto Select Layer box in the upper left is checked.

- Move your photographs around to form a pleasing layout.

- Use grid lines and rulers if desired.

- When finished, save your file as a PSD with the layers so you can easily make changes.

- Crop the overall figure if necessary.

- Flatten and save your image as a TIFF or JPEG, ready for printing, website, or other use.

The small photographs were arranged into a freeform "S" curve kind of a shape that follows the basic timeline of the wedding. You start in the upper left of the image and follow the curve down to the bottom as the wedding progresses. This particular image was designed to be a framed wall hanging piece. You could also have arranged the images on several pages to go into the regular wedding album.

Figure 10.10 *An entire wedding is covered with these 42 images taken with a digital toy camera.*

Figure 10.11 The initial drag and drop of the images onto the new document.

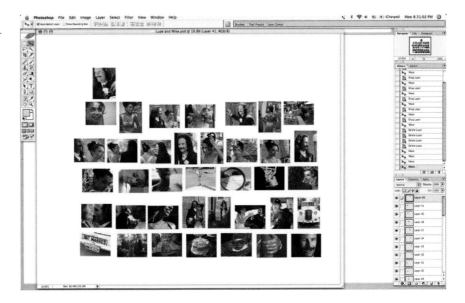

Figure 10.12 The final image after the smaller photographs were rearranged.

Gallery of Sequences Images

CHAPTER 11

Digital Pinhole

PINHOLE PHOTOGRAPHY is creating a photograph with a camera that uses a pinhole to focus the light rather than a conventional lens. Pinhole cameras and photography have been around for a very long time. They were in existence even before the invention of film. In the past they used film or enlarging paper to "capture" the image. In this chapter we will talk about using a digital sensor instead of film.

Many photographers love to create pinhole film cameras because they are so simple to make. All you need is a relatively light-tight container, a pinhole, something to cover the pinhole to act as a shutter, and photosensitive material to expose. The incredible variety of objects that have been used as film pinhole cameras is fascinating. They include oatmeal boxes, orange juice cans, a hotel room, a car, a bell pepper, someone's mouth, a hole in the ground, a matchbox, and many more mundane objects. Because digital sensors are more difficult to work with and the knowledge to build your own digital camera is more complex, we are going to start with an existing digital camera. We are going to take advantage of the fact that SLR digital camera lenses can be removed and use a digital SLR camera with its lens removed as our digital pinhole camera. If you don't have a digital SLR camera, and you are handy, you might be able to use a cheap digital toy camera and remove the existing lens. Since that takes skills that many people don't possess, we will leave that to those who want to experiment. Unfortunately, you do need a digital SLR camera to do these lessons. Used digital SLR cameras often are available on eBay or even your local camera store at very good prices. Many photographers want the latest and greatest digital tools, and bargains are available for older used equipment. You do not need the latest fancy equipment to make your pinhole camera. Most of the features and quality of a current digital SLR will be wasted in pinhole photography. If a bell pepper can be used as a pinhole camera, surely a five- or six-year-old digital SLR should work fine.

Figure 11.1 *A digital SLR camera with its lens removed.*

Lesson 11.1—Making Your Own Digital Pinhole Camera

This is the fastest, easiest, and least expensive way to make your own (assuming that you already own a digital SLR camera), but it is not the way to produce the best pinhole. Suggestions for improvements will be given at the end of the lesson. It will take you no more than five or ten minutes to make this pinhole camera, including the time to gather the materials. Here is a list of what you will need (see Figure 11.2):

- A digital SLR camera with a removable lens.
- A piece of heavy duty foil about 4 inches square.
- A sewing needle, the finer the better.
- A piece of cardboard from the back of a writing pad.
- A pair of scissors.
- A small roll of duct or gaffers tape.

Figure 11.2 Here is most of the items you will need to make your own digital pinhole camera. Just add a digital SLR camera without the lens and a pair of scissors and you are ready to get to work.

Get a roll of heavy-duty foil. The thin cheap stuff may not work as well, but feel free to try what you have. Cut a piece of foil about 4 inches on each side. Put the cardboard on a table and lay the foil on top of it. Get the thinnest sewing needle you can find and place the point in the middle of the foil. Holding the needle and pressing on it, turn the foil so that the needle will drill a hole down into it. You turn the foil so that the hole will be round. Push only the point of the needle through, not the entire needle. The smaller and sharper the hole is, the sharper the image will be. Just as with the aperture on a regular lens, the larger the hole, the brighter the image. It is always a trade off. A small hole will produce a sharper, dimmer image. A larger hole will produce a brighter, softer focus image. Figure 11.3 shows the result of a large hole, and Figure 11.4 shows the result of a smaller hole. Figure 11.3 shows a bit of a double exposure because the needle jumped while turning the foil and made a tiny second hole next to the first one, another issue to watch for while you are making your own pinhole camera.

You have your pinhole, now you just have to attach the pinhole to your camera. Remove the lens from your digital SLR camera. Use a couple of small pieces of the duct/gaffers tape to hold the foil to your camera body. Scrunch the foil around the lens mount on the camera to keep down the light leaks. If you damage your pinhole, it is cheap and easy to make another one. Once you are done, it should look like Figure 11.5.

One thing to be concerned about is the amount of dust that your sensor will attract through the small opening. Try to keep your camera away from dusty environments while you have the pinhole attached. Anytime you have the lens off of your camera, dust can get in. Be sure to use a body cap on your camera if you are going to leave the lens off for more than a moment.

Figure 11.3 *A pinhole image made with a larger, less perfect hole as the pinhole. The double exposure effect is caused by the needle jumping slightly as the foil was turned making a tiny, almost unnoticeable second hole next to the first one.*

Figure 11.4 *A pinhole image made with a small, sharp pinhole.*

Figure 11.5 *The foil with the pinhole is taped to your SLR camera body with the lens removed.*

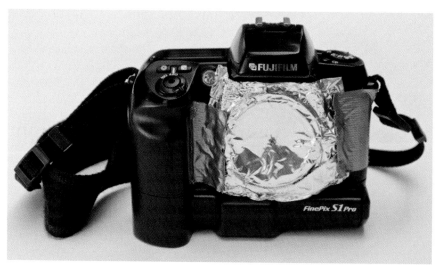

Some characteristics of pinhole cameras include:

- The smaller the hole, the sharper and dimmer the image.

- The larger the hole, the softer and brighter the image.

- Pinhole images need a lot of light because the f-number of the "lens" is on the order of f180 (normal lenses are more in the range of f1.4 to f2.8). This means setting your camera on a higher ISO rating (1600 or higher if you have it available) and/or longer exposures.

- The depth of field is huge. Objects that are far away are just as much in focus as images close up.

- You have to be concerned about dust getting in through the small pinhole and depositing on your image sensor.

- The image will be soft and not sharply in focus.

If you enjoyed making your own pinhole, there are a few things that you can do to improve it. The first is to start with a body cap so that you won't have to tape it to your camera. Then cut or drill a small opening in the body cap, about one-quarter inch across. Next, instead of using aluminum foil, get one of those disposable aluminum pie pans that come with pre-made pies. The pans can be purchased on their own at the grocery store, too. Cut a small square out of the bottom of the pan and drill your pinhole in that. The pinhole will be more difficult to drill because the aluminum is thicker. It sometimes helps to wrap some tape around the top of the needle to keep you from punching a hole in your finger as you press down. Use some extremely fine (600 grit) emery paper to sand down the backside of the pinhole aluminum to remove burrs. Sanding a bit also makes the aluminum thinner right at the pinhole. This will tend to reduce flare. Tape this aluminum square inside the body cap with the hole in the center. Tape it in securely. If you use black electrical tape to hold it in, you will cut down somewhat on the internal flare.

Now you can easily attach and remove your pinhole whenever you'd like. If you enjoy pinhole photography, you probably will get tired of taping and untaping the pinhole. If you like the concept but don't want to make your own fancier pinhole, move on to the next lesson. We will also go into more general information about photographing with a digital pinhole camera.

Lesson 11.2—Using a Commercial Pinhole Attachment

There are several companies that offer pre-made pinholes to attach to your camera. Check out Appendix B or the author's website (johngblair.com) for information about where you can purchase one. They are pretty inexpensive, about $20 or so plus shipping and handling. Figure 11.6 shows the body cap lens, and Figure 11.7 shows it mounted on a camera. They are available for various camera makes.

Figure 11.6 *A pinhole body cap lens for a Nikon camera. This will attach to a Nikon SLR camera instead of the lens.*

Figure 11.7 *The pinhole body cap lens is attached to a camera.*

Now for some fun. Let's go photograph! You need a lot of light for pinhole photography. Start outside. Set your camera on manual. The actual exposure will depend on the size of your pinhole. Out in bright sunlight, try an exposure of 1/8 second with an ISO setting of 1600. Typically the pinholes are around f180. As you photograph, watch out for photographing towards a bright light such as the sun because pinholes are susceptible to flare. Figure 11.8 shows an example of flare.

***Figure 11.8** The image is suffering from flare because of photographing towards the sun.*

One of the features of pinhole photography is the great depth of field. Figure 11.9 shows both the foreground and the background in focus. Keep in mind that focus is usually not very sharp in a pinhole camera. You can use a flash to add more light to a pinhole, as was done in the portrait shown in Figure 11.10.

There is no focusing or aperture to set. It is almost like a point-and-shoot camera. The viewfinder will be very, very dark. You can usually just see through the viewfinder if you are photographing in the bright sun and press your eye up against the viewfinder. Let your eye become accustomed to the darkness for a moment, and you can usually make out shapes and shadows. You will need a tripod most likely if you are using the camera outdoors in the shade or indoors. The exposure times will be much longer.

Work with subjects that will benefit from a soft and romantic kind of feel. Don't be afraid to experiment. Burn up those pixels!

Figure 11.9 *This image has both the background and foreground in focus, one of the characteristics of pinhole photography.*

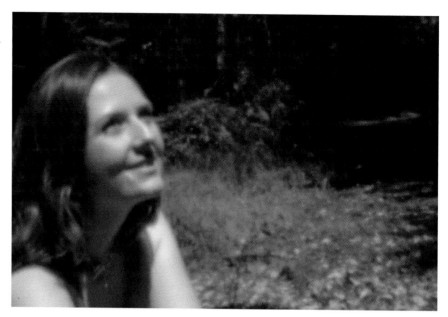

Figure 11.10 *A flash can be used with a pinhole camera as was done for this portrait.*

Gallery of Digital Pinhole Images

CHAPTER 12

Digital Infrared

Infrared photographs have an unearthliness about them. They tend to be a bit dramatic and unusual. Plants will photograph white because they reflect infrared light. Skin glows white and seems nearly transparent.

What is infrared light? Light is made up of various wavelengths of radiation that are measured in nanometers (nm), a unit equal to one-billionth of a meter. Visible light falls roughly into the band of 380nm to 730nm. Infrared begins at the upper side, about where the visible color red ends.

When we talk of infrared photography, we mean the band from about 730nm to 900nm, which is the lower portion of the spectrum known as *near infrared*. Near infrared runs up to about 1,200nm. *Far infrared* begins there and goes up to one million nm. Far infrared can be felt as heat. Infrared photography is not sensitive to heat radiation.

Some people confuse infrared photography with thermal imaging. Infrared photography is sensitive from about 730nm to 1,200nm. Thermal imaging cameras are sensitive from about 7,000nm to 14,000nm.

Objects that reflect infrared light are light colored in infrared photographs, and things that absorb infrared light are dark. Plants will reflect infrared, and the sky will absorb it, for example. One suggestion when you photograph is to use the raw format if your camera supports it. This allows more adjustments afterwards, as the exposure is a bit tricky to get right.

The focus for infrared rays is different than for visible light. Older lenses made before autofocus had a red dot to show how the focus needed to be adjusted for infrared photography. Most modern autofocus lenses do not have that feature. Closing down your lens a bit more to increase the depth of field will help. Some Canon lenses have a built-in anti-infrared coating on them. They will not work well for infrared photography. There may be other lenses coming out with this coating as well, so be sure to test before you buy if you are going to be using them for infrared work.

Here is a word of warning. When you are working with infrared filters, many of them will appear quite dark. *Do not* look at the sun through the filters. The infrared radiation from the sun will pass through the filter even though it is not visible. It can permanently damage your eyes very quickly and without you feeling it in time to stop.

Before digital photography came around, if you wanted to create infrared images you had to use a special infrared film, and only a couple of types of film were available. The film required special handling; it had to be loaded and unloaded in complete darkness. It was difficult to get the exposure correct, and photographers had to bracket their exposures by several stops each side of what they believed the exposure to be.

Still, even with all of this extra work, infrared had its devotees. Now, with the availability of digital photography, these are no longer issues. It is easy to create digital infrared images with a variety of tools. These tools will be explained in the lessons that follow.

The first step is to see if your camera is sensitive to infrared radiation. Camera manufacturers install an infrared cutoff filter over the image sensor to reduce the amount of infrared radiation striking the image sensor. Over the years, these filters have tended to improve, making it more difficult to capture infrared images with more recent cameras.

There are several factors, including the size of the pixels and the type of internal filter, that determine how sensitive your camera is to infrared. Luckily, there is a simple test. All you need is your camera and a remote control, such as the one you use to operate your cable box or television. If your camera has an electronic viewfinder that you use when taking a photograph (not just to display the photograph afterwards), then you simply point the remote at the camera lens from about 12 inches away and press and hold the button. You should be able to see a white spot as in Figure 12.1. The brighter and whiter the spot, the more sensitive it is. If you see just a faint red spot, then it is questionable whether your camera is sensitive to infrared light.

If your camera does not have an electronic viewfinder (for example, most digital SLRs have an optical viewfinder and not an electronic one), then you will repeat the same test. Instead of looking at the viewfinder, simply take a photograph, and you should get something similar to Figure 12.1. If your camera is sensitive to infrared, you are ready to move ahead to the lessons.

Figure 12.1 This is what you should see when looking at a remote control pointed at the lens of your camera with a button held down.

Lesson 12.1—Making Your Own Infrared Filter

Now you know that your camera is sensitive to infrared light. To use your camera to take infrared photographs, you need to place something over the lens that stops the visible light from getting through but still allows infrared. There are a number of different filters that you can use. In this lesson, we will show you how to make a free or nearly free one first. In an interesting twist, due to the properties of transparency film, it is designed to allow infrared radiation to pass through the film after it is processed. This helps to prevent damage when it is used in a slide projector. If you take a piece of film that is unexposed but processed, it will be black, allowing very little visible light through, but still allowing the infrared light to pass. Depending on the size of the lens on your camera, you may be able to use 35mm film, or you may have to use larger film such as 120. It needs to be color transparency film and nearly black. To test the theory, just hold the piece of film in front of the lens.

Figure 12.2 shows a photograph taken with a single layer of exposed, processed transparency film in front of the lens. It is not a great photograph, but it shows that the concept works. This is how it looks straight from the camera. It has a bit of a greenish color given to it by the slight greenish color of the film. You could leave it as is or reduce the green as seen in Figure 12.3.

Figure 12.2 Here is an infrared photograph taken with a piece of transparency film held in front of the lens. This is just as it comes from the camera.

Figure 12.3 The same photograph as in Figure 12.2, but the green is removed, and the contrast is increased a bit.

If you like it this far, get a UV filter that will attach to the end of your lens. Then cut a piece of the film so it fits on the inside of the filter (so it won't get scratched as easily) and then tape or add a couple of drops of glue around the edge to hold it in place. Now you have a much more serviceable filter setup.

Next is to use two layers of film. One layer allows some visible light through. Two layers allows almost no visible light to pass. Later in this chapter, in the section "Comparison of Different Infrared Techniques," there are sample photographs of the same scene photographed with one or two layers of film as well as commercially available filters and other techniques.

What should you photograph? Here are some suggestions: outdoor scenes, indoor plants, portraits, animals, and outdoor gardens, among other things. Experiment and see what works. See Figures 12.4 through 12.8 and the others throughout this chapter to give you some inspiration. Soon you will find what works well and what doesn't.

Lesson 12.2—Using a Glass Filter

In the previous lesson, we talked about using pieces of film to create your own filter. That may work to get you started, and it saves money. In the long run, if you enjoy infrared photography, it is likely that you will want to move up to glass filters for better quality. The next step is to see what filters you already have and if they will work.

Since you are trying to stop visible light from reaching your sensor but allow infrared to pass through, you need a filter or filters that will stop the visible light. If you have a dark red filter (25A) and a dark green filter (X1), you can combine them and try that.

Figures 12.4–12.8 *Here are some suggestions on good subjects for infrared photographs.*

The red filter will stop the green and blue visible light and allow only the red through. The green filter will stop the red light from going through. Both of these filters will permit infrared to reach the sensor.

The next filter that can be used is the Hoya R72. It permits mostly light above 720 nm (in the near infrared) to pass through. It is a very dark red in color and permits a little bit of visible light. With practice you can put your eye to the viewfinder, let it become accustomed to the dark, and see enough to make out some forms on a bright sunny day. This will allow you to compose your photograph. Figure 12.9 shows an uncorrected photograph taken with this type of filter. The Hoya brand is one of the least-expensive commercially made infrared filters available. You can find them starting at about $30 and up, depending on size. The author used a 72mm to fit his zoom lens, and that sells for about $130. Other brands are also available, although they may use other numbering systems. The Kodak Wratten 89B is equivalent to the Hoya R72.

The next filters permit no visible light to pass. They are a bit more rare and more expensive. These are the Kodak Wratten 87 and 87C. When using these filters, a tripod is usually needed. You compose the scene and then lock the tripod and camera, attach the filter, and photograph. Each filter provides a slightly different effect. The exposure will vary through each filter and for each scene.

Light meters give only an approximation of the light because they don't measure infrared directly. Luckily, with the instant feedback of digital, it is easy to get the exposures nailed down. After a while you will start to be able to estimate the exposure settings yourself so that you can adjust the camera settings. It is often easiest to photograph in manual mode.

Besides the premade filters, you can purchase plastic infrared filter material from companies such as Edmund Optics (edmundoptics.com). You can search for optical cast IR longpass filters. They come in various sizes and are fairly inexpensive.

Another use for the inexpensive material, or even the pieces of film, is to make a filter to go over your electronic flash. This will filter your flash so that only infrared light will come out. This will allow you to photograph indoors more easily. In addition, your flash will be much less of a distraction because only infrared (or mostly infrared) light will come out.

Figure 12.9 An uncorrected infrared photograph taken with a filter equivalent to the Hoya R72.

Figure 12.10 This is the corrected version of Figure 12.9. The red was mostly removed, leaving just enough to give it a bit of warmth. The contrast was increased, and it was cropped slightly to straighten it. Since it was handheld, and the view is very dark through the filter, it is difficult to compose the scene exactly.

Lesson 12.3—Using a Customized Infrared Camera

The easiest way to do infrared photography is to use a camera that has been modified to photograph only in infrared. This is done by removing the infrared cutoff filter (also known as a *hot mirror filter*) that is attached over the image sensor and replacing it with an infrared filter that passes only near infrared light. The advantage is that the viewfinder can see normally, making it easy to compose the scene. Because the cutoff filter is removed, the exposure times are much shorter than when a filter is used on your lens. This permits handheld and even action photography. Exposure times are typically about one stop slower than with visible light photography instead of the six or seven stops or even more that is normal when using the lens filter.

You can convert your camera yourself if you are skilled and extremely careful. This is especially true if you are working on an old or very inexpensive camera. If you do an online search for "infrared camera modification" or "IR camera modification," you can find directions on how to do it yourself. It is not a task for the faint at heart.

You can also pay to have your camera modified, and there are several companies that do it. The Lifepixel Company (lifepixel.com) modified a Nikon D70 camera that the author purchased on eBay especially for that purpose. The conversion is not inexpensive. It starts at about $250 and goes up, depending on the camera brand. However, if you like infrared photography, using a converted camera is certainly the best and most convenient option.

When using a converted camera in color mode, there is a slight colorcast to the images. The modified D70 produces an image with a slight blue tone to it, as shown in Figure 12.11. Many people find that color pleasing as is. If you prefer black and white, you can adjust the image in Photoshop or Lightroom to produce the black-and-white image shown in Figure 12.12. For ideas on converting to black and white, see Chapter 1.

You can use an electronic flash with your camera because it emits infrared light. This will allow you to photograph indoors more easily or use for fill flash outdoors. You can make an infrared filter to go over your flash either with pieces of film from Lesson 12.1 or some of the plastic filter material if you purchased it for Lesson 12.2.

Figure 12.11 *An infrared image as it comes from the camera with a slight bluish tint.*

Figure 12.12 *This is the same image as Figure 12.11 except that blue has been removed and the contrast increased a bit more.*

Lesson 12.4—Simulating Infrared in Photoshop

The final way of generating an infrared look is to create one in Photoshop from your color digital image. This will not be a real infrared image, of course, but depending on the image and your Photoshop skills, you can get very close. Like most things in Photoshop, there are many ways of accomplishing this. This lesson will show one of the easier methods to get you started. For other techniques, do an online search of the web for "infrared Photoshop," which will turn up thousands of links. Besides these techniques, Photoshop CS3 has an infrared preset built in the new Black & White dialog box. In addition, there are plug-ins available for older versions of Photoshop that will create infrared images from color ones automatically for you.

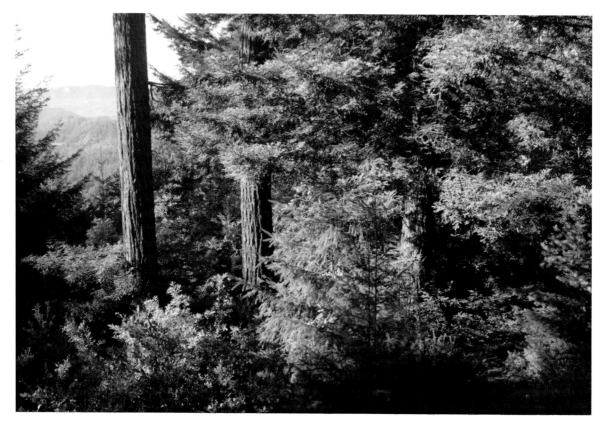

Figure 12.13 The original color image we will use.

Figure 12.14 The Channel Mixer dialog box pops up.

The first step is to open your image and create a new Channel Mixer layer (Layer > New Adjustment Layer > Channel Mixer Layer). The dialog shown in Figure 12.14 will pop up. Check the Monochrome box in the lower-left corner to get rid of the color. Since the green foliage in infrared images is very light, we want to move the slider for green to its maximum value. Balance it by reducing the blue and red sliders. Typically, the three values should add up to a total of about 100, but adjust them until they look good to the eye. Figure 12.15 shows that they were each set at 50% as the best value. Adjust Constant as shown in Figure 12.16 to change the relative lightness or darkness to your liking and click OK.

Figure 12.15 Maximize the green
channel and reduce the red and blue
channels to compensate in the Channel
Mixer.

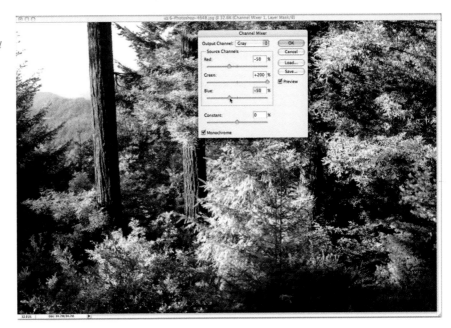

Figure 12.16 Adjust the Constant
slider to get the overall lightness or
darkness the way you like it.

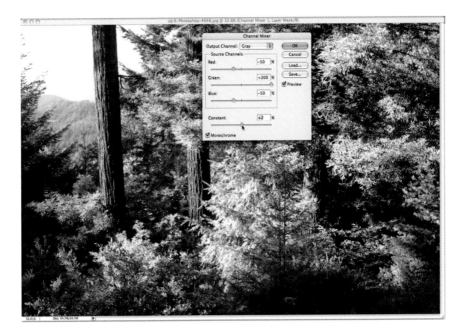

The image shown in Figure 12.17 is a good likeness to an infrared image. If you are trying to simulate infrared images generated from film, there is another step or two you can take to get a slightly different look.

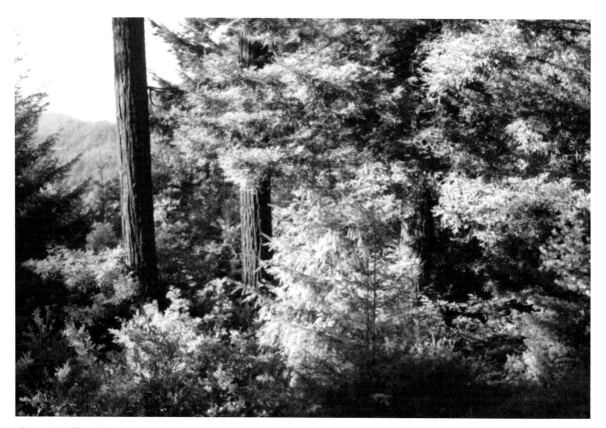

Figure 12.17 The resulting image.

Some films, such as Kodak infrared film, have a kind of a glow about them. To add this glow, flatten your image (Layer > Flatten Image). Create a duplicate background layer (Layer > Duplicate Layer). Blur this duplicate layer (Filter > Blur > Gaussian Blur). The dialog box shown in Figure 12.18 pops up. Experiment with different values to suit your taste. We chose 5.0 pixels to start with. Adjust the opacity in the upper right of the Layers Palette. We chose 35% to keep the glow from overwhelming the photograph. Once you are satisfied with the result, you can save the image in a PSD format so that you can adjust it later if needed. Figure 12.19 shows the completed images.

Figure 12.18 *Dialog box for the Gaussian Blur.*

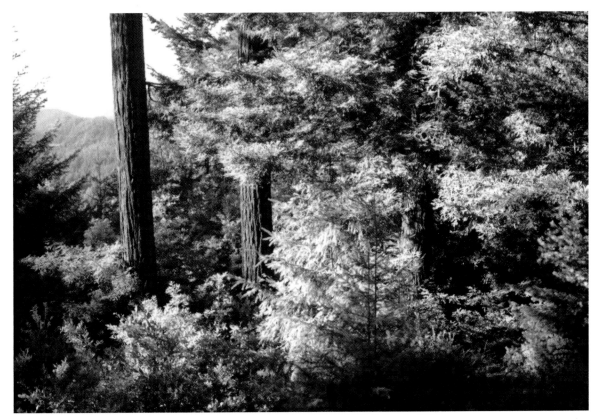

Figure 12.19 *The resulting image.*

For a final touch, you can add some film grain. First duplicate the duplicate layer (Layer > Duplicate Layer) and then apply the film grain (Filter > Artistic > Film Grain). The dialog box shown in Figure 12.20 pops up. Play with the settings until you like it. You can reduce the opacity of that layer in the same way as before if needed. Now save your PSD version, and you are finished. The final image is shown in Figure 12.21.

Figure 12.20 *The Film Grain Filter dialog box.*

Figure 12.21 *The resulting image with both blur and grain added.*

Comparison of Different Infrared Techniques

With this section you can quickly compare a number of different infrared techniques to see which appeal to you the most.

Figure 12.22 The original image in color.

Figure 12.23 An infrared image created with a filter made from one piece of transparency film.

Figure 12.24 An infrared image created with a filter made from two pieces of transparency film.

Figure 12.25 An infrared image created with a filter equivalent to a Hoya R72.

Figure 12.26 An infrared image created with an infrared converted camera.

Figure 12.27 The original color image was modified in Photoshop to simulate infrared.

Figure 12.28 The original color image was modified in Photoshop to simulate Kodak infrared with blur and grain added.

Gallery of Digital Infrared Images

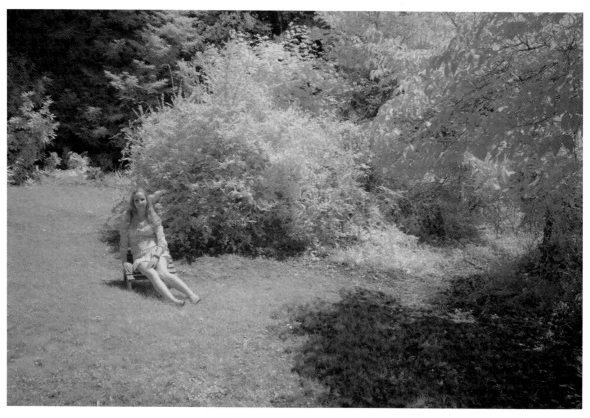

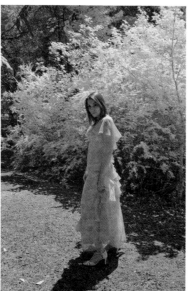

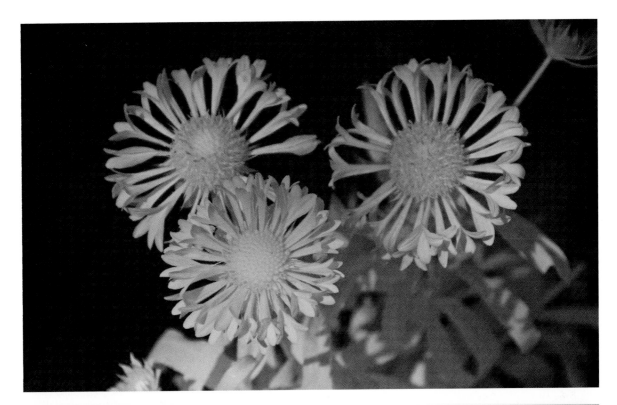

CHAPTER 13

NEOSYMBOLISM

THE WORK of the painter Paul Gauguin (1848–1903) is usually called *impressionism.* Some of his work appears to be different than other impressionists such as Claude Monet. This portion of Gauguin's work is flat and full of bright colors. This is especially true of his work done in Tahiti. It is this style of work that the author is emulating in this chapter. The author has named this style of work *Neosymbolism.* As you can see from the figures, it is quite different from most other types of photography.

Although it may be possible to create these works in Photoshop by starting with a normal-looking color original, all of the images in this chapter were created with a special function in the Sony Mavica FD7 (see Figures 13.1 and 13.2) or its little brother FD5 (the same camera with a shorter and much less useful zoom lens). Both of these cameras have a function known as "Pastel." Because of the lack of popularity of this function, it was dropped from later models of the Mavica line of cameras.

It is easy to see why this function was dropped. The images right out of the camera tend to be gray and lifeless (see Figure 13.3). The processed and retouched image shown in Figure 13.4 is much more interesting. Indeed, the author bought his first FD7 new (about $700), and it was two years before he even tried the function and another year before he began to experiment with pastel images.

The FD7 and FD5 have not been manufactured for about 10 years, but they are readily available on eBay in the $20 to $30 range. One interesting thing about these cameras is that they use floppy disks to store the images. If you have a floppy disk reader for your computer, you do not need any special software to download the images. Also, the images can be read equally well on a Mac or PC computer.

Figure 13.1 This is the front of the Sony Mavica FD7 that was used to create the images in this chapter.

Figure 13.2 This is the back of the Sony Mavica FD7 that was used to create the images in this chapter.

Figure 13.3 A sample image done in Pastel mode as it looks right out of the camera. You can see how dull and lifeless it appears in its original form. Compare this one to Figure 13.4 after it is processed.

Figure 13.4 The same image as in Figure 13.3 except that it has been processed and retouched.

One downside is that the images are quite small. They are only 300K pixels (0.3 megapixels). Each image is 640 × 480 pixels. This means that the images will require more work to print larger than about 3 inches × 2 inches. The author has successfully printed these images up to a size of 11 inches × 14 inches.

The first step before creating our Neosymbolism images is to get the exposure correct. This is not as easy as it seems at first glance. You really have to watch out for blown highlights in important areas.

The first step is to load a diskette and turn on the camera. Next, press the Picture Effect button on the lower left of the camera (see Figure 13.5). The first one to come up is Pastel. Keep pressing the button, and it will cycle through all the options.

Figure 13.5 The back camera controls.

Next, on the LCD screen in the lower-left corner are four control points shown in Figure 13.6 that are controlled by the big round button shown in Figure 13.5. If you don't see the four control points on the LCD screen, push the display button, and they should show up. The upper-left one is –EV, and the upper-right one is +EV. Pressing either one will vary the auto exposure up or down by one-half f-stop.

Figure 13.6 The LCD control points in the lower left of the LCD screen.

On your first photography outing, select your subject and start with –1.5 EV (three pushes with the round button once you highlight the –EV control). Then move up one-half f-stop by pushing the +EV control and take another picture. Continue all the way up to +1.5 EV. You now have seven images varying from each other by one-half stop, as shown in Figures 13.7 through 13.13. Look at the highlights on each image and notice the level at which they start to show. You want to select an image to work on that has the fewest blown highlights. In this case it is Figure 13.9, with an exposure of –0.5 EV. It won't always be that way. You have to select the exposure that works for a particular photograph.

To the extent possible, try to control the lighting so that it is even and without hotspots. The hotspots, either on your subject or on the background, will tend to blow out and make more work for you later.

One note about the flash: It is difficult to use without overexposing your subject. One trick is to put a small piece of black electrical tape over part of the flash to reduce its output. You can even put your finger over it as a temporary measure. By reducing the output and with practice, you have the ability to use the flash for a bit of fill flash in your photographs. There is no output to operate an external flash. You can use a second automatic flash on a flash bracket if you use a flash sensor to trigger the second flash. The small amount of light from the FD7's internal flash (reduced with the black electrical tape) will trigger the sensor, which will fire the automatic flash.

Figure 13.7 The photograph taken with −1.5 EV.

Figure 13.8 The photograph taken with −1.0 EV.

Figure 13.9 The photograph taken with −0.5 EV.

Figure 13.10 The photograph taken with 0.0 EV.

Figure 13.11 The photograph taken with +0.5 EV.

Figure 13.12 The photograph taken with +1.0 EV.

Figure 13.13 The photograph taken with +1.5 EV.

What are good subjects to photograph in this style? Colorful objects definitely work well. Take a look at the Gallery at the end of this chapter for some ideas. Skin usually photographs well, so portraits, swimsuits, and figure studies are good subjects. Tropical subjects have bright colors, so those also work well. Look to the impressionist painters for more ideas. There are online galleries and books available.

The next step is to remove the gray dull "coating" that seems to be on top of these images. There is only a hint of what is underneath, but it can be pulled out with the help of Adobe Photoshop, Adobe Photoshop Lightroom, or similar processing programs. Now you can move on to the following lessons to see how that is done.

Lesson 13.1—Neosymbolism—Creating in Lightroom

This is the easiest way to adjust these images quickly. If you don't have Adobe Photoshop Lightroom, you can download a free 30-day trial at www.adobe.com. Check the computer requirements to make sure your computer is supported. If you don't want to use Lightroom or can't, Lesson 13.2 will show you how to adjust the images in Photoshop (or Elements). In this lesson we are using Lightroom 1.1.

As always in Lightroom, you first download your images to your computer and then import them into Lightroom. Once they are downloaded, use Grid (hit G) to view and select your favorite. Double-click on an image (or hit E) to see it larger in Loupe mode. Use the Pick tool (highlight the image and hit P) to select your favorites and Reject (hit X) those that are out of focus or not to your liking. To change your mind about an image, Unpick it (hit U). In the filmstrip at the bottom, use filters to select just your picks (click on the left flag) and those not yet flagged (the middle flag). As you reject images, they will disappear from the screen but not be deleted. Use Cmd/Ctrl+Z to undo any flagging mistakes. Figure 13.14 shows the filter flags. You can also use the colored labels or the stars to filter and select images. Flags are local and seen only in that folder or collection. Color labels, keywords, and rating stars are global and follow the image everywhere.

Figure 13.14 The filters are set by clicking on the flags. The left flag (filled in) is for picks. The middle flag (hollow) is for images without a flag. The right flag (with an X in it) is for rejected images. Select the two left flags, and the rejects will disappear from the screen as you reject them.

Select your favorite image and hit D to go to the Develop module. You can also open the Module Picker at the top if it isn't open by clicking on the small triangle at the top center. When the Module Picker opens, click on Develop. Now your image should look like Figure 13.15. Notice that the image does not fill the screen because it is so small (only 300K pixels).

Now comes the fun part. Drag the contrast to the right, usually as far as it will go. Then adjust Brightness and Blacks to taste. Increase the Vibrance and Saturation also and move Clarity about halfway up. Once that is all done, click on the image to make sure it is at 1:1.

Now adjust Noise Reduction and Sharpening. You have to be at 1:1 in order to see the effects of the Noise and Sharpening sliders. The final settings are shown in Figure 13.16. Now go back to the Library (press E and it will take you back to the Loupe mode in the Library) and then Export your image if it is done (Export button or File > Export, or Shift-Command-E) or edit in Photoshop if you want to do some

retouching, in the gray background for example. To do that, select Photo > Edit in Photoshop (you will have two choices, depending on how you set your preferences). Figure 13.17 shows the final image before any retouching.

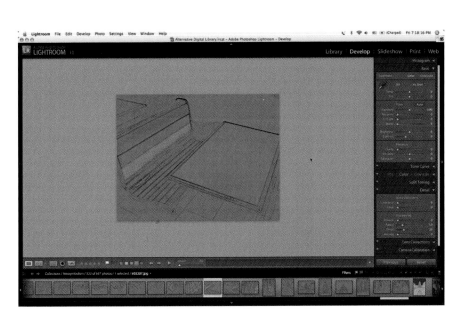

Figure 13.15 *The image is open in the Develop module.*

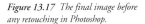

Figure 13.16 *The final settings.*

Figure 13.17 *The final image before any retouching in Photoshop.*

Lesson 13.2—Neosymbolism—Creating in Photoshop

In this lesson we will go over the adjustments if you are working in Photoshop or Elements. Even if you get the basic work done in Lightroom as shown in Lesson 13.1, it is likely that you will need to do some additional work in Photoshop to clean up some details. Figure 13.18 shows a regular color image taken by the FD7. Figure 13.19 shows the Pastel version of the image. Now open the image in Photoshop.

Figure 13.18 A regular color image taken by the FD7.

Figure 13.19 The pastel version of Figure 13.18.

There are a several different ways in Photoshop to get the same job done. The first is to simply increase saturation (Image > Adjustments > Hue/Saturation) as shown in Figure 13.20. The second method is to increase contrast and reduce brightness (Image > Adjustments > Brightness/Contrast) as shown in Figure 13.21. The third method is to increase saturation and reduce brightness in a sort of combination of the first two. This is shown in Figure 13.22. The fourth method is to adjust levels and curves to create what is seen in Figure 13.23. This is the technique that will be demonstrated here.

The first step is to decide how large you want the final image to be. Use Image > Image Size and choose Bicubic Smoother to enlarge your image to its final size. The more you increase the size, the more work you will have to do in retouching to smooth the jaggies and deal with pixelation. Next create a Levels layer. By putting it into a layer, this allows you to go back and make adjustments later. Figure 13.24 shows how to create the new layer. Click OK on the next pop-up box. Then the Levels adjustment dialog pops up (Figure 13.25).

Figure 13.20 The image after increasing saturation.

Figure 13.21 The image after increasing contrast and reducing brightness.

Figure 13.22 The image with increased saturation and reduced brightness.

Figure 13.23 The image after levels and curves were used.

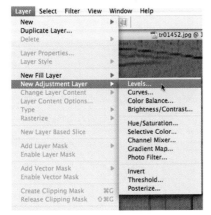

Figure 13.24 The Levels Layer menu.

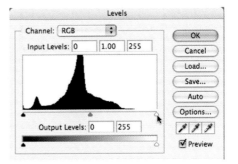

Figure 13.25 The Levels adjustment dialog.

Slide the right-hand (white) triangle to the left to the first black point on the curve. You would do the same on the left (black triangle), but this image has the black curve running to the left edge. Move the center triangle (gray) back and forth until you are pleased with the result. Figure 13.26 shows the Levels dialog after adjustment, and Figure 13.27 shows the resulting image.

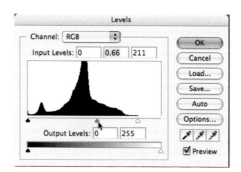

Figure 13.26 *The Levels adjustment dialog after adjustment.* **Figure 13.27** *The adjusted image.*

Now create a new Curves layer in the same way as the Levels layer was created. Figure 13.28 shows the Curves dialog box. Pull down the center point, push up the bottom quarter, and push up the top quarter to create a sort of S curve. Figure 13.29 shows the adjusted curve. Figure 13.30 shows the resulting image.

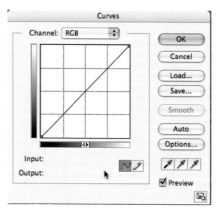

Figure 13.28 *The Curves dialog box.* **Figure 13.29** *The adjusted Curves dialog.*

Figure 13.30 *The resulting image after levels and curves have been adjusted.*

The next step is to retouch the image in places to make it look less pixelated. Be sure to save your image as you go along. Use the Pencil tool to draw in any heavy lines. If the lines are straight, you can use the Line tool. Adjust the color in the toolbar so that it is not pure black. A drawing tablet is often easier to use than a mouse or track pad. In Figure 13.31, just the main heavy lines have been drawn in. If you wanted to spend more time, you could also sketch in the finer lines as well.

The next stage is to decide if you like the mottled background. If you don't, there are a number of ways to change it. You can use the Art History brush and modify it (see Figure 13.32), or you can use the magic wand and select it all. Then use the Airbrush tool to paint in a different color, such as the dark brown shown in Figure 13.33. You could use the Smudge tool (looks like a finger pressing down) to smear it a bit (see Figure 13.34).

Figure 13.31 *The heavy lines have been drawn in.*

Figure 13.32 *The background has been changed by using the Art History brush to modify it.*

Figure 13.33 *The background is airbrushed to a dark brown after selecting with the Magic Wand and other tools.*

Figure 13.34 *The Smudge tool is used to smear the background.*

The final method used here was to change it to pure black by selecting the background (again with the Magic Wand and other tools) and then using the Airbrush with a large size and spraying just the background (see Figure 13.35). A bright pure color, black, or white will usually work best to show off the other bright colors.

Figure 13.35 *The background was selected and then airbrushed pure black with a large brush for this final rendition.*

Gallery of Neosymbolism Images

CHAPTER 14

SELECTIVE FOCUS

ONE OF THE WAYS to pull your photographs out of the ordinary is to adjust the focus over the image so that only some areas are in focus, and others are blurred. This can be done in Photoshop or Elements, and there are lenses you can purchase that provide a lot of focus flexibility. The most well-known of these lenses are the Lensbabies (www.lensbabies.com). A number of them are shown in Figure 14.1.

Figure 14.1 *This is the lineup of Lenbabies. From left to right, middle row (front row is lens caps): Original, Lensbaby 2.0, Lensbaby 3G; back row: macro lenses, telephoto, and wide-angle add on lenses. The funny shaped objects with the round gray film canister lids next to the Lensbabies are the tools and holders for the aperture disks for each of the Lenbabies.*

The differences between a normal photograph and a Lensbaby photograph are shown in Figures 14.2 and 14.3. Both images are straight from the camera without any adjustment. The Lensbaby photograph is using the Lensbaby Original. It produces a softer, dreamier look, similar to what you might get with a Holga or pinhole camera, than either the Lensbaby 2.0 or 3G. The Original uses a single-element uncoated glass lens. That is why you will get some flare (diffusion in the highlights) when using it. That is part of its charm.

The 2.0 and 3G models both use coated glass doublet lenses. This means that they are both sharper and faster than the Original. All of the Lensbabies use aperture disks that are inserted to use different f-stops. The 2.0 and 3G start at f2.0, and the Original starts at f2.8, one full stop slower.

Both the Original and 2.0 focus by pressing in or pulling on the flexible lens housing. The 3G is similar to the 2.0 except that the three knobs lock the lens in its bent position. This is a great feature if you are working on a tripod photographing still lifes. It allows you to adjust things until you get the image just the way that you would like it.

Figure 14.2 *An image straight from the camera without adjustments or retouching.*

Figure 14.3 *The same scene as in Figure 14.2, but the foot was photographed with the Lensbaby Original.*

If you use a digital camera that has been converted to infrared (see Chapter 12), you can use a Lensbaby on it. You can also use the film trick shown in Chapter 12 or purchase a 37mm infrared filter to create Lensbaby infrared images. There are a couple of example images in the Gallery at the end of this chapter.

Lesson 14.1—Photoshop and Blurring

One way to provide selective focus in your images is to use Photoshop to blur some areas and concentrate interest in other areas. Figure 14.4 is the Original image we are going to work on. It is a nice image, but it could use some work to give it some additional "pop." Jennifer has great eyes, and we want to concentrate more attention on them and less on her surroundings.

To start off with, open the image in Photoshop. Next, do any normal retouching that you would do on a portrait. On this image, we touched up under her eyes with the Clone and Heal tools. Next we used the Clone tool and Airbrush to tone down the two big hotspots behind her—they were too distracting. After we finished the retouching, we ended up with the image in Figure 14.5.

Figure 14.4 The original image that we are going to work on.

Figure 14.5 The retouched image ready to blur.

Now we are ready to start the blurring process. The first step is to create a snapshot. You do this by clicking on the camera icon in the bottom of the History Palette as shown in Figure 14.6. To display the History Palette, go to Window > History. Snapshot appears at the top of the History Palette. Click on Snapshot, and the icon to the left of it will move from the upper figure to the new Snapshot (Figure 14.7). Now click on the Background layer in the Layers Palette (display the Layers Palette by selecting Window > Layers).

Select the Eraser tool. In the top Eraser tool menu, click on the Erase to History box (see Figure 14.8). This will work only if you have created a snapshot, selected it to be the history source, and then clicked on the Background layer to work on it. If you made any changes to your image after the snapshot, then you may have to create a new snapshot and start again.

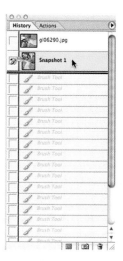

Figure 14.6 Create a snapshot by clicking on the camera icon in the bottom of the History Palette.

Figure 14.7 Click on Snapshot, and the icon to the left of it will be selected. Next, click on the Background layer below in the Layers Palette.

Figure 14.8 Select the Erase to History function in the Eraser menu.

Now you are ready to blur the image. Go to Filter > Artistic > Blur > Gaussian Blur as shown in Figure 14.9. In the pop-up menu (Figure 14.10), choose an appropriate strength of the Gaussian function. In this case we chose a radius of 7 pixels, but you should choose what works for your image and taste. It is also dependent upon the size of the image.

Figure 14.9 *Select the Gaussian Blur command in the Filters menu.*

Figure 14.10 *The Gaussian Blur pop-up menu.*

The image is now blurry. We are going to use the Erase to History tool to remove the blur in critical areas. Set the opacity in the tool menu bar to something low such as 30% or even lower, and select a brush size as we did in Figure 14.11. In this image, touch the eyes and the lips a couple of times and click. Each time you do, you remove 30% (or whatever you chose for the opacity). Then sweep the edge of the face to sharpen the hairline a bit. Maybe sweep once through the hair. You blend and layer it by sweeping through smoothly with Opacity set low. If you can see the overlapping marks, undo what you have done (click Cmd/Ctrl+Z or Edit > Undo or click back through the History steps), dial down the Opacity, and start again.

Ideally, the eyes and lips are 100% (you can't do more than 100%, no matter how many times you hit the eyes and lips with the Eraser); the nose and face are 70%, the hairline 30 to 50%, the hair 30%, and so on. The Eraser tool is erasing the layer of blur you put on top of the figure and is revealing the sharp image underneath. When you are finished, you have the image shown in Figure 14.12.

Figure 14.11 *This shows how large the brush is as we begin to erase the blur on parts of the face and hair.*

Figure 14.12 *The completed image.*

Lesson 14.2—Lensbaby 2.0 and 3G

The Lensbaby is one of the more fun photography tools to use. The results are often unpredictable, which adds a nice touch to the somewhat sterile world of digital photography. The processes of focusing and exposure are more hands on than other types of digital photography, too.

First, put the Lensbaby on your camera just like any other lens. With a Lensbaby, the exposure may be set manually or using aperture priority, depending on your camera. If you are setting the exposure manually, you change exposure by adjusting the shutter speed and ISO setting. The f-stop (aperture) for the lens is set by changing the aperture disks for the lens. A good starting point is to leave the one that it arrives with installed (f4 for the Original) so that it is easiest for someone just starting out to focus. Then you just look for the sweet spot of sharpness and move it around by turning the flexible lens and pushing it from side to side.

You also pull it in and push it out at the same time to do the actual focusing. It takes a bit of time to get comfortable with it, and then the squeezing, pushing, and pulling of the lens become almost second nature.

Figure 14.13 shows the first attempt, and the sweet spot of focus missed Laura's face. You can see it is sharp in the background in the top right. The next attempt is shown in Figure 14.14. This time the sweet spot was correctly placed on her face. Once you have that down, you can choose the f2.8 aperture for a more impressionistic, softer look, or you can choose f5.6 or f8 for a sharper image with soft edges.

Another thing to watch out for as you move the focus spot around is that you don't bend the lens too far. If you do, you will vignette part of the image as shown in Figure 14.15. The black band at the bottom is caused by bending the lens too far upward.

Figure 14.13 The sweet spot of focus missed her face and ended up on the background in the upper right.

Figure 14.14 The second attempt is much better, and the sweet spot was correctly placed so her face is in focus.

Figure 14.15 The lens is bent too far upward, and a black band of vignetting is created across the bottom of the image.

For more variations, you can use the wide-angle, telephoto, and macro lens attachments that are available separately (see Figure 14.1). Figures 14.16, 14.17, and 14.18 show the different views available with the wide-angle and telephoto attachments. If you are going to use the Lensbaby very often, these are handy to have when you can't get closer to or farther away from your subject.

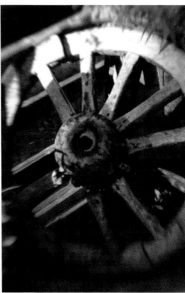

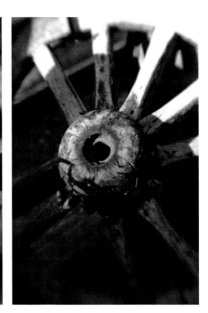

Figure 14.16 This was taken with the wide-angle attachment on the Lensbaby Original.

Figure 14.17 This was taken with the Lensbaby Original without any attachments.

Figure 14.18 This photograph was taken with the Lensbaby Original with the telephoto attachment mounted on the front of the lens.

The final attachment is the set of two macro lenses (a +4 and a +10). You can get some macro effect (closer focusing) by simply pulling on the front of the Lensbaby instead of pushing to focus. This has its limits as to how close you can focus. Using one of the two-macro attachments allows you to get much closer, as close as two inches. In addition, any 37mm attachment or filter can be used on the front of any of the Lensbabies. Several of the close-up images in the gallery were used with the macro lens attachments.

Lesson 14.3—Lensbaby Original

The other two Lensbabies, 2.0 and 3G, have the same optics. They use a coated doublet lens that is sharper than the single uncoated lens that the Original uses. The main difference between the 2.0 and 3G is that the 3G has locking knobs so that the focus point and adjustments can be locked into place. This is especially useful if you are working on a tripod photographing still-life subjects. This allows finer adjustments to both the focus and the subject. It depends on the type of photography that you do as to whether you would prefer the Lensbaby 2.0 or 3G.

Figure 14.19 shows an example of an image photographed with the Lensbaby Original, and Figure 14.20 was photographed with the Lensbaby 2.0. Both images used the f4 aperture ring that comes preinstalled in the Lensbabies. The second image is much sharper than the first one, yet both have the soft edges.

Figure 14.19 *This image was photographed with a Lensbaby Original with the f4 aperture ring installed.*

Figure 14.20 *This image was photographed with the Lensbaby 2.0 with the f4 aperture ring installed. It is much sharper than the previous image.*

Figures 14.21 and 14.22 are further examples of the differences between the Original and 2.0. In Figure 14.22 you can see how much overall softness there is in the image compared to Figure 14.21. In fact, much of Figure 14.22 looks almost impressionistic. This is the main factor in deciding if you should use the Lensbaby Original or the Lensbaby 2.0 for a particular photograph. If you enjoy using the Lensbabies, then the addition of the telephoto and wide-angle attachments will be useful. Sometimes you cannot get far enough way or close enough to your subject to compose the scene as you'd like. Cropping the image will change the amount that is sharp versus the amount that is blurred. Using either of the attachment lenses will give you more options.

Deciding between the Lensbaby 2.0 and 3G has a lot to do with the types of subjects that you photograph, as well as your working style. Photographers that work slowly and deliberately and who need a lot of control over what they do will favor the 3G over the 2.0. Those who prefer to work more quickly and freely will more than likely enjoy the 2.0 more than the 3G. If you work both ways from time to time, you will benefit from having both Lensbabies in your camera bag.

Figure 14.21 The flowers are photographed with the Lensbaby 2.0 in this figure. Compare it to the softness of Figure 14.22.

Figure 14.22 This photograph was taken with the Lensbaby Original. It is much softer than Figure 14.21.

Gallery of Selective Focus Images

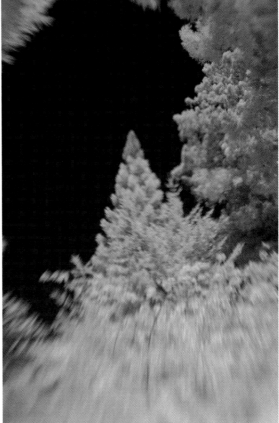

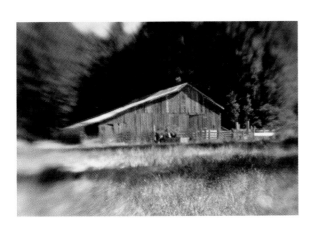

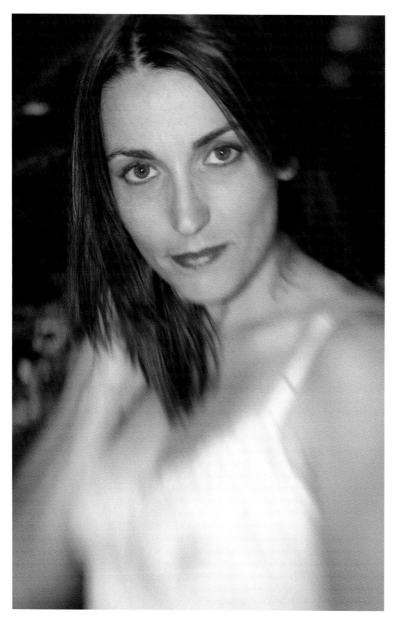

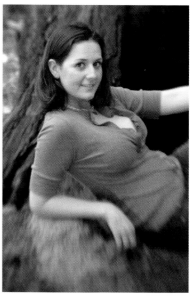

CHAPTER 15

Neomysticism

NEOMYSTICISM is a term coined by the author to describe a kind of soft focus image produced by the Holga, Diana, and similar types of Chinese-made plastic film cameras that use 120 size film (see Figure 15.1). They produce negatives that are 6cm × 4.5cm or 6cm × 6cm, depending on which insert is used. These plastic cameras have plastic lenses and an overall cheap construction that adds to the randomness of the results. The cameras were designed to be giveaway items. They were discovered by artists about 40 years ago and have been very popular since.

Figure 15.1 This is a Holga plastic film camera, popular for use by artists.

Now that the digital age is here, photographers want the same results in a digital format. Of course, photographers can and do use film and then scan the negatives, producing results similar to Figure 15.2. This chapter will show you how to produce similar images without the use of film. Lesson 15.1 will show you how to use Photoshop to produce a Neomystical image. Lesson 15.2 will show you how to use the lens from a Holga camera on your digital camera.

Figure 15.2 *This is a photograph taken with a Holga camera. The negative was scanned to produce this image. The film marks were left for artistic effect.*

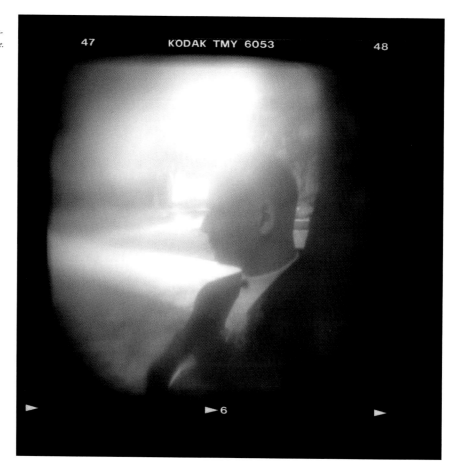

Lesson 15.1—Photoshop Techniques

This lesson will show you how to create images that look similar to those produced by Holga cameras. In this lesson you will be starting with a digital image and using Photoshop. First we need to determine the characteristics of a Holga photograph. Since it has a plastic lens, a Holga photograph tends to be soft and have flare in the highlights. Depending on the film insert that is used, the image may have vignetting that gives it dark edges. These are the things we need to look at as we work on our image.

Figure 15.3 is the image we will be working on. After opening the image in Photoshop, we see that the image needs some minor retouching done to smooth the skin. Next we duplicate the Background layer as shown in Figure 15.4 (Layer > Duplicate Layer). With that new layer selected, we add Gaussian blur, which is shown in Figure 15.5 (Filter > Blur > Gaussian Blur).

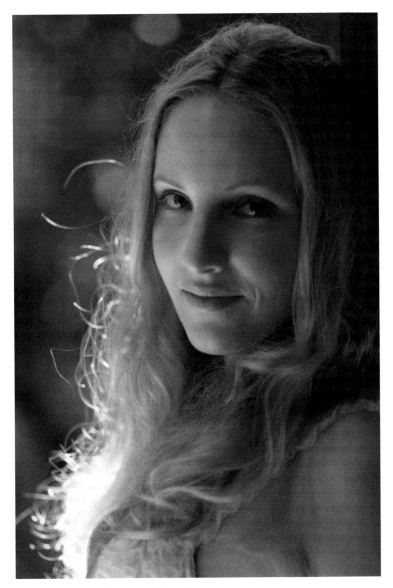

Figure 15.3 The original image we will be working on.

Figure 15.4 Duplicate the background layer.

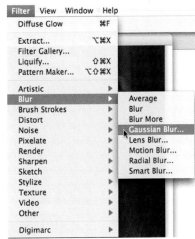

Figure 15.5 Select the Gaussian Blur filter.

Now the Gaussian Blur menu pops up (see Figure 15.6). Set a good amount of blur—we used 30%. The amount that you use will depend on your image and your taste and style.

Next adjust the opacity of the blurred layer. Here it was set to 54% (Figure 15.7). Now we just have to darken the corners with the Burn tool. Select the Burn tool (Figure 15.8) and choose an Exposure setting (Figure 15.9). Here we used 35%, but you may need to experiment to find what works. You may also need to vary it as you work on the corners.

Also shown in Figure 15.9 is the selection of shadows, midtones, and highlights. Work through each of them and burn in the corners until it looks like the Holga image. The final image is shown in Figure 15.10.

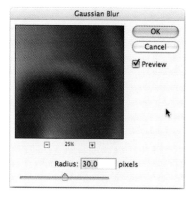

Figure 15.6 The Gaussian Blur menu pops up.

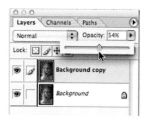

Figure 15.7 The opacity of the blurred layer is changed to 54%.

Figure 15.8 Select the Burn tool.

Figure 15.9 Select Range and Exposure for the Burn tool.

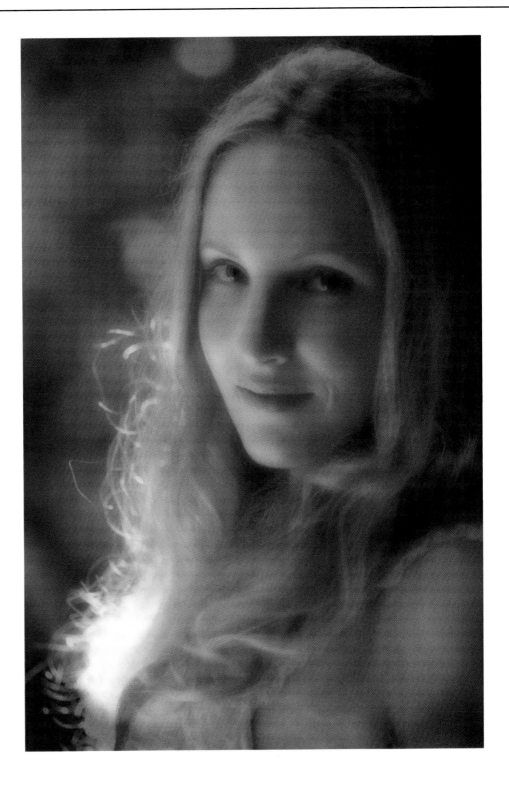

Figure 15.10 *The final image is modified to look like a Holga photograph.*

Lesson 15.2—Using a Holga Lens

One way to get the look of a Holga photograph is to put a Holga lens on your camera. You can purchase a Holga camera, buy a body cap that fits your particular digital SLR camera, cut the lens off of the Holga, cut a hole in the body cap, and glue the lens to it. It is a little more involved than that, but those are the basic steps. If you search online for "digital Holga," you can find detailed directions to do it yourself. Or you can take the easy way out and buy one premade. You can find them online at holgamods.com. The Holga lens used here from holgamods.com is shown in Figure 15.11.

Figure 15.11 A Holga lens from holgamods.com.

The lens attaches to your digital SLR like a normal lens, but since it is built on a body cap, it doesn't lock into place. Depending on your camera, it could be a loose or a tight fit. You have to hold it in place as you focus the lens. The focus scale shows four icons. The single person is equal to three feet, two people icon means six feet, the group of people means nine feet, and the mountains icon stands for infinity. The lens has an approximate f-stop of f8, but it varies by camera. Depending on your camera, you may find that manual exposure is the best solution. You can control the exposure with the shutter speed and ISO setting. Using the "Sunny 16 rule" (exposure = 1/ISO at f16 on a sunny day), a good starting point is a shutter speed of 1/400 and an ISO setting of 100 on a sunny day. Experiment and vary the settings a little in each direction until you are satisfied with the results. Your lens may vary from f5.6 to f11.

If you want the vignetting that is characteristic of the 6 × 6cm version, cut a rough hole in the lens with a sharp knife (be careful not to cut yourself!). You don't want a smooth hole such as one that is cut by drilling. You can experiment with cutting holes in a piece of cardboard to see how large you want the hole. The smaller the hole, the more the lens will vignette, and the less light will get in. In our lens cap we cut a hole about one-quarter inch across (see Figure 15.12). It made the lens one full stop darker, so we have to use a faster ISO or slower shutter speed when we use the cap. You can cut the hole directly in the center, and then your vignetting will be centered. If you cut the hole off-center, the vignette will be off center. This works well for portraits, but it means that you have to constantly adjust it when you focus, as the vignette will move around.

Figure 15.12 The Holga lens cap with a hole cut in it to provide the vignetting.

Figure 15.13 shows a photograph created with the Holga lens. Figure 15.14 shows a photograph with the lens cap on and the hole off-center. You can see the vignette effect strongly in the second image. Figure 15.15 shows a portrait that uses the off-center vignette better. There are more examples in the Gallery section.

Figure 15.13 This image was made with the Holga lens on the camera.

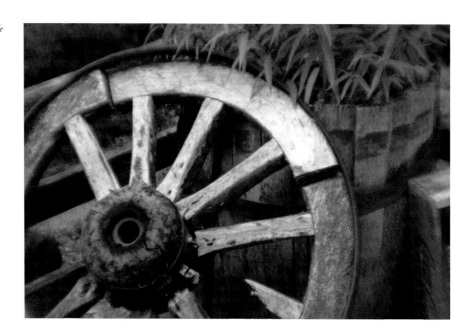

Figure 15.14 This image was made with the Holga lens and the lens cap on. The lens cap has an off-center hole in it.

Figure 15.15 This portrait used the off-center vignette to better advantage.

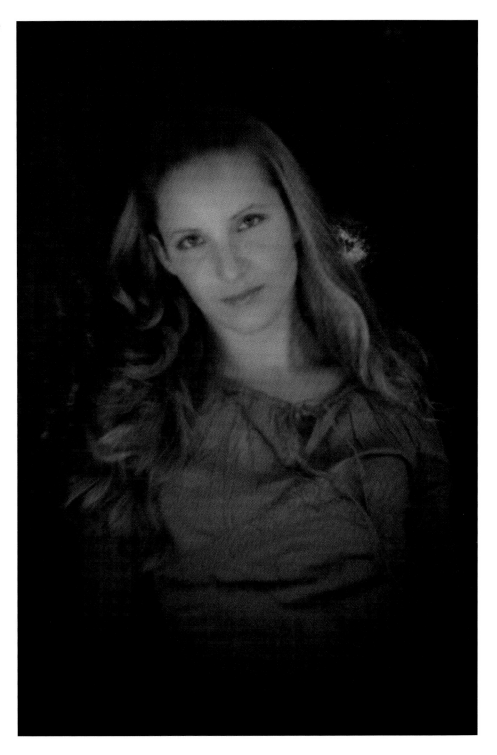

Gallery of Neomysticism Images

 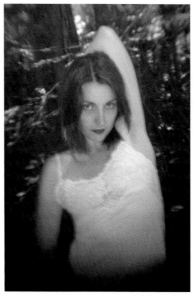

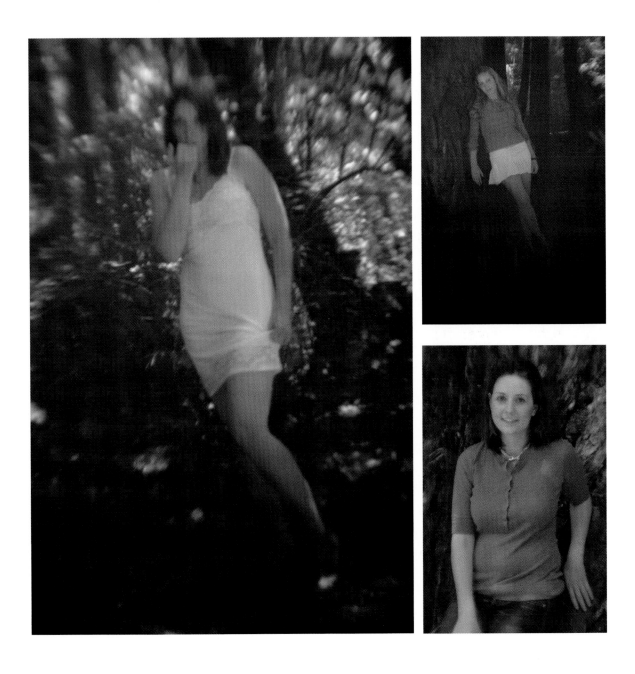

CHAPTER 16

Digital Toy Cameras

Using a Digital Toy Camera

for photography has to be one of the most fun chapters in this book. Most of the cameras have only a few controls such as an on and off button, a shutter release, and a few settings. They have a generally low quality image that is combined with unpredictable results and automatic functioning. This means that you are always excited to look at what you have taken to see what might have turned out.

What is a digital toy camera? It is a camera that has an image size usually about 1.3 megapixels or less, and usually more like 300K pixels. The lens quality is generally low, so they have a tendency to flare in backlit situations. The final criterion is that they are inexpensive: generally $20 or less. In fact, most of these cameras were purchased online, and the price varied from $8 to $31 including tax and shipping and handling. It is not very expensive to get started in the digital toy camera field. Figure 16.1 shows the author's collection of digital toy cameras. Some of the cameras have been discontinued and are only available used. You can find more detailed information, such as where you can buy them, at the author's website: johngblair.com.

Figure 16.2 shows two cameras that are either a little pricier or have more exposure controls, but still have a small image size. The Sony Mavica FD7 is used elsewhere in this book for other artistic functions. New it sold for $700, but today it can be purchased used for $25 or so on eBay (including shipping and handling). It has a lot more controls than the other digital toy cameras, and it has an LCD viewing screen for a viewfinder. It also has a zoom lens that none of the other cameras have. The Rolleiflex MiniDigi (a miniature digital replica of a Rolleiflex twin-lens film camera) produces a square image and has a miniature LCD screen for a viewfinder. It costs about $200. The quality of its images places it in the digital toy camera arena even though it is 3 megapixels. Both of these cameras are very fun to carry around and use.

Figure 16.1 This is the author's collection of digital toy cameras, which continues to grow.

Figure 16.2 Two more cameras in the author's collection: the Sony Mavica FD7 and the Rolleiflex MiniDigi. Both of these are on the edge of the definition of digital toy cameras, but they are also among the most fun to use.

The next question is how to get the images from the camera to your computer. Seven of the 17 cameras will work with a Mac. The other 10 are PC only. Six of the cameras will use MMC cards, SD cards, or diskettes. A card reader on a Mac or a PC can read some of the cards. Other times, the photographs are recorded in a special format, and you must use the camera manufacturer's software and download from the camera anyway. Most of the cameras will come with software if they are purchased new. If you purchase a camera used without the software, an online search may lead you to where it can be downloaded. Most of the cameras have a software driver designed just for that camera. If you end up with a number of different cameras, then you will also have a lot of software programs to keep track of.

Mac users may be able to run Windows on their Mac. If they have a new Intel Mac, they can run Parallels Desktop or Bootcamp (free beta software from Apple), which sets up a virtual PC on their Mac. Older Macs may be able to run Virtual PC with varying degrees of success, which emulates a Windows PC computer. Some special Mac drivers have been written, for example for the JamCam even though the cameras were discontinued a number of years ago. If you are a Mac user, you can buy a used PC laptop or desktop computer to download the photographs and then transfer to a small drive. The author paid about $100 for a used PC laptop at a local computer-recycling center. Then he used an old Microdrive and card reader to transfer the images from the PC to his Mac.

The toy cameras can be used for fun and for creativity. They can even be used for client photography if the presentation is done creatively. Figure 16.3 is a sample image from one of the toy cameras for a wedding client.

Figure 16.3 A sample image from one of the toy cameras for a wedding client.

Lesson 16.1—Dealing with Toy Camera Characteristics

There are a number of issues to deal with when using toy digital cameras. The first issue is the lack of a true viewfinder. Most of the cameras do not have an LCD screen, and so you must contend with the optical viewfinder. In some cases, where you put your eye will change what you see through the viewfinder. Other cameras request that you hold the camera about 12 inches from your eye. It is sometimes difficult to get accurate composition. Figure 16.4 shows some of the resulting images from the problem viewfinders. Still, one of the endearing features of digital toy cameras is their unpredictability. Be sure to test your cameras carefully after you get them. The digital toy cameras have a tendency to go through batteries (typically AAA batteries) fairly quickly. Be sure to download your images right away as they are often only kept in memory. When the batteries die, the photographs may be lost. Remove the batteries after downloading the images if your camera uses them quickly. Some cameras will work fine on rechargeable batteries and others do not like the lower voltages typical of the rechargeables.

Figure 16.4 Two images from toy cameras where their viewfinders do not line up exactly with the camera lens.

One of the next issues to deal with is camera movement. The cameras usually adjust their exposure by varying the shutter speed. The typical range of shutter speeds on some of the cameras that will tell you the information is from 1 second to 1/1000 of a second. There is no warning if the speed becomes somewhat slow. You just have to anticipate this based on the light levels. Hold your camera steady, which is difficult to do with these really small cameras, or brace it against a wall, post, or other object. Or just let it be one of the interesting features of your camera and purposely twist or move your camera as you photograph. Look at the example images in Figure 16.5. Which are accidental and which were done on purpose?

Figure 16.5 Camera movement caused these distortions. You can exploit this for artistic effect or brace the camera better to eliminate it.

In general, toy digital cameras do not handle backlighting situations too well. Their automatic exposure is fooled by the backlight and makes the image too dark when it averages the scene brightness. Try to eliminate as much backlight as possible. In Figure 16.6, the backlighting can be seen in the blown-out portions of the background. To average that, the camera reduced its exposure, which made the subject too dark. By simply turning the camera slightly, the brightly lit background is eliminated. When the camera averages the light to calculate the exposure, it does not have the bright background to take into effect, so the subject shown in Figure 16.7 is more properly exposed. Both of these figures are direct from the camera without any adjustments in post processing.

Another problem is the lack of consistency of the color due to the cheap electronics. These images can be left as is, or they can be color corrected in post-processing if desired. Figure 16.8 shows the color variation of two photographs taken only moments apart with the same digital toy camera.

Sometimes you will get digital artifacts in your images such as those in Figure 16.9. If this happens occasionally, then that is just one of the interesting and quirky things about digital toy cameras. Check your battery to make sure it is seated properly. That

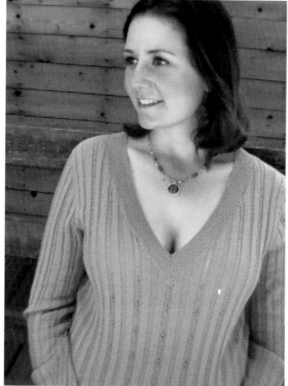

Figure 16.6 The camera's exposure system is fooled by the bright background that is averaged into the exposure. This makes the subject too dark.

Figure 16.7 By turning slightly, the too bright background is eliminated, and the camera's exposure calculation is much better, as shown here.

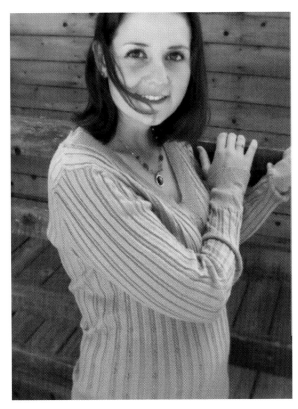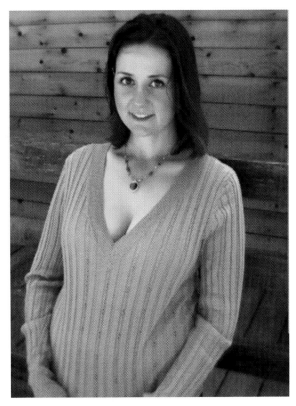

Figure 16.8 *The color varies from photograph to photograph even using the same camera. These two images were taken moments apart and are straight from the camera without any post-processing.*

Figure 16.9 *Sometimes you may get digital artifacts such as these in your image. It could be a one-time situation, or your camera may be damaged or dying. Luckily, these cameras are cheap!*

is about all you can do. If you have a loose connection or a camera that is damaged, you just have to replace it unless you are handy with tools and want to take it apart and play with it.

One of the final issues to deal with is the flare that is produced by the poor-quality optics. Some of these cameras have plastic lenses. Some have single instead of double lenses. Many times the optics will not be coated. All of these conditions increase the likelihood that your camera will suffer flare in the highlights like those in Figure 16.10, depending on the angle at which the light strikes your subject. If you want to avoid flare, and not everyone does, make sure that the light is more or less behind you and does not strike the camera lens directly. If you like the flare, then you need to choose a camera that suffers from flare more often and use lighting conditions that promote it.

Figure 16.18 *You may likely get flare under the right conditions due to the cheap nature of the optics of toy digital cameras.*

Gallery of Digital Toy Camera Images

CHAPTER 17

Color Negative

THE FINAL ALTERNATIVE digital technique is called Color Negative. This can produce a pretty interesting series of colors in your image when all of the colors are reversed. We are not used to seeing these colors even when looking at color negatives because color film has a built-in orange color mask applied (see Figure 17.1). This color negative technique looks like our color film negatives with the orange mask removed.

We will cover two ways to get this color negative effect in the following lessons. The first way is to reverse the colors in Photoshop or a similar image-processing program. The second method is to use a camera that produces the color negative effect directly from the camera.

Some of Sony's Mavica digital cameras offer this capability. If you purchased a Sony Mavica FD7 for use in Chapter 13, "Neosymbolism," or in Chapter 16, "Digital Toy Cameras," then this is another place you can use it. Other digital cameras may offer this color negative feature also.

Figure 17.1 This is a color film negative. Notice that it looks quite different from a color negative image with the orange mask removed in Photoshop, such as the one in Figure 17.2.

Figure 17.2 The same image with the orange mask removed in Photoshop is a lot more interesting.

Figure 17.3 This is another view of the same scene as the chapter opening image shows. This one is shown in regular color. The Sony Mavica FD7 camera took both images, and both are 640 × 480 pixels, which is 0.3 megapixels.

Lesson 17.1—Color Negative with Photoshop

You can create the color negative style of images pretty easily in Photoshop. Start off with your original image and open it in Photoshop. We will use the image shown in Figure 17.4. Next invert the colors of the image with the Invert command (Cmd/Ctrl+I or Image > Adjustments > Invert) as shown in Figure 17.5. The resulting inverted image is seen in Figure 17.6. It is pretty light and needs to be darkened to be really effective. Although the Curves function is usually a good way to adjust images, in this case the Levels command seems to be better to get the job done.

Figure 17.4 The original image that we will be working on.

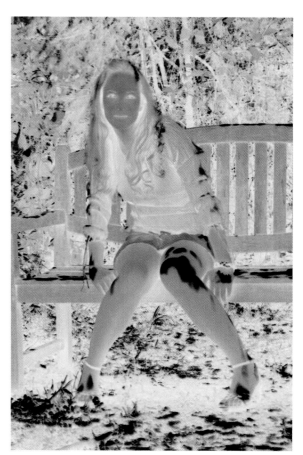

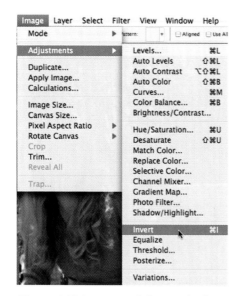

Figure 17.5 *The Invert command selection in Photoshop.* **Figure 17.6** *The resulting inverted image.*

Figure 17.7 shows how to call the Levels function. It is best to do it as an adjustment layer so that you can modify it until you get it exactly right. Select Layer > New Adjustment Layer > Levels. The Levels dialog box pops up (see Figure 17.8). Move the right triangle (the white triangle) to the edge of the main black curve (as seen in Figure 17.8). Then do the same for the left triangle (the black triangle). In this case, the black triangle does not need to be moved.

Now adjust the middle gray triangle until the colors are deep, as seen in Figure 17.9. This usually happens when the gray triangle is placed in the middle of the large black mass at a kind of balance point. This balance point means that the total mass of the figure is balanced on the gray triangle. This is a good starting point. The final figure is shown in Figure 17.10.

Figure 17.7 Calling up the Levels function.

Figure 17.8 The Levels dialog box pops up. The right triangle (white triangle) is being adjusted to the edge of the main black curve.

Figure 17.9 Adjust the center gray triangle until the colors are deep.

Figure 17.10 This is the final resulting image after the adjustments have been made.

Lesson 17.2—Color Negative with a Digital Camera

As mentioned at the beginning of this chapter, some digital cameras such as many in the Sony Mavica line have a color negative function. You simply set a control, and you can photograph and generate the images without having to use the Photoshop technique shown in Lesson 17.1. The reason that this is useful is not that the Photoshop technique is so difficult, but rather that not all subjects are as suitable for this technique. With a Mavica (shown in Figure 17.11) or similar camera, especially those with electronic viewfinders, you can see the result before taking the photograph. Figure 17.12 shows a color image of the scene that looks nice. The color negative version shown in Figure 17.13 is just not that interesting compared to the other images we have seen.

If you are using a Sony Mavica similar to the FD7, you first must call up the color negative function. Figure 17.14 shows the back controls of the FD7. Other versions of the Sony Mavica camera with higher resolutions are available. Many have been discontinued for some time but are available used on eBay or similar locations. These cameras tend to be fairly inexpensive. The FD7 came out in 1997 and can be purchased on eBay for around $25 or so. Other Mavica models are somewhat more expensive, depending on their features.

Turn on the camera. Press the Picture Effect control shown in Figure 17.14 twice. The negative function (called Neg. Art on the display) will show up. Since the FD7 has an electronic viewfinder, you can now compose your image and see what you will get.

Figure 17.11 *The Sony Mavica FD7. Other versions of the camera with higher resolutions are available used as well.*

Figure 17.12 *The regular color view of a portrait scene.*

Figure 17.13 *The color negative version of the same portrait scene. It is just not as interesting as earlier color negative images.*

Figure 17.14 *The back controls of the Sony Mavica FD7. Other Mavica cameras will have similar controls.*

As a side note, this feature is handy to look quickly at color negatives on a light table or held up to a window to see them more easily.

In the lower part of the LCD screen you should see the controls in Figure 17.15. If you don't see them, press the Display button until you do. When you see them, use the large round button to highlight the –EV or +EV to change the exposure adjustment that is applied to the automatic exposure. It is adjustable in half-stop increments from –1.5 EV to +1.5 EV, where 0 EV means no adjustment to the automatic exposure. You can watch the image through the electronic viewfinder and adjust it until you like the general exposure. The exposure will darken as you give it a higher EV number and lighten as you reduce it.

Figure 17.15 Adjustments to the automatic exposure are shown on the LCD screen. If they aren't shown, press the Display button.

Figure 17.16 shows a normal exposure with no adjustment. Figure 17.17 shows a –1.5 EV and Figure 17.18 shows a +1.5 EV. Figure 17.18 appears to have richer colors and is therefore more desirable. Once you get the hang of it, the adjustments can be made very quickly. In general you will find that you are darkening the images more often than lightening them. The dark, rich colors help to give the technique its cool look. You may even find that a bit more darkening in Photoshop with the Levels function or Curves function will help some images reach their full potential.

Figure 17.16 A normal exposure
with no adjustment to the automatic
exposure function.

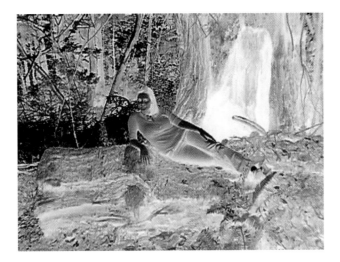

Figure 17.17 An adjustment of –1.5
EV is applied to the exposure.

Figure 17.18 An adjustment of +1.5
EV is applied to the exposure.

Gallery of Color Negative Images

APPENDIX A

GLOSSARY

THERE ARE AN incredible number of terms used in digital photography. Here are the definitions of many of them.

35mm camera: A popular camera size that uses 35mm film cassettes. Standard lenses for digital cameras are often compared to the same size lens on a 35mm film camera and called "35mm camera equivalent."

abstract: A type of photography without detail, but which is different from photoimpressionism. *See* photoimpressionism.

accessory shoe: The shoe on top of the camera that is designed to hold electronic flashes or other accessories. Most accessory shoes on modern cameras have built-in contacts for an electronic flash. *See also* hot shoe.

ambient light: The natural, existing light around a subject that is available without the photographer having to add more. It can be indoors or outdoors.

aperture: The opening in the lens that the light travels through on its way to the sensor. The size of the opening is controlled by the camera settings and can be larger or smaller to let in more or less light. A number such as f5.6 indicates the size of this opening. *See also* f-number.

aperture priority: A setting on the camera where the photographer sets the aperture desired, and the camera automatically sets the shutter speed. A photographer uses this setting when he wants to control the depth of field by making it larger (more area in focus) or smaller (less area in focus).

application: The software used on a computer. In digital photography, it is more specifically the software used to transfer the images from the camera to the computer, to process the images, and to save them in a more permanent form.

artifact: An unwanted destruction or modification of a pixel or group of pixels that shows up in an image. It is often in the form of small, multicolored halos or other patterns in a photograph.

artificial light: Any light that is not natural (from the sun). It can be an electronic flash, floodlights, or any other man-made lights.

ASA: American Standards Association. Although this organization sets standards for all kinds of products and measurements, in photography the term referred to the speed or sensitivity of film. It is no longer used and was replaced by "ISO."

aspect ratio: A number such as 3:2 that represents the length of a photograph divided by its width. Some digital cameras and 35mm film have an aspect ratio of 3:2, and other digital cameras and computer monitors have a ratio of 4:3.

autofocus: A feature on most digital cameras by which the camera will determine the correct focus.

automatic aperture: Means that the camera will determine the correct aperture for the photograph. The aperture remains open (brighter) until the shutter is pressed, at which time it closes to the correct size to take the photograph.

automatic camera: A camera that selects a combination of shutter speed, aperture, and focus to produce a photograph.

automatic exposure (AE): Also called "autoexposure." The camera selects a combination of shutter speed and aperture settings based on its programming and the settings selected by the photographer to create a proper exposure. This "proper exposure" is not necessarily the "best" exposure in any situation. Typically, the more expensive the camera, the more sophisticated the camera's programming and the more easily it can handle difficult lighting situations. Even the most expensive and most sophisticated camera requires interpretation on the part of the photographer to create the desired image.

automatic flash: An electronic flash that connects to a camera and sends information back and forth to select the proper amount of light to match the camera's settings. Like automatic exposure, automatic flash needs the input of a photographer to provide the best results.

automatic lens: Remains open, set on its widest aperture, until the shutter is pressed. This is important when using a lens on an SLR camera. It is faster and easier to use and provides a brighter viewfinder on an SLR. The opposite of an automatic lens is a "manual lens." Manual lenses are rarely used with digital cameras except for special-purpose lenses.

available light: *See* ambient light.

back lighting: Lighting coming at your subject from behind. It generally causes a glow around the subject. You need to watch for flare when using back lighting.

backdrop: The scene behind a subject in a photograph. It generally refers to man-made backgrounds in a studio, but a backdrop could be used outdoors as well. *See also* background.

background: In a studio, the "background" is the same as a "backdrop." Outdoors, it is whatever is behind the subject in the photograph. *See also* backdrop.

bit: The smallest unit in computers. A bit is either one or zero. *See* byte.

bit depth: The number of bits of data needed to represent a pixel. A typical digital image needs at least eight bits for each of the three colors (RGB = Red, Green, and Blue), giving a total of 24 bits needed. Some higher-end digital cameras can use 12 bits for each color.

blur: When parts of a photograph are "smeared" and lacking in sharply defined edges. Camera or subject movement causes it generally, although the photographer can create it with some cameras by zooming while operating the shutter. It can be used as a creative tool. Don't confuse it with the image being out of focus or caused by undesired camera shake. To eliminate blur, it is necessary to use a faster shutter speed.

brightness: Along with hue and saturation, brightness makes up the components of color. Brightness refers to the intensity of the light or image.

built-in flash: Most digital cameras have a small flash built into the camera. These are often difficult to use and can overexpose or underexpose the image. They are usually not very powerful and are useful only for subjects 10 feet away or less.

byte: The basic unit used in computers. It is made up of eight bits.

calibration: The process of adjusting any digital device, such as a camera, monitor, printer, or scanner, to reproduce color in a consistent manner. An image file processed on a properly calibrated system will reproduce the same on any calibrated printer or look the same on any calibrated monitor. This is a process that all professional photographers must become proficient at.

camera shake: Movement of the camera when the shutter is pressed. It will often cause unwanted blur. To reduce camera shake, hold the camera firmly and rest your body against a tree, wall, or other suitable support. Increasing the speed of the shutter or using a tripod will also help.

catch light: The reflection of a light in the subject's eyes. Without it, the eyes often look dull and lifeless. It is often a problem outside when the light is on the side or in the back. Using a flash outside will usually add the catch light back.

CCD: Charge coupled device. It is the light-sensitive chip used in many digital cameras that is used to generate the image. The small cells, or pixels, on the CCD send electrical signals to the camera's processor to create the image.

CD: Compact disc. In digital photography, CDs are often used to store images and to transfer images from computer to computer. CDs vary greatly in quality and can have a life expectancy of anywhere from a few years (if you are lucky) for the really cheap CDs to 100 years or more for the archival, more expensive ones. They typically will hold up to 650 to 700MB. The actual amount of storage available is somewhat due to directory size requirements.

CD-R: Refers to a CD that can only be written to once. *See* CD.

CD-RW: CD-Rewritable. Can be written to many times. Because of the possibility of overwriting and changing the information stored on a CD-RW, they are not as useful for long-term storage of images. *See* CD.

cloning: A function available in image-editing programs to take a portion of an image and place it over another part of the image. For example, a piece of "clean" skin can be cloned or stuck over the top of a blemish to remove the blemish.

close-up: When the subject tightly fills the frame of the photograph.

CMOS: (Pronounced "C-moss") Complementary Metal-Oxide Semiconductor. It is a type of image sensor used in some high-end digital cameras.

cold mirror: A mirror designed to reflect visible light and transmit infrared light. It acts as a dichromatic interference filter and is constructed with coatings of dielectric materials to have those characteristics. *See* dichroic mirror *and* hot mirror.

color balance: The relationship of different colors to each other. Normally, the concept is to adjust the color balance so that it reproduces as accurately as possible the scene that was photographed.

compact camera: A small and usually simple camera that is often called a point-and-shoot camera.

CompactFlash: A type of memory card used in some digital cameras to store images.

compression: A technique where the size of an image file is reduced through various computational methods. This makes transmitting or storing images faster and takes up less room. Some methods such as JPEG lose data when they compress (called "lossy"), and others such as TIFF-LZW do not lose data (called "lossless") but do not compress images as much. Also, although Photoshop will handle TIFF-LZW files, not all programs will.

contrast: The range of brightness in a scene or photograph. It is the amount of difference between the brightest points, or highlights, and the darkest points, or shadows.

contrasty: An image that has a large amount of contrast; for example, an image that has bright sunlight and dark, deep shadows has a lot of contrast.

cropping: The method by which portions of an image are removed to improve composition or delete extraneous items from the photograph. It is also the name of a tool in Photoshop.

depth of field: The distance, or depth, in a photograph that is in focus. It is also sometimes called "depth of focus."

dichroic mirror: A mirror that also filters light. Some frequencies of light are reflected, and others are transmitted through, depending on the construction of the dichroic mirror. A common use for a dichroic mirror is to reflect infrared light and pass through visible light. This is known as a "hot mirror" because it reflects infrared, which includes thermal or "hot" energy. These are often used in digital cameras to keep infrared light from affecting the digital image. If a mirror will pass infrared light and reflect visible light, it is known as a "cold mirror." These are often used in slide projectors to keep the heat from the lamp from damaging the slide being projected. *See* hot mirror, cold mirror, and RGB

digital camera: A camera that uses a light-sensitive image sensor instead of film to record the image.

digital infrared: Infrared images created with the use of a digital camera. *See* infrared.

digital zoom: A feature on some cameras that enlarges the image electronically instead of optically. It is not a true zoom and does not do anything that cannot be done to the image later on the computer.

download: The process of getting the images from the camera or media card into a computer.

dpi: Dots per inch. Used in the printing industry, and often used incorrectly in photography to refer to the resolution of a file. *See* ppi.

DSLR: Digital single lens reflex camera. *See* single lens reflex (SLR).

DVD: A storage medium that currently can hold up to 4.7GB. A DVD is the same physical size as a CD, and often the same drive can be used to create (or "burn") both. New technologies allow recording on both sides of special DVDs to double the amount of storage.

editing: Sometimes confused with the term "retouching," editing refers to the selection of the best images.

EI: *See* exposure index.

electronic flash: A device that creates a bright flash of light to add light to a scene. Batteries often power it, although some studio units plug into the wall. The color temperature of the light it produces is similar to daylight, so it mixes well outdoors. Indoors, the light is colder (more blue) than the light produced by ordinary incandescent room lights.

existing light: *See* ambient light.

exposure: The combination of shutter speed and aperture settings allowing light to pass onto the digital image sensor.

exposure compensation: An adjustment that can be set on many digital cameras to change the automatic exposure determined by the camera to better reflect the desires of the photographer.

exposure index: Also called "EI." This is a number reflecting how sensitive a particular setting on the camera will be to light. It is a rating used by digital cameras to represent how they would act if the sensor were film instead of electronic.

f-number: Refers to how much light a lens will pass. The smaller the number, the more light it will let through. Usually the smaller the number, the larger the diameter of the front glass will need to be to let in additional light. In addition, the smaller the number, the more expensive the lens will be. It is a number that relates the size of the focal length of the lens to the diameter of the lens.

f-stop: The f-number setting on the lens. The generally used whole f-stops are 1.4, 2, 2.8, 4, 5.6, 8, 11, 16, 22, and 32. There are sometimes numbers in between, such as f1.8, which are partial f-numbers. Each f-stop provides twice as much light as the one above it. So f2.8 allows in twice as much light as f4.

fast lens: A lens that has a larger aperture opening, allowing more light to enter the camera.

file format: The generic term for the method of storing an image in digital form. JPEG, TIFF, and raw are common types of file formats, but there are many more.

fill flash: A method of using an electronic flash to add light to a scene to reduce the contrast. It is often used outdoors to remove shadows from a face or to brighten it.

fill lighting: Similar to "fill flash" except that the lighting does not have to be from a flash. It could be from a reflector or a floodlight, among other kinds of lighting.

film speed: A measure of how much light is needed to provide an exposure on film. It is also a generic term that refers to a similar amount of light falling on a digital sensor. The "faster" the speed, or the higher the number, the less light needed to produce an exposure. There is usually a penalty paid in either increased grain (film) or increased noise (digital) when a higher speed is selected.

FireWire: A technical specification and type of cable used to transfer data or images from one digital device to another. FireWire is faster than USB, another technical specification. It is also called IEEE 1394.

flare: The bright light hitting the camera that causes a reduction in contrast and bright streaks or patterns in the image. Usually shooting into the light or having an object in the scene reflecting light directly into the lens causes flare. The use of a lens hood or other shading device will help to reduce this, as will moving to a different angle.

flash: A sudden bright light used to add light to a scene. Today it almost always refers to an electronic flash, built-in or added on, although flash bulbs and flash powder have been used in the past.

flash exposure compensation: Similar to "exposure compensation" except that it refers to an adjustment to increase or reduce the amount of light produced by the flash on the camera.

flash fill: *See* fill flash.

flat lighting: Lighting that produces little or no shadow. This results in an image that is lacking in light direction and contrast. Generally some contrast is desirable in a photograph.

floodlight: A regular, incandescent light bulb used to light a scene, generally indoors. The light is continuous rather than an electronic flash and is usually quite warm. The color temperature of the bulb is warmer (more red) than daylight or an electronic flash.

focal length: Tells the relative angle of view of a lens in comparison to other lenses. With digital cameras, it is related to a 35mm equivalent, the result of the lens if used on a 35mm film camera. The number is expressed in millimeters, or "mm." It is calculated by setting the focus of the lens to infinity and measuring the distance between the focal point of the lens and the film plane or image sensor location. The focal length of a lens is usually engraved around the end of the lens or on the lens barrel. Lenses around 50–55mm are considered "normal" lenses because they approximately reproduce the angle of view of the human eye. Lenses smaller than that are wide angle, showing a wider field of view in the image than the human eye. Lenses larger than that are telephoto, magnifying the scene so that everything appears closer.

focus: An image is said to be "in focus" when it is sharp and well defined. Focus is also the process of adjusting the sharpness.

foreground: Everything closest to the camera or in front of the main subject is considered the foreground.

formatting: The preparation of the digital camera's memory card to receive images. It is similar to erasing the memory card. To avoid problems, it is best to format the memory card in the camera and not in a computer. It should be done every time after you have downloaded the images from the camera into the computer. Be careful when you format. It essentially erases the images from your memory card, although there is some software that can reverse the process if you have not taken any additional photographs yet. Sometimes formatting is also called *initializing*.

fresco: A type of photograph modified with Photoshop filters that resembles a painting done on a plaster wall.

gigabyte (GB): About 1,000 megabytes, or about a billion bytes. It is a unit used to specify the size of camera media cards and disk drives.

grayscale: Another term for a black-and-white image. Because there are no colors, just shades of gray, grayscale is a way of representing a black-and-white digital image without using RGB, thus it is one-third the size. Because it uses a bit depth of eight, there are 256 different shades of gray between pure white and pure black.

guide number: A number assigned to electronic flash units to indicate how powerful they are. The higher the guide number, the more powerful the flash is. Use this number with caution. Manufacturers have been known to exaggerate this number by the way they measure it. It is dependent on the sensitivity setting of the camera, so the number is usually quoted, by convention, at an ISO of 100. The guide number is equal to the aperture (f-stop) times the distance from the camera to the subject and will reference either feet or meters. Thus, a guide number of 40 means that you could use f4 at 10 feet. Usually, this number is useful when purchasing different flash units as a way to judge how powerful a flash unit is, but otherwise is not used very often with automatic cameras.

hard lighting: Lighting that produces sharp shadows. It is produced when the apparent size of the light source is small in comparison to the subject size. Thus the sun produces a hard light, but a hazy day produces a soft light because the entire sky becomes the light. Usually in portrait photography, soft lighting is more flattering and what we aim for unless we are trying to produce a special effect.

high contrast: The opposite of flat lighting. When an image or scene is high in contrast, that means there are fewer tones between black and white.

high key: An image made up mainly of light tones. An example would be a woman wearing a white dress on a white background. If done properly, a high-key image can be very striking because the skin tones stand out in contrast to everything else.

highlight: The brightest part of an image.

histogram: A feature available on many digital cameras that shows a graphical representation of how much of each tone a photograph has in it. When an image is displayed on the camera's LCD (or in Photoshop), there is a button to activate and display a small graph. The graph should be a curve starting at the left (dark tones) side, rising in the center, and falling on the right (light tones) side. If the curve is not centered or is "piled up" at one end, it often indicates an exposure adjustment would be useful.

Holga camera: An inexpensive plastic camera that uses 120 film and has a plastic lens. It is used by film photographers to create a dreamy, mysterious effect. Digital photographers can use a Lensbaby to duplicate the effect. *See* Lensbaby.

hot mirror: A mirror that reflects infrared radiation and transmits other forms of radiation such as visible light. It is used in optical devices to protect them from heat. An example would be in a slide or digital projector to protect the slide or internal components from the heat produced by the very bright and hot projection bulb. *See* cold mirror.

hot shoe: What the accessory shoe on a camera is called when it has contacts that match up with the contacts on an electronic flash so that no cord is necessary.

HSB: An abbreviation for the three parts of color: hue, saturation, and brightness. *See* each term separately.

hue: The representation of color, often using a color wheel.

image browser: Software or a computer program used to view images. An image browser is usually built into each computer and usually comes on a CD of software with each digital camera.

image-editing program: A piece of software used to make corrections to images. Photoshop is an example of an image-editing program. Digital cameras usually come with an image-editing program on their software CD.

image resolution: *See* resolution.

infrared: A spectrum of light (electromagnetic radiation) that is not visible to the human eye. The wavelength of infrared light is longer than that of visible light and appears on the electromagnetic spectrum near red light in the visible spectrum. Some digital cameras are sensitive to infrared, and others can be modified so that they are. Photographs made with infrared light are very ephemeral and "other worldly" in their appearance. There are a number of uses for digital infrared imaging in medicine, science, and night vision applications.

initializing: *See* formatting.

inkjet: A type of printer used to print images that operates by spraying tiny droplets of ink onto the paper. It usually uses ink in the colors of cyan, magenta, yellow, and black, the standard colors used in printing presses as well.

interpolation: A technique used by computer programs such as Photoshop to enlarge images by creating pixels between existing pixels. If done properly, and not to a high degree, it will result in a larger image than the original.

ISO: International Organization for Standardization, the replacement of ASA to set standards for many businesses and technologies. In photography it is used as a measurement of film speeds and digital camera sensitivity, such as ISO 400.

JPEG: Joint Photographic Experts Group, a file format widely used in digital photography. The file format compresses the size of digital images by throwing away data that the algorithm believes is duplicated. The amount of compression determines the amount of data that is thrown away. In Photoshop, the compression can be set from 1 (most) to 12 (least). Each time you open and resave the image, it throws away data and gets progressively worse. This should obviously be avoided. It is called a "lossy format" because some data is lost. The format of the filename is *sample*.jpg.

Lensbaby: A commercially available lens that can be used on a DSLR camera. It is notable for its ability to modify and adjust focus zones throughout the image. Some versions can be used to simulate the effect of a Holga camera. *See* DSLR *and* Holga camera.

lens hood: A device attached to the end of a lens to help shade the lens from light and prevent flare. Sometimes the lens hood is built in and simply slides out. Other times it is a separate device that must be snapped in place. Zoom lenses or wide-angle lenses often have a funny, almost flower-shaped lens hood because of how wide the lens sees. It is sometimes called a *lens shade*.

lens speed: A rating of a lens based on its widest aperture or smallest f-number. A "faster" lens has a smaller f-number.

liquid crystal display (LCD): The small display screen on the back of most digital cameras. This is one of the most powerful features of digital photography—instant feedback. Do not use LCD screens to judge exposures. Only histograms can help you there.

lossy format: Refers to a file format that compresses a file to save space by throwing out or losing data. *See* JPEG.

low key: The opposite of "high key." The tones in the image are usually middle or dark with no light-colored objects.

luminosity: The brightness of a color.

manual focus: The opposite of autofocus. The focus must be done by the photographer by hand instead of letting the camera do it. Manual focus is also a feature on some cameras that can be used in difficult situations where the scene is changing faster than the camera can focus, where the desired focus point is different from what the camera can select, or when objects are moving between the camera and the subject, fooling the autofocus system.

media: Where images are stored. Memory cards, CDs, and DVDs are all examples of media. *See* memory card.

megabyte (MB): A measure of how large an image is when it is opened up or stored in an uncompressed format. Although *mega* means million, a megabyte is actually 1,048,576 bytes, due to the way measurements are done on computers.

megapixel (MP): Refers to how many pixels a camera uses. *Mega* means million, so a 3MP camera has 3 million pixels.

memory card: The device inserted into a camera on which to store images. It could be considered "digital film." *See* media.

midtones: The tones in the middle between highlights and shadows. They are also called *average tones.*

model release: Permission given by a model for a photographer to use an image in the way defined by the release. A model release is best done in writing and is governed by individual state laws in the United States or by the laws of other countries. Since a model release is a contract, the model must be given something of value in return. Things other than money can be "something of value," but that varies in each state or country.

mosaic: A type of photography where images are overlaid to create a larger image.

natural light: Generally refers to light outdoors, so it means sunlight or naturally reflected sunlight.

Neomysticism: A term coined by the author to describe the mystical images created by Holga plastic cameras and their digital equivalents, Lensbabies. *See* Holga camera and Lensbaby.

Neosymbolism: A style of art characterized by bright colors in an almost cartoon-like manner. Artist Nick A. Demos claims to have invented the term in 1998 to describe his painting of words on canvas with bright colors. The author has used the term for many years to describe some of the bright images displayed in this book. Other artists have used the term as far back as the early 1900s.

noise: Some people call noise "digital grain." However, noise is rarely an attractive feature of an image, whereas film grain can be. It can be recognized as multicolored speckles throughout the image. Noise is usually caused by too little light so that the image has to be enhanced electronically, either in the camera or after the fact. Noise is reduced by adding more light, increasing exposure time, reducing the ISO sensitivity, or all of the above.

normal lens: A lens that closely approximates the view of a human eye. The 35mm equivalent is around 50–55mm.

on-camera flash: A flash attached directly to the hot shoe of the camera.

optical zoom: A zoom lens where the focal length of the lens changes by twisting, pulling, or pushing a button. The focal length of the lens changes by moving the various optical glass elements in relation to each other. It is a useful and convenient lens to have on the camera. It is usually just called a zoom lens.

overexposure: When too much light arrives on a light sensor. Usually the image is very light with no detail in the highlights and few or no blacks in the image.

photoimpressionism: A type of photography that emulates impressionistic paintings.

Photoshop: A popular and somewhat expensive photo manipulation software made by Adobe. Professional digital photographers usually need to be familiar with and use this program or else pay someone else to do their image editing.

pinhole: A type of camera where the lens is a tiny hole, often in a piece of thin metal, instead of a glass or plastic lens element. These types of cameras tend to have a large f-number, generally a soft overall look, and a great depth of field. Pinhole cameras were among the first types of cameras. Digital cameras with interchangeable lenses can often be adapted to create pinhole images.

pixel: The smallest digital photographic element. It stands for picture (or "pix") element. Each pixel is made of a red, green, and blue (RGB) component.

pixelation: The undesirable effect of seeing the image break down into pixels where the sizes of the individual pixels are larger than the detail in the image. Enlarging an image too much usually causes pixelation.

pleinart: A style of imagery that is similar in look to impressionism but with more detail. It should not be confused with the Plein Air art movement that denotes art created outdoors, a technique often used by impressionists.

point and shoot: Refers to a simple type of digital camera. *See* compact camera.

Pop Art: A style of art that is noted by its bright, brash colors. Andy Warhol was noted for his Pop Art pieces.

portfolio: A group of images, usually in a folder or notebook, to show off the work of a photographer or model. It should show style, range, and experience. It is used to show to prospective clients.

ppi: Pixels per inch.

raw: A format offered by some digital cameras that stores the unprocessed electrical signals from the sensor in a special format. The raw format is usually different for each camera. The advantage of the raw format is that many decisions on things like white balance or color temperature can be decided by the photographer later and processed in the computer rather than in the camera. The photographer can try a number of options until he gets the image exactly the way he wants it. Disadvantages are that the file format takes up more storage space on the digital memory card, the camera often works more slowly, and it takes more postproduction time at the computer. Note that since raw is not an abbreviation, it is written as "raw" and not RAW, although that spelling is often seen.

recycling time: Refers to the period of time after an electronic flash has fired until it is ready to be fired again. This period usually increases as the batteries get weaker.

red eye: When a subject's eyes appear to be red. The irises of the eyes are red instead of black because light from the flash is reflected back from inside of the retina directly to the camera. It can be avoided by moving the flash head away from the center of the lens either to one side or higher on an arm. It is difficult to do with many hot shoe flashes.

red-eye reduction: A feature of some cameras where the flash has multiple short bursts of light before the main flash to reduce the size of the iris of the subject's eye so that there is less red reflection.

reflector: Any object that will reflect light to use in a photograph. It can be a large white piece of cardboard, a sheet, or foil glued to a board.

reflector fill: A way to reduce harsh shadows with a reflector instead of a fill flash.

removable media: *See* media *and* memory card.

resolution: A measure of how much fine detail is in an image either in a printer or a camera. It is often measured by pixels per inch (ppi).

retouching: Changing things in photographs to reflect what the photographer saw in his mind rather than what was really there. Examples include the removal of blemishes not hidden by makeup, fixing straps that should not have been seen, or other kinds of manipulations.

RGB: Stands for Red Green Blue, the three colors used to form a digital photograph.

Rule of Thirds: A compositional technique. Dividing an image into three equal sections vertically and three horizontally provides an image with nine rectangles, sort of like having tic-tac-toe inscribed on the image. The four junctions where the lines meet are good areas for subject placement when composing a photograph.

saturation: One of the three components of color and refers to the purity of the color. When a color is saturated, it is the purest color possible.

SD memory card: A type of memory card, just as CompactFlash is a type of memory card. *See* memory card.

shadow: The darker portions of an image.

shadow detail: The amount of detail that can be seen in the darkest shadow portions of an image.

sharpness: The amount of definition between adjacent elements of a photograph. An image is said to be sharp when the edge between lighter and darker portions is very fine.

shutter: The part that covers the aperture and is removed to take a photograph. The shutter blocks light from traveling through the lens and striking the image sensor on a digital camera. It can be made of curtains or blades.

shutter lag: The amount of time between when the shutter release is pressed and the shutter fires. The best camera manufacturers try to make this time as short as possible. Be sure to test any camera before you buy to make sure any shutter lag will work with your subject matter.

shutter priority: An automatic setting on a camera allowing the photographer to specify the shutter speed and have the camera select the aperture. It is often used for artistic effect when the photographer wants to use a slower shutter speed than the camera would normally select.

shutter speed: The period of time that the shutter is open, allowing light to reach the image sensor. The faster the shutter speed, the less light reaches the sensor.

side lighting: When the subject is lit by light coming from one side.

silhouette: When the subject is dark and has no detail, but the background is lighter and is well exposed.

single lens reflex (SLR): A type of camera in which the optical viewfinder sees through the same lens as the light sensor. This type of camera allows the photographer to see exactly what he will be photographing. It also allows the changing of lenses. SLRs are typically more expensive than other types of cameras due to their greater complexities.

soft lighting: The opposite of "hard lighting." It is lighting that produces shadows without a sharp edge. It is generally more flattering to women than hard lighting. It is produced by any light source that is large in comparison to the subject. The larger and closer a light source is to a subject, then generally the softer it is.

stop: A term used to describe either doubling or halving the amount of light, which equals "one stop." *See* f-stop.

studio: Generally refers to an indoor location, such as a room, used just for photography. The photographer has complete control over many elements of an image such as lighting.

subject: The main focus of the image.

telephoto: Having a narrower field of view than the human eye does. It brings everything closer.

thumbnail: A small representation of an image. It is usually grouped together with a number of other, similar-size images so that a quick glance allows you to look at a group of images. They can be shown on a computer monitor or printed on a sheet of paper.

TIFF: Tagged Image File Format, a common file format. It takes up more space than a JPEG image, but it does not lose information when it is repeatedly opened and resaved. Any image that will be worked on should be saved in the TIFF format rather than JPEG. TIFF images are identified by having the letters "tif" after the period in the filename, as in *sample*.tif.

tripod: A three-legged device designed to hold a camera steady to avoid camera shake on longer exposures.

tungsten light: A type of light, usually called *incandescent light*, that is a continuous light rather than a flash. Typical room lights are tungsten, but fluorescent lights are not. The color temperature is warmer (more red) than an electronic flash or daylight, and compensation must be made for that.

ultra-wide-angle lens: A very wide-angle lens, usually 24mm or wider. The photographer needs to be careful when using such a lens to keep his feet out of the image.

underexposure: Where the image is too dark because not enough light reached the sensor to create a proper exposure. Although some corrections can be made, the resulting image will not be as good as if a proper exposure were done in the beginning. Extra noise often ends up in the darker areas of an image.

unsharp masking: *See* USM.

USB: Universal Serial Bus, another technical specification for transferring data between digital devices. It is slower than FireWire. USB 2.0 is an updated and faster version.

USM: Unsharp masking. Although it is called "unsharp," it is actually a technique used to increase the apparent sharpness of an image by increasing the contrast of pixels next to each other. Programs such as Photoshop have the ability to perform USM.

white balance: A control on digital cameras used to adjust how colors are recorded on a camera so that white appears white. Most digital cameras have settings like "auto," "tungsten," "daylight," and so on.

wide-angle lens: A lens that has a wider field of view than the human eye or a "normal" lens.

window light: The light illuminating an indoor scene that comes through a window. Normally, it is not direct sunlight, but a softer light from the sky areas.

zoom lens: A camera lens with a variable focal length. It is probably the most popular type of lens in use today. Nearly all digital cameras with nonremovable lenses have zoom lenses built in.

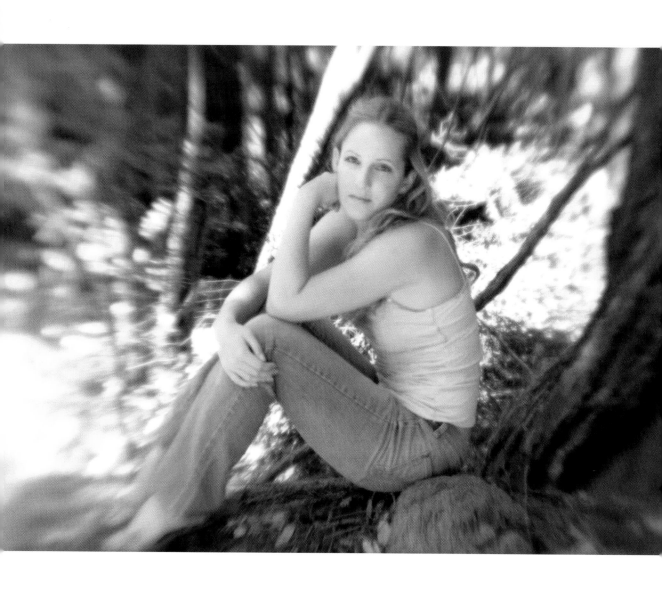

APPENDIX B

Resource List

Manufacturers and Suppliers

This is a listing of some of the manufacturers and suppliers that were mentioned in the book as well as others that you will find useful. Also check the author's website (johngblair.com) for more information plus any changes in the website links.

Books

Amazon.com—New and used books

Half.com—Used and out-of-print books

Digital Toy Cameras

Amazon.com—Has a number of online stores that carry photographic equipment.

eBay—Besides being a photo auction site, there are lots of small stores that carry photography equipment. *www.eBay.com*

B and H Photo and Video—A well-known and respected New York camera dealer with a big online presence. *www.bhphotovideo.com*

Holga Suppliers

Holgamod.com—*www.holgamod.com*

Freestyle Photo—*www.freestylephoto.biz*

Infrared Cameras

LifePixel—They will convert your digital camera so that it will always photograph in infrared. Visit their website for a list of the cameras that they can convert to infrared operation. *www.lifepixel.com*

Pinhole Lens Suppliers

Holgamod.com—*www.holgamod.com*

Freestyle Photo—*www.freestylephoto.biz*

Calumet Photo—*www.calumetphoto.com*

eBay—Besides being a photo auction site, there are lots of small stores that carry photography equipment. *www.eBay.com*

Selective Focus Lenses

Lensbabies—The well-known supplier of the unusual flexible lenses known as LensBabies. *www.lensbabies.com*

Software Suppliers

Adobe—Adobe created Adobe Photoshop, Adobe Photoshop Elements, and Adobe Photoshop Lightroom. *www.adobe.com*

Apple Computers—Apple is the creator of the Macintosh computer and the Aperture software program. *www.apple.com*

Websites

This is a listing of interesting and useful websites. Since the web is in constant flux, there is no way any book can stay current on the changes. Please visit the author's website, listed below, for the most current information.

www.johngblair.com—This is the author's website. Any corrections or additions to this book will be shown here. In addition there will be more links to useful websites.

www.pinholeedun.com—For information about pinhole photography.

www.toycamera.com—For film-based toy cameras.

www.litratista.org—Instructions for making a homemade Holga lens to attach to your digital camera.

theonlinephotographer.blogspot.com/2006/12/10-digital-camerahow-do-they-do-it.html—Discusses $10 digital cameras.

www.thejamcam.com—Support information for the discontinued JamCam toy digital cameras.

www.flickr.com/groups/tinycams/pool—A group that discusses tiny cameras.

geektechnique.org—A website with interesting projects. Search "infrared" for a method to convert your own digital camera to photograph in infrared.

Suggested Reading

Here is a listing of books on topics similar to alternative digital photography, along with a brief description or review of each book. It is difficult to recommend particular books because it depends on your taste in photography, your skill and experience level, and where you want to go next. As of the time of writing, this is a pretty complete list of the books currently available either used or in print that may be useful.

Digital

Digital Infrared Photography: Professional Techniques and Images
Author: Patrick Rice
ISBN: 1584281448
Publisher: Amherst Media
Year Published: 2004
This book is well regarded, but is limited to only one alternative technique.

Digital Photography Special Effects
Author: Michael Freeman
ISBN: 0817438254
Publisher: Amphoto Books
Year Published: 2003
Both softcover and hardcover editions appear to be out of print, as Amazon does not stock it.

Digital Art Photography for Dummies
Author: Matthew Bamberg
ISBN: 0764598015
Publisher: Wiley Publishing
Year Published: 2005
Mainly focused on standard digital photography, but good background information if your digital photography skills are weak.

Digital Camera Tricks and Special Effects 101: Creative Techniques for Shooting and Image Editing
Author: Michelle Perkins
ISBN: 1584281766
Publisher: Amherst Media
Year Published: 2006
Similar in focus to *Alternative Digital Photography*, but with a very light touch on the subject due to a broader subject matter and fewer pages.

The Digital Darkroom: Black and White Techniques for Using Photoshop
Author: George Schaub
ISBN: 1-883403-51-0
Publisher: Silver Pixel Press
Year Published: 1999
Although the digital side is far out of date, the book shows the beautiful things that can be done digitally in black and white. If you love black and white, then this book is worth purchasing if a used copy can be found on Amazon.com or Half.com.

Related Topics—Film Based

Although *Alternative Digital Photography* is about digital photography, much can be learned from reading about the film-based techniques that preceded them. In many cases the example photographs will give the reader ideas on using the digital techniques as well.

Infrared Photography Handbook
Author: Laurie White
ISBN: 0-936262-38-9
Publisher: Amherst Media
Year Published: 1995
About 40 pages of really beautiful infrared images created with infrared film that can serve as examples. The rest of the book is technical information mainly focused on film-based techniques. The book is worth purchasing if a used copy can be found on Amazon.com or Half.com.

Infrared Nude Photography: A Guide to Infrared and Advanced Technique
Author: Joseph Paduano
ISBN: 0-936262-67-2
Publisher: Amherst Media
Year Published: 1998
If you enjoy photographing the nude, this book has great examples. About 50 pages of really beautiful infrared images of the nude created with infrared film that can serve as examples. The rest of the book is technical information mainly focused on film-based techniques. The book is worth purchasing if a used copy can be found on Amazon.com or Half.com.

Pinhole Photography: Rediscovering a Historic Technique
Author: Eric Renner
ISBN: 0-240-80231-4
Publisher: Focal Press
Year Published: 1995
Lots of good information on the history of pinhole photography and how to build your own film pinhole camera. There are many pages of pinhole photography examples that will whet your appetite for doing more. Good technical and background information as well.

Polaroid Transfers: A Complete Visual Guide to Creating Image and Emulsion Transfers
Author: Kathleen Thormod Carr
ISBN: 0-0174-5554-X
Publisher: Amphoto Books
Year Published: 1997
Kathleen is the master of the Polaroid process. The numerous example images in her book can serve as inspiration for the digital photoimpressionism images. If you like these techniques, then you will "ooh and aah" at her images.

Watercolor Portrait Photography: The Art of Polaroid SX-70 Manipulation
Author: Helen T. Boursier
ISBN: 1-58428-032-8
Publisher: Amherst Media
Year Published: 2000
This book contains some good examples to give you ideas of how to manipulate your images digitally. The book is worth purchasing if a used copy can be found on Amazon.com or Half.com.

Photo-Imaging: A Complete Guide to Alternative Processes
Author: Jill Enfield
ISBN: 0817453997
Publisher: Amphoto Books
Year Published: 2002
Although she uses a computer for some of her work, it is based upon analog rather than digital photography. It is similar in concept to *Alternative Digital Photography*, but it is out of date on the digital side. Otherwise her work is quite beautiful.

INDEX

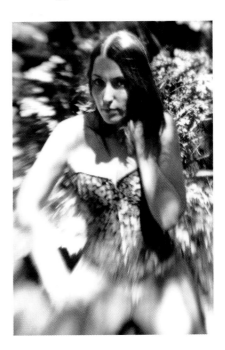